William
Aiken
Walker

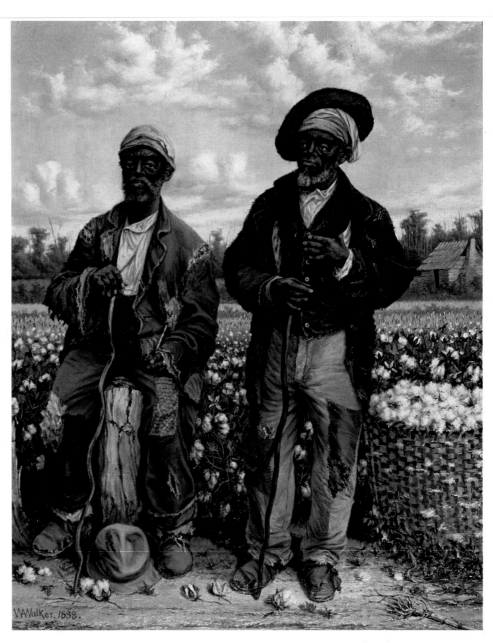

Calhoun's Slaves
Lower left: W. A. Walker 1888
Oil on canvas, 21 x 16 inches
Present owner: Jay P. Altmayer, Mobile

August P. Trovaioli

and Roulhac B. Toledano

William Aiken Walker
Southern Genre Painter

Louisiana State University Press
BATON ROUGE

ISBN 0–8071–0234–2
Library of Congress Catalog Card Number 72–79340
Copyright © 1972 by Louisiana State University Press
All rights reserved
Manufactured in the United States of America
Type set by Typoservice Corporation, Indianapolis, Indiana
Printed and bound by Halliday Lithograph Corporation,
 West Hanover, Massachusetts
Designed by Dwight Agner

The publishers gratefully acknowledge the generous support of Mr. Jay P. Altmayer of Mobile, Mr. George Arden of New York City, Mr. J. Cornelius Rathborne III of San Francisco, Mr. Herman A. Schindler of Charleston, Mr. Walter A. Soefker, Jr. of Memphis, and Mr. Rudolf G. Wunderlich of the Kennedy Galleries, New York City.

Contents

I truly love the South. It is my home and I am its captive. My family has lived here since the 1830's—in Georgia and Alabama, in Mississippi and Kentucky. Many were merchants; a few were cotton farmers; all had identity with the land. When my mother died some ten years ago I found among her possessions a receipt given my grandfather by remnants of the Southern army fleeing south from Vicksburg. The receipt was for cotton which my grandfather had grown when he was sixteen and which had been burned so that it would not fall into Union hands.

Holly Hill Nov. 10th 1863

To all whom it may concern

 This is to certify that I burnt on the plantation of Wm. P. Ruissom fifty four (54) bales of Cotton belonging to Jacob Pollock Port Gibson weighing twenty five thousand one hundred and ten (25,110) pounds, middlings.

Corporal B. B. Paddock Co K
Wirt Adams' Regt

But this is only incidental to why I collect the paintings of William Aiken Walker. I am confident that I have collected Walker's work for a most fundamental reason. Though I have covered much of the world, I prefer the landscape of the South to all others. I love its forests, its swamps, and its natural beauty. Perhaps I should explain that hunting and the outdoors are among my hobbies. From childhood I have spent endless hours in the woods, and I have seen thousands of times almost every scene and subject which Walker recorded.

I have a broad collecting interest in Americana, with notable emphasis on American paintings of the nineteenth century. Almost half of the total group of some two hundred and fifty paintings in my collection are Southern genre, and more than forty of these are by Walker. Whether he is considered a fine painter or a poor painter is of relatively little concern to me. I have no interest in whether or not his subjects are conceptual or perceptual. To me, his technique is inconsequential. What is of importance to me is that this man has no parallel among American genre painters as a visual recorder and pre-

server of life in the rural South during the post–Civil War period when cotton was still king of the economy.

At precisely that moment in America's westward expansion when such important artists as Remington, Russell, Bierstadt, Schryvogle, Moran, and a host of others were roaming the West, recording the liquidation of both Indian and buffalo as well as the hardships of pioneers crossing the continent, William Aiken Walker was diligently at work in his native region.

Walker found the forgotten man. He portrayed the black cottonfield worker, obviously the least popular subject at the time, with dignity and realism, as did no other American artist of the period. For me his paintings have some sociological overtones. He found in those newly freed slaves a group of incredibly poor people, not in the least sorry for themselves but proudly trying to adjust to a new way of life. None of his subjects show hostility or bitterness.

I am a strong believer in dissent and challenge, particularly as a method of achieving fundamental patterns of communication between all peoples, and it is my opinion that Walker held similar feelings. Instead of painting the easy, indolent life of the plantation owner, he focused on the far less popular and less romantic character, the field hand. To me, this clearly spells out the greatness of the painter. He was avant garde. He was a half-century ahead of the social changes that are occurring at this moment. This alone makes him great. There are no doubt those who will not see the subtle sociological overtones that I read into his paintings. Even so, I believe there are few, if any, who will challenge the fact that Walker left behind a most meticulous record of rural life in the Southern United States as it existed from the 1860's to the early 1900's. I believe he will endure because no other painter so completely recorded the people, the area, and the scenes that his canvasses cover.

JAY P. ALTMAYER

Mobile, Alabama

Preface

Research concerning Southern artists who were most productive between the end of the Civil War and the beginning of the First World War is difficult at best. The South was far too occupied with economic survival to worry about archives and collections of the products of its creative minds at work during that era. Even today the sources to which one would expect to look for study of the visual arts furnish, for the most part, the greatest disappointment. Documentation of these artists is sparse, and examples of their work in Southern museums are all too few. Indeed, the need for serious collectors of Southern art is well known. It is to the few outstanding private collections that the researcher must turn or to those astute and knowledgeable antique dealers whose firsthand information has been collected through contact with many hundreds of individuals and then thoughtfully sifted. The value of regional creative efforts also has too often gone unrecognized by the region itself and has been instead discovered by connoisseurs in a small number of New York galleries who occasionally found excellence in the work of totally unknown artists. Such men were generally among the first to amass information about and examples of the fine Americana originating in the nineteenth-century South. Of these connoisseurs, most instrumental in recognizing William Aiken Walker was Harry Bland of the Bland Galleries.

In the South, one of those willing to pursue an interest in unknown artists is August Trovaioli, an art conservator and educator who became interested in the work of William Aiken Walker in the 1960's. To a degree this interest was accidental; among Trovaioli's clients were three major collectors of Walker paintings, Jay P. Altmayer of Mobile, Herman Schindler of Charleston, and George Missbach of Atlanta. Work for these gentlemen and other collectors who were somewhat interested in Walker resulted in the preservation of some one hundred and twenty-five paintings. Trovaioli also is a collector of early numbers of magazines—*Harper's, Scribner's, Appleton's* and *Century*—which contain illustrations of life in the

postwar South. Because of his familiarity with such visual documentation, Trovaioli was quick to realize that Walker was responsible for perhaps the most vivid personal depiction of the rural Southern scene.

I had heard of August Trovaioli some years before I met him. He was known to reside in a seemingly mythical area called Grand Bay, Alabama, just around the turn from Bayou La Batre. Upon meeting him, I was overwhelmed by the extensive solitary and affectionate work on Walker's art this gentleman had done. This book is the result of his dedication, my own complementary research and organization of the material, and the indispensable, sensitive photography of Betsy Swanson. Jay P. Altmayer has also been essential to the project from its inception. He shared his ideas and information enthusiastically, and his outstanding collection of American art served as a base from which Walker's work could be fairly assessed. The four of us have studied over four hundred and ten Walker paintings and thirty photographs, as well as three sketch books with over one hundred and ninety drawings. All of these document Walker's life; all the sketches, the photographs, and many of the paintings were also annotated and inscribed by the artist with valuable information.

Since many of these paintings belong to friends of Walker or to the families of original owners, often letters from the artist and specific information about him were also made available to us. Most notable of the written material is the collection of Mrs. W. H. Cogswell III of Charleston, grandniece of the artist. Her collection includes a diary of the Cuban trip, 1869–1870, a poetry book by the artist, and a collection of Walker's effects brought from Ponce Park, Florida, after he died. Other invaluable components of the Cogswell collection are oil-colored and black and white photographs, some of them annotated, numerous paintings which had not been sold at the time of the author's death, and other memorabilia.

Fifteen letters from Walker to Dr. C. Lewis Diehl of Louisville, Kentucky, and two letters dated 1899 and 1914 to Diehl's daughter Katie were made available by the Ann Katherine Caldeway Estate, Louisville. The personal scrapbook of A. J. H. Way, with memorabilia on all aspects of South Carolina history from 1830 to 1865, housed in the Charleston Library Society Collection, provided invaluable newspaper clippings from Baltimore and Charleston relating to Walker's work and travels. Herman Schindler, one of the earliest and most consistent collectors of Walker material, made available a large base of information about Walker in his extensive slide collection of the artist's work and the files he had compiled as a

dealer in Southern antiques during a period of thirty-five years. George E. Missbach, long a Walker collector, provided Civil War information and made available photographs and provenance of his collection of twenty-eight paintings. The late C. H. King of Atlanta, a personal friend of the artist, had two letters from Walker written in the 1890's. Richard S. Hawes III of St. Louis, Missouri, also a collector of Walker paintings, made available photographs of twenty-eight paintings.

The compiled research from these conventional written sources did not define Walker's unique life style. When we realized that only extensive photographs of the artist's work and a series of personal interviews at all the places Walker worked and visited would make possible the presentation of the artist, we proceeded to meet that need. For a period of four years, August and Iris Trovaioli spent considerable time traveling throughout the South interviewing art and antique dealers who had handled the artist's work through the years. This in turn led to visits with various painting restorers who, like the authors, had become interested in Walker after seeing the range of his subjects while restoring his work. Contact was eventually made with friends and acquaintances of the artist. An invaluable resource contact, without whose contribution the Florida section would not have been possible, is Mrs. Charles Moore of New Smyrna, Florida. Mrs. Moore, a granddaughter of Gomersinde Pacetti, introduced Trovaioli to Walker's Florida, to the Pacetti boarding house and to acquaintances of the artist.

With these considerable leads, August and Iris Trovaioli and my husband and I made separate trips throughout the South. We found Walker paintings in small museums, private homes, antique shops, and even filling stations. We interviewed some of Walker's old friends and acquaintances as well as local historians who, with detailed knowledge of their towns and counties, often filled in pieces of the Walker puzzle and recreated the postreconstruction era for us. Most important, we began to identify a new and little-known phase of the artist's work—his late naturalistic landscapes and documentary landscape painting.

Betsy Swanson made trips to Charleston, Columbia, and Mount Pleasant, South Carolina, and to Savannah, Mobile, Baton Rouge, and Atlanta to photograph large Walker collections as well as remnants of the physical environment as Walker knew it. She gathered documentary information about the hundreds of paintings she photographed, since many still belong to the descendants of the original owners. Had it not been for her ability to conduct fruitful interviews, select the

more meaningful paintings for illustrations, and indeed, to find paintings in unlikely spots, much of the Walker project would remain unfinished. She also made available her extensive file on Southern landscape painting and historic sites.

In our tours of Walker's Southland seventy-five years to a century later, we looked for and found what is left of the South that Walker knew. We found it in the countryside of the Black Belt where the "Quarters" remain in the cotton fields with firewood stacked in the yard and smoke coming from the leaning chimneys. The tobacco fields of North Carolina are dotted with the same clay-chinked log cabins, now mostly deserted; the South Carolina lowlands often have not only the board and batten cabins in the now sometimes uncultivated fields but often inhabitants remarkably reminiscent of a Walker painting. A television antenna replaces the martin pole, and there is a car out front where the pigs and wagon used to be. Even in the small cities of the South, Walker's world can be recalled if one looks upward along the city streets, above the plate glass and modern false fronts to the cornices and upper windows of the commercial buildings. Many of the mills and factories built in the 1880's still stand, and the reflections of their Gothic, Italianate, and Tuscan Revival details shimmer in the streams and rivers beside which they were built. In the older sections of places like Augusta, Vicksburg, and Mobile, one can see the tree-lined avenues with galleried houses where Walker used to visit. The once elegant, fluted columns now have broken caps; the wooden Victorian jigsaw work is unpainted; and rusty ironwork, and cracked, etched leaded glass now characterize the houses where Walker roomed or attended musical soirées and dinner parties. In Charleston, Savannah, St. Augustine, and New Orleans, where there is now interest in the tourist trade which was thriving even in Walker's day, the setting Walker knew is better preserved. The sandy beaches and palmettos of Florida are still there, though hardly as peaceful as they were. In the urban areas of Florida's east coast the scenes Walker knew have vanished completely, as have the rice fields of the South Carolina lowlands. Sugar cane is harder to find, grown now in a much more limited area of Louisiana than it was in Walker's day; and the back bayous are much farther back. Thus Walker's work as a historical record looms more important year by year.

Acknowledgments

During the course of our research, museum and library personnel, restorers, dealers, collectors, historians, old friends of the artist, descendants of early Walker collectors, or people who just happened to have inherited "an old Walker painting

up in the attic" all participated enthusiastically in the project, and the authors are indeed appreciative.

Helen McCormack, director emeritus of the Gibbes Art Gallery, Charleston, contributed primary source material about Walker and his Charleston days. Mrs. E. Milby Burton recalled Walker's visits to her father, Captain C. C. Pinckney at Runnymede, the family estate near Charleston, and at their summer home in Arden. George Walker and Edward H. Walker, the artist's grandnephews, provided information which illustrated facets of the artist's personality. Also helpful were the following South Carolina relatives of the artist: Mrs. W. H. Cogswell III, Mrs. Edith O. Prentiss, and Mrs. Henry C. Heins, Jr., all of Charleston; Mrs. W. H. Bradley of Mount Pleasant; Mrs. George Archie Martin of Columbia; and Mrs. Elizabeth Willingham, now of North Palm Beach, Florida. Francis Bilodeau, director of the Gibbes Art Gallery, Mary E. DeLegal, reference librarian at the College of Charleston, and Virginia Rugheimer of the Charleston Library Society assisted. Dr. and Mrs. William Coles did much of the Charleston research, locating and photographing important Walker paintings.

Throughout Georgia, my husband and I were graciously received by historians and other interested people, such as Joseph Cumming, whose family has lived in Augusta long enough to have entertained George Washington and the Marquis de Lafayette. Cumming was an essential link to Walker's Augusta. Clement de Baillou, director of the Augusta Richmond County Museum, and his assistant Jean Wheadon located photographic prints and information about Summerville, where Walker went to improve his health. John Bonner of the Rare Book Room at the University of Georgia in Athens whose office hours fortunately extend to 10:00 P.M. in the summer, stayed even later to locate material. Mrs. Craig Barrow, Walter and Cornelia Hartridge, Muriel and Malcolm Bell, and Lilla Hawes, curator of the Georgia Historical Society, made us aware of Savannah's post–Civil War literary and artistic world.

Alonzo Lansford, an essential resource for Walker material in New Orleans, also contributed information on the artist in Charleston and Savannah, where in both cities Lansford served as director of the Gibbes Art Gallery and the Telfair Academy in the 1930's and 1940's. Felix Kuntz, an early and astute collector of Southern painting and *objets d'art*, provided much needed information, and it is through an exhibition of his collection presented at the Louisiana State Museum by the Friends of the Cabildo in 1968 that much of the back-

ground material for this book was collected. Mrs. Malcolm Monroe and Mr. W. P. Monroe, the heirs of Robert Stanley Green, catalogued the former Green collection and lent memorabilia. Ray Samuel made paintings, old scrapbooks, and files available, as did General Kemper Williams and Boyd Cruise, curator of the Historic New Orleans Collection, and the staff of the Louisiana State Museum. Clive Hardy, bibliographer at Louisiana State University in New Orleans, and Consuelo Griffith of the Tulane University Library made available manuscripts, early catalogues, and newspapers. Carroll Bowers, Juanita Elfert, Marc Antony, Mrs. William Treadway, Phyllis Hudson, and Mrs. William Scoggin, granddaughter of Aristide Hopkins of New Orleans, collected information and provided research material for various phases of the project. Joseph Ewan, author and professor of botany at Tulane University, and Royal Suttkus of the Tulane biology department studied Walker's paintings and letters in terms of their own specialized fields, contributing much to the appreciation of Walker as a documentarian. Dr. Jessie Poesch, professor of American art at Newcomb College, James Byrnes, director of the Isaac Delgado Museum of Art, Martin and Margaret Weisendanger, and Mrs. William Christovich worked extensively on the manuscript, each contributing major ideas developed in the book. To these friends and to the twenty-two Louisianians who contacted me about their Walker paintings and made them available to photograph go our thanks and appreciation. Special mention must also be made of Mrs. J. Cornelius Rathborne of Westbury, Long Island, and New Orleans and to J. Cornelius Rathborne III of San Francisco, formerly of New Orleans, for their interest, assistance, and contribution of photographs of paintings in their collection. Mrs. Rathborne's father, James Monroe Winship of New Orleans, collected Walker paintings during the artist's lifetime, and Mrs. Rathborne grew up with Walker Southern scenes among the paintings at the family home in the Lower Garden District. Mrs. Rathborne's children and grandchildren collect Walker paintings, including some of the more unusual works and at least four of the major Walker canvasses.

Beale Fletcher of Asheville, North Carolina, was a major source of information relating to the North Carolina years. He provided historical details and the ledger from Arden Park Lodge in which Walker had written comments and poems. Maria Beale Fletcher and Mrs. E. L. Shufford of Asheville, daughters of the owner of Arden Park Lodge, recalled seeing Walker at their home when they were children. The Sporting Gallery of Middleburg, Virginia, also lent photographs of North Carolina paintings.

Mrs. Charles Moore put us in touch with Ianthe Bond Hebel of Daytona Beach, Florida, secretary of the Volusia County Historical Commission. Miss Hebel knew Walker when she was a young school teacher living near New Smyrna; our correspondence and interviews with her have been most helpful. Frederic A. Sharf of Somerville, Massachusetts, provided information about the artist's life in St. Augustine. David Langdon from Fort Lauderdale, Norman Simmons of the Pensacola Historical Museum, and Ada Wilson of Pensacola were also helpful. Dena Snodgrass, Mrs. Timothy Smith, and the staff at the Cummer Art Gallery in Jacksonville provided information and background about the area. Mrs. Mercedes Pacetti Cates of Centre, Alabama, provided Walker correspondence to Mrs. B. J. Pacetti and paintings that he gave the Pacetti family.

Information about the Mississippi trips and paintings was provided by Nell Davis, director of the Lauren Rogers Library and Museum of Art, Laurel, Mississippi, and by Mrs. James Bernard O'Keefe and Mrs. Virginia C. Bradfield, both descendants of the Bradfield family in Vicksburg. Clarke Reed and Brodie S. Crump of Greenville, Mississippi, located the Ferguson home and provided information on Walker in Greenville. Mrs. John A. Murfee of Columbus, Mississippi, spent many hours reading and correcting the manuscript.

In New York City, Rudolf G. Wunderlich and George Schriever of the Kennedy Galleries were most cooperative in lending photographs and making information available as were Kenneth M. Newman of the Old Print Shop, Robert Chapellier of the Chapellier Gallery, George Arden, and personnel at the Frick Art Reference Library. Edward J. Smits, director of the Nassau County Historical Museum in East Meadows, Long Island, New York, was also helpful.

Files were made available to us by the staffs of the Art Department of Johns Hopkins University, the Baltimore Museum of Art, the Methodist Historical Society, and the Peale Museum in Baltimore. Eugene W. Leake, president of the Maryland Institute, Eugenia Calvert Holland of the Maryland Historical Society and Martha Ann Peters of the Maryland Department of the Enoch Pratt Free Library documented Walker's Baltimore years. Mary F. Williams, librarian at Randolph-Macon Women's College, Lynchburg, Virginia, Samuel L. Lowe of Lowe Galleries, Inc., Boston, and the Vose Galleries there, assisted with photographs and information on Walker collections in New England.

Iris Trovaioli and Ben C. Toledano have contributed untold hours and major ideas to the development and production of this book. Both have fine collections of Southern paint-

ings which include Walkers. Toledano's extensive collection of Southern literature and his knowledge of American Negro history enlarged the scope of this book. He also arranged for his good friend M. E. Bradford, the gifted Faulkner scholar, to advise me on the manuscript.

Mr. Trovaioli's interest has, then, allowed many to follow Walker's path. A great deal of enthusiasm has accompanied participation in this project by all those mentioned above. The result is the following text and illustrations. The text provides basic information about Southern art and artists as well as clarification of William Aiken Walker's role in nineteenth-century art; and the illustrations present a Walker "Southern Tour" reminiscent of that given by *Appleton's Handbook of American Travels* some time ago.

Roulhac Toledano

New Orleans
March, 1972

William
Aiken
Walker

With these words, William Aiken Walker defined a way of life and an artistic purpose that lasted three quarters of a century. Walker's "magnificent world" was the Deep South. He was painting in Charleston by the time he was twelve years old and continued painting until 1921 when he was eighty-three. His extensive travels included visits to the Carolinas, Florida, Georgia, Mississippi, and Louisiana almost every year from 1869 to 1912 when he was finally too old to catch the train at Savannah.

Walker's prolific painting also enabled him to make a living at a time when many Southerners had lost home and land or means of livelihood. Walker painted the Southern Negro and landscapes as he traveled. And his journeys included forays along the eastern coast of Florida, with prolonged stays at St. Augustine and Ponce Park, and briefer stays in Augusta and Savannah, Georgia. He spent time along the Mississippi Gulf Coast at Biloxi, in New Orleans, and up and down the Delta to Vicksburg, Greenville, and Memphis. He made trips to the popular health spas, sport centers, and resorts in the mountains of North Carolina. In the leisurely environment of America's finest vacation spots, he was able to cultivate patrons for his paintings while living the life of a gentleman. Advertisements for Southern resorts in the 1870's and 1880's exhorted the public to come by train to the great railroad hotels of the South where fish and game were abundant and easily available, and that is where Walker went. He found a new commercial market in tourists and rich Yankees at the plush resorts, and he sold them nostalgic mementos of "Old Dixie."

To understand and appreciate Walker's painting, it is essential to know the artist as a Southerner and to follow him into the mind of the South. For certainly no other Southern artist, naturalist, or chronicler so prolifically portrayed his land during the Civil War, Reconstruction, and the developing New South.

Born in Charleston in 1838 to an Irish Protestant father and a mother of South Carolina background, Walker grew up a

Introduction

I am like the machine: I paint and repaint these subjects so that many can share the feelings I have for this magnificent world of ours. Art is not only for the artist, it is for all and I shall do my best to see that all can afford it, to the extent that I shall paint and paint and paint until the brush runs dry.[1]

Southerner through and through. Though prewar Charleston was among the most cultivated cities in the United States, the pervading atmosphere was rural. Commerce was based on cotton and rice that came from low and middle country plantations. There was daily movement of country folk, black and white, coming to market by wagon, sloop, and barge. Woods and wilderness were just minutes away from the Battery by boat, and the young Walker's paintings attest to his enjoyment of the traditional pastoral aspects of Southern life.

A thoroughly public person interested in all aspects of cultural life, Walker nonetheless selected the rural South and its people as subject for a period of seventy years. Paradoxically, for a man from the city steeped in the tradition of European portraits of aristocrats at the comparative expense of landscape painting, the visual foundation of Walker's taste consisted of poor Negroes in town and country and of the land he traveled extensively.

Enjoying a steady, if extremely modest market for over a century, Walker's paintings were found again and again on the national and international markets. With changing times and tastes, individual collectors have sought similar Walker paintings for the widest variety of reasons. During the 1970's, interest and appreciation of Walker's work has skyrocketed and his works are sought out with greater zeal than ever before. Today, particularly when the great literature of the South has brought about greater understanding of the region and its people, an extensive collection of Walker's visual presentation of this world will make an important contribution to that understanding. In addition to this collection of Walker's paintings, some study of the man in his time is necessary to put his work in perspective, especially since his efforts "to paint and repaint these subjects so that many may share . . ." is probably an unconscious gesture toward historical preservation.

Walker's own word for the world he painted was "magnificent." Today, his sincerity might be questioned considering how often impoverished people and their homes were subjects in his painting. But Walker was probably portraying a culture simply as he saw it, with no conscious intention to editorialize or philosophize about the political, cultural, or social conditions which gave rise to what he saw. Walker was neither portraying oppression by his attention to rural rustic Negroes at work, nor was he celebrating oppression through his subjects' apparent contentment in the rural setting.

In fact, the attraction of his work is in large part due to a simple, recurrent theme: an unconscious affirmation of faith

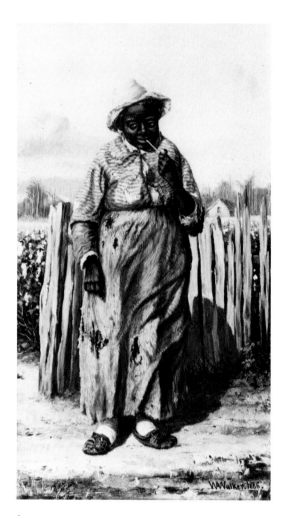

1
Negro Woman with Pipe
Standing in Front of Fence
Lower right: W. A. Walker, 1886
Oil on canvas, 18 x 10 inches
Present owner: Herman Schindler, Charleston

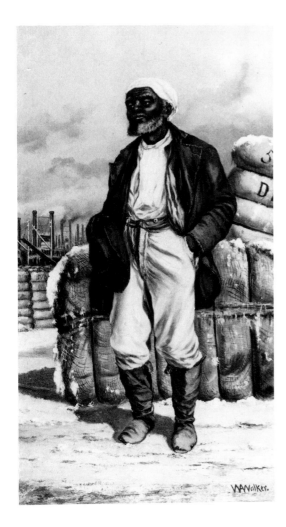

2
Negro Man at Docks in New Orleans
L.r.: W. A. Walker, n.d. [c. 1883]
Oil on canvas, 18 x 10 inches
Present owner: Herman Schindler,
Charleston

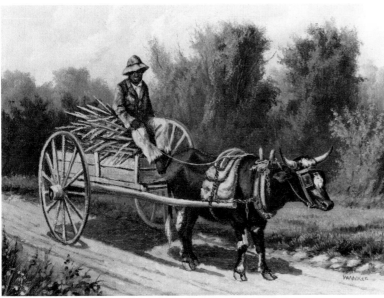

3
The Ox Cart
L.r.: W. A. Walker, n.d.
Oil on canvas, 7½ x 10¼ inches
Photograph courtesy of Kennedy
Galleries, Inc., New York

in the land, in the undying spirit of humanity, in a broad but sensitive humor in the people themselves. His work is an elegiac celebration of the variety and wealth of human character, and of the variety and fecundity of nature. Regrettably, it is easier for us to appreciate much the same theme in one of Jean François Millet's paintings of French peasants hard at work without our being preoccupied with the political and social conditions that created the lot of the French peasant at the time the paintings were done.

Walker's first painting at age twelve was of a Negro on the docks of Charleston. His final effort was a Negro tenant's shack in a North Carolina country setting. In the years between, he painted Negro children stealing cotton from the levee in New Orleans (see fig. 6, p. 88), stevedores loading steamships, and hundreds of portraits depicting the dress, customs, and traditions of black people in everyday life. He also made a study of the various African tribes whose descendants were slaves in the South. And he painted portraits from his own photographs of blacks. In fact, his preoccupation with Negro subjects was almost to the total exclusion of the white man.[2]

At the same time, he was visiting old acquaintances made during the war and friends who lived on plantations throughout the South. During these visits he sketched and painted all aspects of plantation life, even setting up studios in the homes of his friends. Fishing and hunting trips with wealthy patrons of the South's resorts and long solitary camping trips gave him constant exposure to the Southern hinterlands. He had always had a fascination for the outdoors, and he became an astute observer, especially adept at recording the differences among the various regions he painted. Walker did not find it necessary to explore other parts of the country or undertake expeditions to South America, for he felt that he had the best of two worlds —the rustic world he painted and the sophisticated world in which he lived. Nostalgic reverence for the Old South that was gone or merely lingering is reflected in the paintings, and the New South is suggested by Walker's clientele and methods of merchandising.

He handled his subject in a variety of ways. The majority of paintings depicting Negroes consists of very small, full-length portraits of plantation workers, single or in groups (Plates 17, 20; figs. 1, 2). Small cabin scenes with their inhabitants comprise a second large group; these were seldom larger than nine by twelve inches. A series of larger plantation scenes with laborers documents the agrarian South from 1870 to 1910 (Plate 18). The implements used for sowing, hoeing,

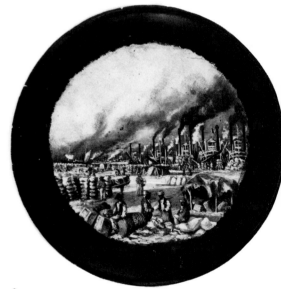

4
Levee Scene at New Orleans
L.r.: W. A. Walker, n.d.
Oil on copper plate, 10 inches diameter
Present owner: Jay P. Altmayer, Mobile

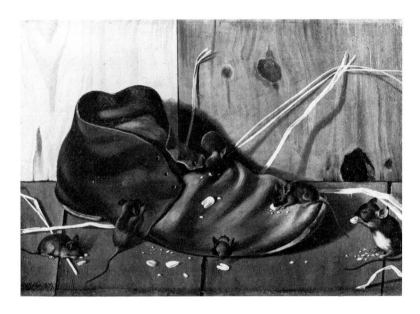

5
Old Shoe with Mice
L.l.: W. A. Walker, 1879
Oil on board, 9 x 12 inches
Present owner: Louisiana State Museum,
New Orleans

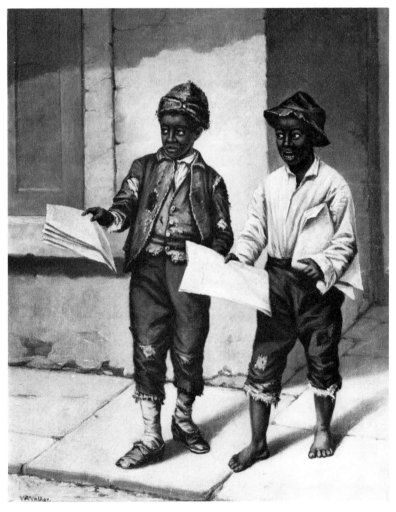

6
Two Negro Newsboys
L.l.: W. A. Walker, n.d.
Oil on canvas, 14 x 10 inches
Present owner: Felix H. Kuntz,
New Orleans

and reaping, as well as methods of transporting crops, workers, and supplies, are recorded in paintings made throughout the Deep South (fig. 3).

The fast pace of life on the crowded levee at New Orleans interested him, and he chronicled the ports of New Orleans, Charleston, Savannah, and other cities in a series of major landscape, levee, market, and river genre paintings in which the Southern working class is presented in an urban setting (Frontispiece; fig. 4). There is a series of small anecdotal or picaresque paintings (fig. 5), and in the Horatio Alger tradition Walker painted newsboys, black and white, from Baltimore to New Orleans (Plate 6; fig. 6).

Landscapes range from scenes of "wooding up" on the back bayous near New Orleans (Plate 1) to hundreds of topographical pencil drawings and paintings of the Florida east coast and the newly developing resort areas around Daytona (fig. 7). After 1890, he painted a series of landscapes, woodland scenes, and mountains (fig. 8) near Arden, North Carolina, and palmettos, beaches, and sand dunes in Florida (fig. 9). Different approaches are evident in these landscape paintings. Early landscapes are actually genre scenes depicting an everyday country setting with numerous figures and animals. The Florida landscapes painted between 1889 and 1905 are documentary, topographical views of the Florida coastal areas, whereas the Florida and North Carolina landscapes dating from 1905 reflect a new simplicity and purity, underscoring the artist's personal reaction to the mountain and woodland scene and to the "exquisite days on the beach, superb skies, of really fair Florida."[3]

Walker, an avid sportsman, began to paint game and fish studies before the Civil War. These paintings and still lifes of the 1860's also reflect the prevailing Victorian taste for these subjects (fig. 10). Similarly, he painted hunting dogs in the field as well as dog portraits. After 1890 Walker's Florida paintings exhibit something of a naturalist's interest in fish and vegetation (fig. 11). At one point he became intrigued with the fish and crustaceans of the Atlantic and Gulf Coasts of Florida and began making carefully annotated studies. Other Florida fish paintings were sold to the fishermen who caught them. A group of still-life paintings based on the precepts of the Dusseldorf School and horse portraits made after the style of John Frederick Herring exhibit Walker's wide range of interest and versatility (Plates 10, 27).

Like most Southern landscape painters after the Civil War, Walker painted an occasional portrait, but these were usually favors for friends, such as those of the Robert Stanley Green

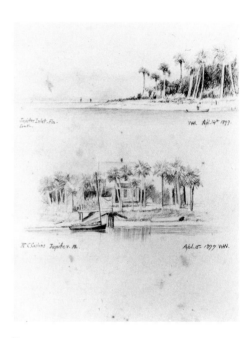

7
Jupiter Inlet, Fla., South
Mr. C. Carlin's, Jupiter—Fla.
W. A. W., Apl. 14th 1899
Apl. 15—1899 W.A.W.
Pencil sketch
Present owner: Mrs. W. H. Cogswell III, Charleston

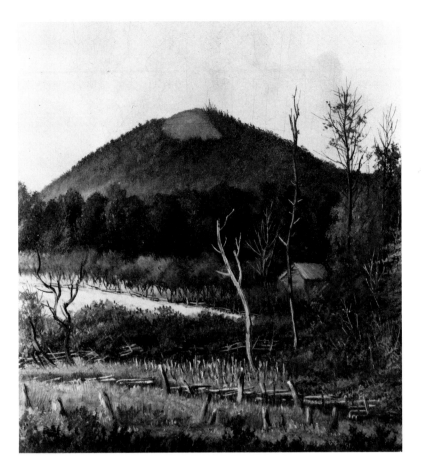

8
Mount Pisgah, North Carolina
Unsigned; n.d. [c. 1899]
Oil on board, 12¼ x 10¼ inches
Photograph courtesy of Kennedy
Galleries, Inc., New York

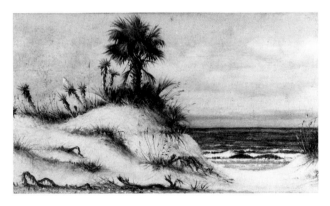

9
Yucca, Sea Oats and Palm on The Beach
L.l.: W. A. Walker, n.d. [c. 1895]
Oil on canvas, 4¼ x 7¾ inches
Present owner: Mrs. Lucia Cogswell Hines,
Charleston

10
Rabbit, Duck, and Snipe
L.l.: W. A. Walker 1887

Oil on canvas, 20 x 24 inches
Present owner: August P. Trovaioli,
Grand Bay, Ala.

According to Mrs. Tobin of New Orleans,
whose father owned the Tobin Steamboat
Lines, Walker painted this picture for
steamboat passage from New Orleans to
Greenville, Mississippi.

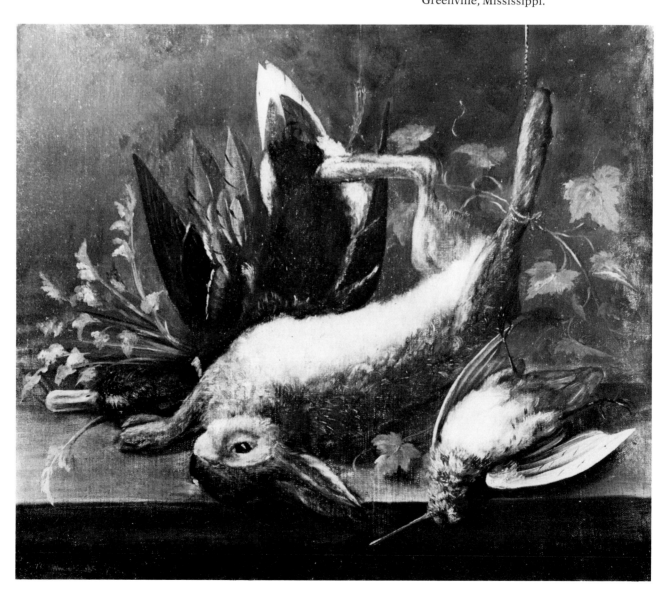

family, whom he visited in New Orleans, or of "Miss Percy Ferguson," daughter of General Samuel W. Ferguson of Greenville, Mississippi. His self-portraits were life-like and skillful. He also took photographic portraits of his friends and their families, finished the portraits in oils, and used them apparently as gifts to thank his friends for their hospitality.

Walker painted and repainted the indigenous themes "like a machine" because they fascinated him and because they were symbolic of the Old South which he had known and loved. He also painted them for the more pragmatic reason that these exotic primitives and nostalgic rural scenes sold well. Paintings of Negroes in cotton fields were sold to tourists on the corner of Royal and Dumaine in New Orleans. His larger Negro cabin scenes, charming and suitable for the Victorian home, were popular as wedding gifts and sold widely

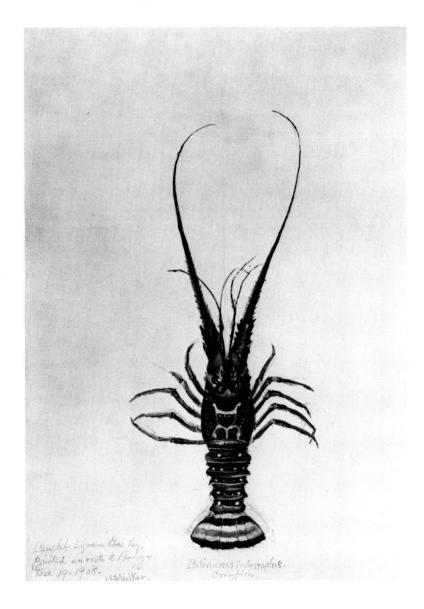

11
Crayfish
L.l.: W. A. Walker, Dec. 19, 1908
Oil on canvas, 19½ x 14 inches
Present owner: The Sporting Gallery, Middleburg, Va.
Inscribed: "Caught Lignum Vitae Key, painted en route to Boggy. *Palinarus Interruptus*, Crayfish"
This is the Florida Spring Lobster.

in the South and North. Yankee clients were available at the Bon Air in Augusta, the Duval in Jacksonville, the DeSoto in Savannah, the Battery Park in Asheville, and in all the great railroad hotels of the South.

Two Walker paintings were published as lithographs by Currier and Ives, and there are some advertisements which may have been made from Walker paintings. Major commissions were accepted from Northern and British clients whom he met at resort hotels. A few large full-length Negro portraits were also painted, possibly on commission. Most of these major works and many serious genre studies are dated from 1879 to 1884, an extended period of serious effort.

Stylistically Walker's paintings reflect the naturalistic trend in American painting of the nineteenth century. His naturalism was an individual and personal one fed by his fascination with the rural South and the desire to portray it in all its natural aspects. His paintings have a primitive, charming quality, common to much North American painting of the nineteenth century. In every instance, the tone is elegiac; as in much Southern literature of the same period, even the imperfections are lovingly depicted.

Walker's most important contribution is perhaps his chronicle of Negro life in the postwar South. As a Southerner who devoted a lifetime to painting the Southern scene and the Negro at a time when neither was considered an appealing subject, he was unique. Interest in Negroes as an object of cultural or sociological study by Southerners was rarely evidenced before the Civil War. The American Indian, on the other hand, was an object of international fascination. Records of the early artists who came with the sixteenth-century explorers to this country indicate that even very early paintings of the American Indian had a large market. Between 1830 and 1838 George Catlin had set out to document a life style and a people he knew would soon vanish forever. Walker painted a people at the last moment before they left the soil and became urbanized. His paintings illustrate the black man in a vanishing economic system.

George Bingham's pioneers recall the people who settled our country; Frederic Remington and Charles Russell had a romantic subject in the Cowboy and the Old West. The life they painted is and was appealing because of its relationship to the exciting American pioneer spirit and energy. Thomas Eakins' "Cowboys in the Borderlands" recently set an auction record for the sale of American painting, and is evidence that such subjects attract us more than ever.[4] Walker's contribution is a record of another important subculture central to the

development of American life and customs. When Walker painted the South, it had just been defeated in a terrible war. Reconstruction and the struggles in the 1880's and 1890's to move from disaster to a workable economy were far from romantic, yet Walker found the lingering tradition which appealed to him, and he sought to catch and preserve something fragile.

During his own lifetime Walker received good reviews, and his unique handling of Southern subject matter was recognized. He was considered to be "the first to enter the field of Southern character sketches and, in his chosen field, . . . without rival." [5] Newspaper reviews praised his portrayal of Negroes: "Walker's drawings of the Negro in his native cotton and cane fields is immutably given with all of the half pathetic raggedness of costume and love of gay colors that renders the darky such good artistic material for one who has the skill." [6] His plantation scenes were said to have "just enough ideality to make them interesting and not to destroy their truthfulness." [7]

Harry Bland commented on Walker's growing popularity in 1940 on the occasion of a retrospective exhibition of the artist's work. "The tremendous interest in the pictorial background of the American people," he said, "has brought from obscurity the work of a group of talented genre painters." [8] William Aiken Walker remains an outstanding representative of this group.

"The fair young land which gave me birth is dead," wrote poet Paul Hamilton Hayne, a contemporary of Walker's. [1] The line is a key to the life and work of Walker. He grew up in Charleston during a period of general prosperity in the South, but the young man came into his majority on the eve of the Civil War, and his entire adult life and work was influenced by the effects of the war on the South, and by the forces at work in the New South.

William Aiken Walker was the second of three sons born to John Falls Walker, a native of County Armagh, Ireland, and his second wife, Mary Elizabeth Aiken. [2] The elder Walker immigrated to Georgia in 1815 and became a naturalized citizen in 1822 at Charleston. Like a number of Anglican Irishmen who came to America prior to the potato famine, John Falls Walker had been attracted to the South after learning of the cotton industry through American imports in Great

Charleston and the Civil War

Britain. He established himself as a cotton factor, and by the time of William's birth on March 23, 1838, was listed in the Charleston city directory as a merchant at the wharf of Boyce and Company. Later he was an accountant with that firm.

By his first wife, Elizabeth Mylne, John Falls Walker had a daughter, Jane Flint, and a son, George William, but both mother and daughter died in 1829. Two years later, Walker married Mary Elizabeth Aiken. In 1831 Mrs. Walker took in boarders at 131 Church Street. Later that year the family resided at 23 State Street where Walker's first wife's mother, Jane Flint, lived with them. John Falls Walker died in 1842, and his widow took the family to Baltimore where they remained until they returned to Charleston in 1848.

The next record of the child is a comment in the Charleston *Courier*, 1850: "... one of the exhibitors at the South Carolina Institute Fair was Master Walker, who exhibits an oil painting." [3] This first recorded painting, painted and exhibited when he was just twelve years old, foretells his lifelong interest in the Negro subject and the port scene (fig. 1). Organized to foster an interest in manufacturing and inventing, the fair was held in the hall which later housed the Secession Convention and was burned in 1861. At the time of the exhibition the boy was attending one of Charleston's private schools, where he must have studied French and Spanish since he wrote poems in those languages before 1860.

There is some evidence from handpainted borders on inscribed poems and illuminated diaries that Walker may have begun painting partly as an adjunct to his social development. In any case, the exposure to art and artists available to him at any time until the Civil War must have encouraged a serious interest in art. Thomas Sully was describing Charleston when he said, "Verily we have talent enough among us to constitute in our city a Florence." [4] An exhibition of the small landscapes, miniatures, and portraits by Charles Frazer was open to the public at the South Carolina Society Hall for several months in 1857.[5] Charleston was an important stop on the circuit for many American portrait painters of the period. Charleston, founded in 1670, was indeed one of the principal cultural centers in America. Artistic taste was as English in Charleston as the mere appearance of the Georgian city suggests. Steeped in English tradition in painting, Charleston's chief art form was portraiture. Landscapes were few and generally installed above doors or mantels and as ceiling or wall decorations.

In this sophisticated setting young Walker developed an interest not only in art but in opera, music, and literature. He read Dickens, read and wrote poetry, became, in short, an epicure. Affectionate, gregarious, and courteous, Walker

flourished in Charleston. The handsome young man became something of a dandy and developed a lifelong reputation of being a natty dresser. He was photographed in Charleston at Quimby and Company, and he painted over the portrait, making what was termed in the period an "oilette." The picture exhibits Walker's dash and flare; the foppish pose, though suggesting the style of English portraiture, intimates a certain egotism (Plate 8).

By 1856 it was expected that William would follow his older brothers into the business world. George and John worked as commission merchants after George's short stint as a grocer, and Joseph was a clerk at Wardlow, Walker & Barnside. However, "Willie," the youngest son of a widowed mother, remained at home where Mrs. Walker encouraged his studies in art and music and approved his efforts to sell his paintings.[6] He displayed his work at Courtenay's book store, and in 1858 the Charleston *Mercury* observed: "A YOUNG ARTIST— Yesterday, we were shown the painting of one of our young city artists, at Messrs. Courtenay's and Company's store. The painting is a copy of one of Herring's farmyard scenes. The young artist is the son of the late John Falls Walker. By a close attention to the working up of color, yet a judicious toning and blending, our young artist may, in a little time, give us a picture equal in painting to his very excellent drawing."[7] Six months later the same newspaper stated: "Promising—that rising young artist, whose works have heretofore been noticed in the Mercury, and who modestly places an anagram at the corner of his canvas, symbolizing the initial W.A.W., has recently hung at Messrs. Courtenay's Book Store, the last and best specimen of his easel. It is a game study showing a few ducks suspended against a wall and would be considered flattering to older artists. It will gratify the attention of every lover of art."[8]

These clippings, dated fish and game paintings from before the Civil War, and his first recorded painting all reflect an early taste for the subjects he continued to paint for seventy years— Negroes, wildlife, and rural scenes. The reference to John Frederick Herring, one of the popular British artists whose horse paintings and barnyard scenes were distributed in America through engravings, indicates an influence over Walker which emerged in the postwar years. In at least one rural scene of horses in a pasture in the Robert Stanley Green collection, New Orleans (Plate 10), there are animals which seem lifted from a Herring composition.

Despite an obvious preference for painting, the time was imminent when Walker would have to begin to think in terms of making a living. By 1860 he was twenty-two, well past the

age when the merchant class began to work; his brothers were married and had families to support, and his mother was going to be dependent upon him. But the bombardment of Fort Sumter and the Civil War saved him from a difficult choice.

George and John immediately volunteered, enlisting in one one of the six infantry companies formed by the wealthy South Carolina planter Wade Hampton. Soon after South Carolina's secession, Hampton had begun accepting volunteers for a legion of six infantry companies, four cavalry companies, and a battery of artillery. Volunteers flocked to the cause in those early days before the action had begun; more than twice as many men volunteered as Hampton was authorized to accept. He outfitted much of the legion at his own expense and led six hundred optimistic South Carolinians into the field at First Bull Run under P. G. T. Beauregard, the Confederacy's first appointed general. Twenty percent casualties were suffered by Hampton's unit, and he himself was wounded, but the soldiers, including the Walker brothers, returned victorious. The glory and life of the soldier as envisioned after Bull Run was more than the twenty-two-year-old Walker could withstand. William enlisted October 7, 1861, at Camp Hampton, South Carolina. Just one month later, on November 16, the Hampton Legion became part of Longstreet's Division, and in June of that year Walker saw action at Seven Pines near Fair Oaks, Virginia (fig. 2). There General Lee took command of the Army of Northern Virginia and began his push to thwart General McClelland's attempt to take Richmond. Walker was wounded in the battle and was removed to Richmond.

After his recovery, Walker was transferred to Charleston with part of Hart's South Carolina battery, ordered there to protect Charleston and the surrounding islands from invasion. While Lee pushed his forces through the Virginia peninsula, Walker's unit was given picket duty in Charleston, and Walker found himself once more at home, relieved of the duties of cotton clerk and with ample time to pursue his old favorite pastimes. He was able to hunt and fish and to paint his game. Game, fish, and wildlife studies dated 1861 and 1862 document his return home and indicate that, paradoxically, this turbulent period probably comprised one of the more contented interludes in Walker's life.

Although in the midst of war, Charlestonians threw themselves into a breathless and exhausting whirlwind of social affairs, and Walker at twenty-three, despite his modest family background, emerged as a popular bachelor. His good looks and talent as a painter, singer, and raconteur were widely known in the city where he grew up and among his fellow

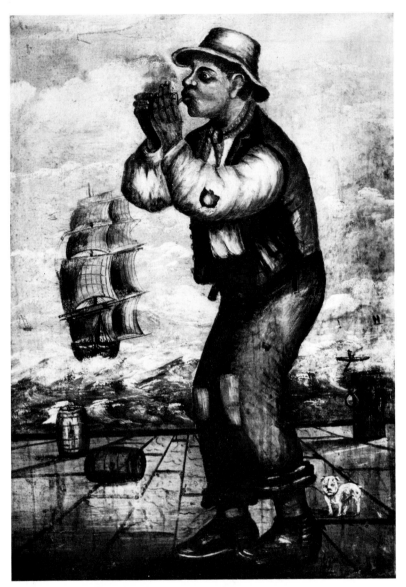

1
Man on Dock Lighting Pipe
L.l.: W. A. W., n.d. [c. 1849]
Oil on tin, 20 x 14 inches
Present owner: Herman Schindler,
Charleston
The artist's first known work.

2
**Confederate Encampment at Seven Pines
(Fair Oaks) Virginia**
L.r.: W. A. Walker, 1862
Oil on canvas, 7 x 10 inches
Present owner: Jay P. Altmayer, Mobile

To date only this campaign painting by
Walker has been documented. Chimneyed
tents and heavily bundled pickets show
that it was painted during the winter.
Violence and war were not Walker's
subject. This pleasant encampment scene
is typically far removed from the raucous,
exciting, and demanding environment
of battle.

soldiers. He was available for the balls and bazaars at the Mills House and Charleston Hotel. Parties, soirées, church socials, and receptions were the order of the day.

Walker's mother died January 18, 1862, and one year later Walker was transferred to the Engineer Corps where he served as cartographer and draftsman. His signed map of Charleston and its defenses dated November 20, 1863, is in an atlas accompanying the official records of the Union and Confederate Armies.[9] From Charleston, Walker's unit went to Wilmington, North Carolina, a small city on the Atlantic at the mouth of the Cape Fear River. It then was the great importing depot of the South.

In this city Walker embarked upon his first serious romance, during which he wrote a series of poems and musical compositions. A song, "My Love is Far Away," is dedicated to "Mlle. Frankie Myers of Wilmington, North Carolina, July 4, 1864." Unrequited love is the theme of a poem in French and English written and illustrated by Walker in October, 1864, and entitled "Belle Ange Que J'Aime." [10]

His most interesting art work of this period is a deck of illuminated playing cards (fig. 3). The deck includes four kings which have detailed likenesses of Jefferson Davis, P. G. T. Beauregard, Stonewall Jackson, and Robert E. Lee. Other cards have miniature versions of the Bombardment of Fort Sumter and crude primitive genre studies of soldiers and Negroes. Winslow Homer, incidentally, serving as a Union correspondent about the same time, published an edition of twenty-four color lithographs, of playing-card size, which portrayed the light side of army life.

At some point in 1864, before the capture of Fort Fisher, near Wilmington, Walker was transferred to Richmond. Stationed there at the same time were Adabert John Volck, William Ludlow Sheppard, and Lieutenant John R. Key, all practicing artists. Volck, a landscape and genre painter who painted "The Blockade of Charleston," joined Walker in Baltimore after the war and became active in the Wednesday Club, a social group devoted to the promotion of all art forms.[11] Sheppard, a native of Richmond, painted a series of watercolors depicting life in the Confederate Army. After the conflict, he remained in Richmond and became known for his sculpture. Key, like Walker, had been a member of the Corps of Engineers in Charleston. He was responsible for contemporary drawings of the interior of Fort Sumter after the bombardment, and for recording pictorially the course of the federal siege of the city (see Walker's sketch and painting of this subject, Plate 4 and fig. 4). After the war, he exhibited in the

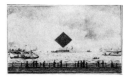

3
Playing Cards
W. A. Walker, Charleston, 1864
(Signed in Gothic script on Ace of Spades)
Watercolor on card stock, 3¼ x 2 inches
Present owner: Jay P. Altmayer, Mobile
Description. Hearts: *Ace,* Monitor and the Merrimac; *King,* Portrait of General Beauregard; *Queen,* Woman guerrilla fighter; *Jack,* Civilian stockade guard; 9 number cards. Diamonds: *Ace,* Battle of Fort Sumter; *King,* Portrait of General Robert E. Lee; *Queen,* Sutler's girl with liquor glass; *Jack,* Saluting soldier (self portrait); 9 number cards.

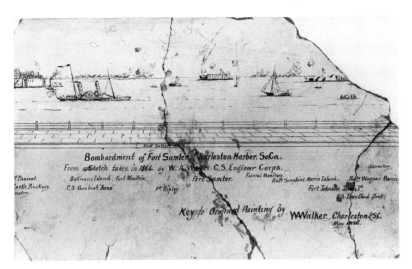

4
**Bombardment of Fort Sumter,
Charleston Harbor, So. Ca.**
*From a sketch taken in 1864 by
W. A. Walker: C.S. Engineer Corps. Key to
Original Painting by W. A. Walker,
Charleston S.C., May 1886*
Ink on paper, 8 x 10 inches
Present owner: Herman Schindler,
Charleston

5
View of Richmond, Virginia
Illustration from *Harper's Weekly* of the
capitol of the Confederacy, where Walker
was stationed in 1864.

Boston Athenaeum and the National Academy, later return-
ing to Baltimore.[12] All four artists had related interests and
similar background.

Richmond was the crowded and busy capitol of the Con-
federacy. Walker may have been stationed at an encampment
like the one on Belle Isle (fig. 5). If so, he would have had
some opportunity to see the Clifton and Spotswood hotels
which housed eminent statesmen, visiting generals, and gov-
ernment officials. The Capitol, designed by Thomas Jefferson,
and the Confederate White House were sights a young soldier
would not miss. Another interesting sight nearby was the
Tredegar Iron Works on the James River, which manufactured
armor plate and parts for the ironclads. Much of this Rich-
mond was later destroyed in the evacuation fire of 1864.

Walker's name does not appear in any Confederate records
after December 31, 1864. The circumstances of his detachment
from the Confederate Army are not known, but still-life paint-
ings and poetry dated Charleston, 1865 through 1866, indicate
his return home. A book of poems entitled *Mes Pensires,
Charleston, South Carolina, 1866*, carefully printed and il-
luminated with gold leaf letters, is dedicated to the mysterious
"Belle Ange" (fig. 6).[13]

The Charleston to which Walker and his brothers returned
after the war was a city without hope. A fine section of the city
had burned in the first year of the war. The destruction caused
by a year and a half of direct bombardment and four years of
blockade and siege was almost beyond description. There was
looting in the surrounding countryside during and after the
war. In 1869 the editor of Charleston's *XIX Century* described
the battered city as "grim, black crumbling chimneys, bending
and broken walls, shapeless piles of former splendor . . . the
silent sentinels, the speechless witnesses of both glory and
ruin."[14] In 1860, the city had 40,500 people; by 1870, with labor
leaving the country and the immigration of ruined small-town
people to Charleston, the population had risen by 800, but ten
years later there was an increase of only 100. Editor James De
Bow, returning to Charleston in 1867, remarked: "Alas dear
old Charleston, the blight is still upon her. At every step the
marks of cruel war. The streets are still unpaved. The wharves
are comparatively deserted. There is no life or activity
visible."[15]

There is very little documentation of Walker's relationship
with the artists of Charleston before or after the war. Admit-
tedly there were few serious painters active there in the years
following the war, but it would be strange indeed if he had no
contact at all with the Carolina Art Association founded in

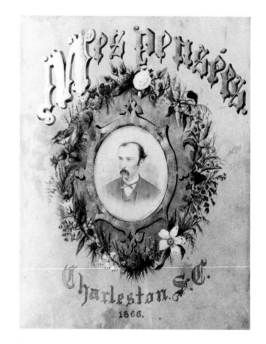

6
Hand-painted Cover of Book of Poems,
Mes Pensires, by Walker
Charleston, S.C., 1866
Present owner: Mrs. W. H. Cogswell III,
Charleston

The book includes twenty-six poems
by the artist and illustrations
which date from 1866.

1855. Organized by dilettante artists and writers, the emphasis of the group was definitely literary, largely because of William Gilmore Simms, a Charlestonian whose writing had achieved national acclaim. While before the war the newspapers and city directories listed hundreds of artists, there was not one listed for some years afterward. In fact, the Art Association had to seek out art teachers and bring them to the city. The dearth of artists was, of course, understandable from an economic standpoint; Charleston could not support them. Then too, the photograph had become popular by the close of the war and demand for the commissioned portrait waned everywhere.[16]

Walker's interests and pattern of life paralleled that of the numerous writers in postwar Charleston. Paul Hamilton Hayne (1830–1886) and Henry Timrod (1829–1867) were Charleston poets active in the Art Association who published in the Charleston *Mercury* and the short-lived *Russell's Magazine*. Like Walker, they were inspired by the work of Wordsworth, Tennyson, and Coleridge. All wrote odes and commemorative poems and long, rambling speeches in rhyme. Hayne, like Walker, also wrote a poem on the occasion of his mother's death. Both poets and other talented young Southern artists, writers, and musicians walked away from Charleston at the close of hostilities.[17]

Financial survival was no minor problem at that time, and a painter was the last thing Charleston needed. Walker's family was little interested in his work, and as he clearly did not want to settle down to eke out a living as did his brothers, they saw no reason to detain him. The family lack of interest in his art is reflected in the attitude of a relative to whom Walker offered a portrait of "Old Ned," a Negro. She declined the painting, saying, "I cannot have one of those in my kitchen anymore. Why should I want one on the wall?"[18]

Walker left late in 1865 and looked northward to Baltimore where he had lived after his father's death. In subsequent years he returned to Charleston for at least a month each year, generally in the fall to visit an elder brother or, in his old age, his nieces and nephews. He maintained a bank account there and in Augusta, Georgia, and listed Charleston or Ponce Park, Florida, as his place of residence on hotel registers. His paintings always remained available in Charleston though they were in little demand. Courtenay's Book Store and, later, Lanneau's Art Store handled his work, as did Quimby and Company, photographers who sold his oilettes. One shop on King Street for years had one window full of embroidery and the other full of Walker's paintings.

He spent some time each year in Charleston having works of the past season framed, and many paintings of the areas throughout the South bear the sticker of Lanneau's Art Store. He also continued to paint Charleston subjects. Oils of the Charleston Market, views from the Battery, and little paintings of Charleston Negroes, all left stored at the home of his nieces and nephews, attest to his sketching trips and wanderings through the streets of his birthplace (figs. 7, 8, 9).

Through the years on his annual peregrinations through Charleston, Walker spent much time visiting friends in the surrounding countryside. One of his favorite haunts was Edisto Island. There are numerous paintings with "Edisto" inscribed on the back. Some actually entitled "Edisto" were exhibited in New Orleans and at the Columbian Exposition.[19] There he visited the plantations of Dr. Julian Woodruff and Dr. Daniel Townsend Pope. It was at the latter place that he painted the portrait of "Old Ned," the butler, which his relative refused. From the autumn of 1861 until the end of the war, Edisto Island had been in enemy hands or evacuated. In early 1865 Sherman, turning from the sea, marched his army through the southern end of the South Carolina low country. When the war ended, Negroes crowded to the Sea Islands promised them by Sherman's confiscating order. Slowly the island was reoccupied by its prewar proprietors and much time and effort went toward rehabilitation of the homes which were not burned, as most had served as troop headquarters or as communal headquarters for groups of Negroes. Rice planting was no longer profitable for a variety of reasons after the war. "Brown seed" cotton instead was planted and flourished on the island until about the time of the First World War, a change reflected in Walker's paintings.

He had friends at Sullivan's Island and also visited there, describing the island in letters. In the summer of 1865 he composed an oratorio for baritone and soprano entitled "O Salutarius Hostia" dedicated to "Miss M. D. O'Connor, Sullivan Island, South Carolina." [20]

Runnymede on the Ashley River was another rural setting he often visited and painted on his trips home after the war (fig. 10). Twelve miles north of Charleston and adjacent to well-known Magnolia Gardens, it was the country estate of Captain Charles Cotesworth Pinckney. Captain Pinckney spent a great deal of time putting his ravaged property in good condition. Walker gave him on one of his many visits there a small oil painting of the house and a larger scene of the oak tree in the garden. A daughter of Captain Pinckney, now Mrs. E. Milby Burton of Charleston, remembers Walker at Runny-

7
South Battery, Charleston
L.l.: W. A. Walker, 1890
Present owner: Frick Art Reference Library, New York

8
Charleston Market where the artist found many subjects. The pillars, arches, and stalls may be seen in some Walker paintings of women at the market.

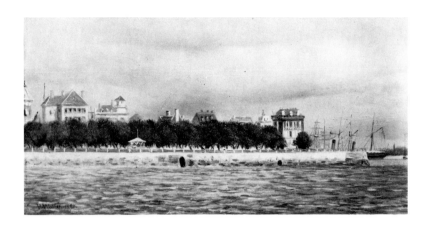

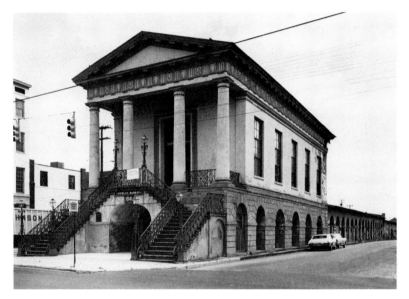

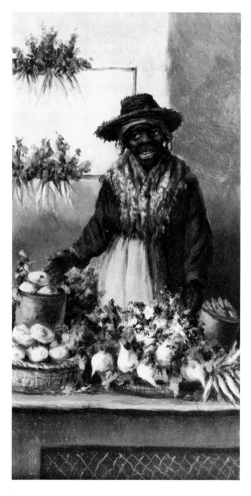

9
Vegetable Vendor at Charleston Market
L.l.: W. A. Walker, n.d. [c. 1870]
Oil on board, 8½ x 4½ inches
Present owner: Jay P. Altmayer, Mobile

mede when she was a child. As he grew older, Walker was always a great favorite with the children. He sang and entertained Miss Pinckney and her two brothers by playing classical music on the living room piano.

Other South Carolina estates and plantations he visited and painted might be identified by the cotton bale markings seen in the paintings. Such is the case with the James Allen Plantation. Others might be identified, like Runnymede, by subject but not always with certainty. A portrait entitled "Calhoun's Slaves" suggests Walker's presence at the Calhoun property, near Clemson, but the slaves may have been in Charleston where Walker could photograph them.

Walker enjoyed visiting friends in their family homes in rural settings and he sought these friends out wherever they were. A fastidious and courteous guest, he was always well dressed and ready to relieve the tedium of the later afternoon and evenings on the isolated plantations with piano and violin music, singing, or reciting to the family group. This dilettantism was part of the development of the gentleman of the period and had practically no relation to intellectual pursuits or to his strictly artistic development.

By virtue of his acceptance as part of the family of the planters he was able to record leisurely the nature of the surroundings, the people, and the land. Although Walker was himself a city dweller and distant from the planter class of the established Southern culture, he was intrigued with the almost medieval quality of the plantation community. The very quantity of the paintings of rural setting and of Negroes

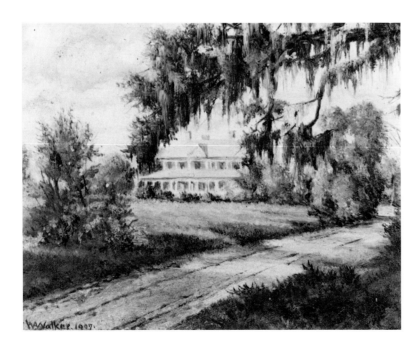

10
Runnymede on the Ashley River
L.l.: W. A. Walker, 1907
Oil on board, 3⅜ x 4½ inches
Present owner: Mrs. E. Milby Burton, Charleston
Runnymede was the summer estate for generations of Mrs. Burton's father, Captain C. C. Pinckney.

laboring on the land reflects his fascination. As a part of the plantation family much like the visiting uncle, he was a communicant in the relationship between landowners and black slaves, between landowners and the tenants and croppers. This relationship was not then, nor is it now, very well understood. The fact remains that there did exist a mutual sense of affection and regard in spite of the differences in station. The land was the common bond between all groups. Each was dependent on it although the degree of enjoyment of the fruits of the land was disproportionate. There was an interdependence of black and white because of the rural and agrarian nature of their mutual existence. Furthermore, the white landowner in many instances had more contact with black people than with white, particularly on a day-to-day basis. It is difficult today to comprehend the degree of isolation experienced by these small and separate communities centered around and dependent upon the economy and social life of the individual plantation. Walker, a single and lonely wanderer, accepted by planter and Negro alike, had a natural appreciation of the land and those who made it productive. He respected and understood Negroes in their association with the land, as did the planter in whose domain he painted. His appreciation of the family unit and its highly co-ordinated work is also evidenced by the repeated presentation of family group portraits and family gatherings in his plantation scenes.

Maryland and Cuba

The year 1865 began a unique and interesting way of life for Walker. By March of that year he had established himself in Baltimore. There he soon became an accepted member of an entourage which met at least once a week on Wednesday evenings at the bachelor quarters of Otto Sutro. The participants in these soirées were either patrons of the arts, particularly music and drama, or professional and semi-professional actors and musicians. According to Sutro's daughter Ottilie, "its members were among the socially elite" and some "ranked with the foremost professionals of the day." Walker had been acquainted at Richmond with two members of the group, Dr. A. J. Volck and John R. Robertson. Among his new acquaintances were Wilkens Glen, a well-known patron of music, and the recognized wit William Prescott Smith. Walker is described by Miss Sutro as one of the "artists endowed with good voices." [1] He was, indeed, in the cultural ambiance which suited him best. It was what he and other members considered the social and cultural elite of North and South alike.

In 1869 the Sutro soirées were officially organized as the Wednesday Club with headquarters at a convenient location for Walker. He could room at the clubhouse, and he left his belongings and extra painting equipment there between trips elsewhere. The Masonic Temple Hall, where he could attend lectures and concerts, and St. Paul's Episcopal Church were closeby. The Holiday Street Theatre, two squares from Barnum's Hotel, had been remodeled in 1854. When he could afford it, Walker joined a group of friends for performances there. Two art galleries were in the vicinity—Mayers and Hedian on North Charles and Butler and Perigo on Charles at Fayette. Bendman's Art Store handled Walker's work, and Otto Sutro may have displayed some paintings at his publishing house.

Contemporary Baltimore newspaper clippings of presently unlocated Walker paintings suggest he used classic subjects or made copies of European paintings. Mentioned are "The Banquet," "The Banquet Interrupted," and "Miss at the Beach." In the Wednesday Club collection there is a sketch by Walker of the performance of a satire by Inness Randolf on Italian Grand Opera. Walker also painted Baltimore newsboys, and fish and game. Negro genre scenes attest to some observation of urban life, but his major emphasis between 1865 and 1867 is on the rural setting. Prolific as his painting was however, ads in the Baltimore newspapers in which he offered to teach French, Spanish, German, and even Danish suggest that he was unable to support himself with his paintings alone.[2]

By 1868 he had begun to use Baltimore as a base of operations from which to travel. He spent the summers there, or, later, at Arden, North Carolina, returning each year to Charleston in the fall and then going south to Augusta, Georgia.[3] After 1876 he would go on from Augusta to New Orleans, or, after 1879, to St. Augustine or Ponce Park, Florida. Everywhere he went he painted the rural surroundings he loved and Negroes at work. At the same time, he was visiting friends and cultivating new friendships upon which he depended for locales in which to paint. He exhibited and sold paintings in big cities at the finest hotels or at resorts which catered to the Northerner or foreigner, to whom Walker's subject matter was exotic, mysterious, and appealing as a memento of the trip South.

As early as 1867, Walker had begun to epitomize the ideals of the New South as they would be developed by postwar literature and the journalism of Henry Grady and Joel Chandler Harris in Atlanta. Preserving the traditional ideas of the Old

South in his conduct and personality and in his love of the rural South, Walker took advantage of industrialism and the railway to create his own unique life style. He bore no sectional grudge; some of his Northern clients became his lifelong friends. Provincial yet worldly, Walker's life and works preserve some essence of the older Dixie, while also achieving a sense of the universal.

Wherever Walker's nomadic life took him, his popularity was assured. His baritone voice and ability to play the violin and piano made him a desirable house guest, especially since music was the major form of entertainment during his lifetime. His singing repertoire varied from the classics to humorous folk songs. His favorite musical presentation was "The Grasshopper on a Sweet Potato Vine," a cantata written by Inness Randolf, the cohort at the Wednesday Club who wrote the satire Walker painted. A niece said, "Uncle Willy would entertain us as children by singing the 'Grasshopper' and we found ourselves looking forward to his visits just to hear the song."[4] Walker was welcome in the heavy Victorian parlors also because he gave art lessons to the young ladies. Walker's vanity and good looks were well known to his contemporaries (fig. 1). One newspaper commented on his fastidiousness: "His clothes were immaculate and he carried a lantern at night after a rain . . . so as to avoid the muddy spots in the streets."[5]

Walker always sought out the cultivated gentry and the artistic community. Intelligence, refinement, sensitivity, and good manners, in addition to one's demand for a fine cuisine, were the criteria upon which he judged people. "It is a great pleasure to go to Charleston often and meet my old friends, and be among refined polite people," he wrote to a good friend, Dr. C. Lewis Diehl of Louisville, Kentucky.[6] In this respect he was pleased with his nephew's wife and children: "My nephew's wife is a bright, well educated woman and good looking, and her children have inherited brightness and good looks and politeness for all say 'Yes or no thank you sir' as required in place of yes and no of twentieth century rudeness. So was I and their father and mother educated, and it is delightful to me to be among my compatriots here for politeness is the rule and Charlestonians are noted for their politeness."[7] In contrast, his life included some solitary rougher days. After a winter of camping in Florida where "tinned food" was often consumed as he fished on his ketch "Sallie," he wrote from New Orleans: "At last I am highly civilized having dined elegantly at 6 P.M. with old friends in their beautiful home."[8]

Like that of many of his contemporaries, Walker's life style was influenced by Dickens, who is mentioned often in Walk-

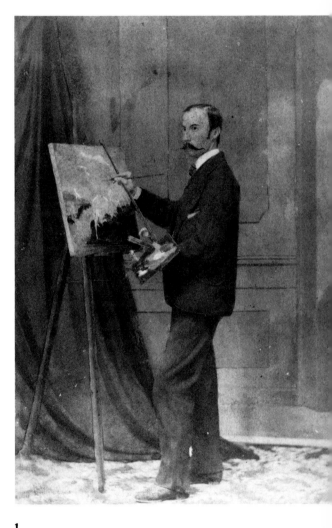

1
Photograph of William Aiken Walker, 1870
Present owner: Mrs. W. H. Cogswell III, Charleston

er's diary. Walker lived as a connoisseur and dilettante on a Pickwickian scale. He rationalized his wandering spirit as romantic in the Dickens tradition. "I got interested in re-reading for how many times I know not, 'Pickwick Papers,' 'Our Mutual Friend' and 'Bleak House,' and find each more beautiful than ever! Who can read the works of Charles Dickens without feeling a better man, more charitable towards all men," he wrote.[9]

He also painted pictures with themes related to events and characters in the novels. The street urchins of London about which Dickens wrote and which George Cruikshank illustrated, appear transformed into Southern characters like the newsboys on the streets of Baltimore and New Orleans (Plate 6; fig. 6, p. 7) and the boys fighting in "Ruffles and Rags" (figs. 2, 3). The picturesque characteristics of numerous paintings like "Pickaninnies Stealing Cotton" also reflect Dickens, whether consciously or coincidentally (see similar fig. 6, p. 88). Walker's careful observation and appreciation of the mode of dress and originality in piecing together castoff clothing recall Dickens' description of Fagan and the poor orphans of the London streets.

Walker preferred to be thought of as an intellectual, be it naturalist, artist, poet, or even author. He was always referred to as "doctor" or "professor" by the people who remember him in Florida, New Orleans, and North Carolina; and Walker signed his poems "Professor Walker." He also wrote one short story and mentioned it in a letter to a friend:

"I believe I wrote you about an adventure with a black cat in my room Christmas Eve? The comic side of it appealed to my sense of humor, so a few days after it happened I wrote it up into a short story and sent it to a literary friend, an author, for his opinion of it and he had advised me to send it to one of the magazines (he writes for them) and praised it very much! It was my first attempt at writing a story and it is based on truth but I have done nothing with it yet as I am a bit modest about it. If I do not send it off before you arrive I will well inflict the reading of it on you for an opinion also."[10]

Traveling constantly, Walker used stage, train, and boat. As the railroads were developed in the postwar South, he followed them, staying at the great hotels built simultaneously. According to *Appleton's Handbook of American Travels*, 1874, "the cost of traveling by rail in the Southern States is about 5¢ per mile—From two to three dollars a day is generally charged for the use of sleeping cars. The average speed on express trains is about 30 miles an hour. . . . Travel on steamboats is somewhat less expensive and less expeditious than by rail." Walker especially enjoyed the leisure of the steamboats

2
Ruffles and Rags
L.r.: W. A. Walker, 1881
Oil on canvas, 16 x 12 inches
Present owner: Jay P. Altmayer, Mobile

In this study the artist capitalized on tattered clothing to add color and variety to the shapes in the composition.

This subject must have pleased the artist or his public because he painted a second version of it (fig. 3) using the New Orleans wharf with steamboats and cotton bales as props in much the same way a photographer changes the studio background on successive portraits. The earlier painting has carefully executed details in the background—the fence, side oats, and the wild flowers and Johnson grass. The second version is given a more cursory treatment. The former painting is signed and dated 1881 whereas the later painting is not dated. It was Walker's custom to date only the first example of a repeated subject.

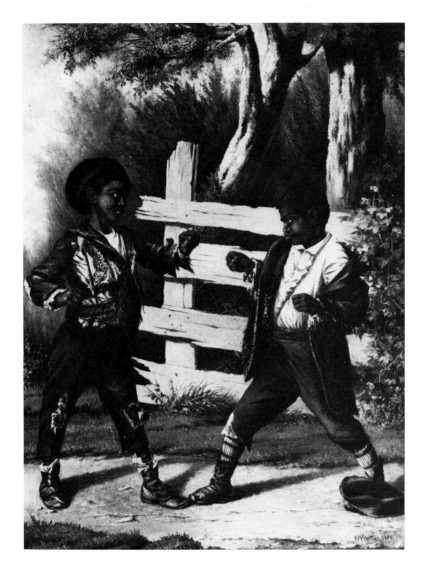

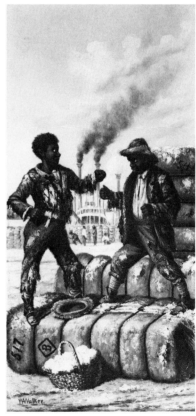

3
Squaring Off
L.l.: W. A. Walker, n.d. [c. 1880]
Oil on board, 12½ x 5 inches
Present owner: Jay P. Altmayer, Mobile

and the plentiful cuisine, in addition to the economy. The slowly changing scenery provided subjects which he could paint on the deck, and he enjoyed conversation with travelers and captain alike. He went from Savannah to Augusta by steamboat occasionally, and the long steamboat trip up the Mississippi from New Orleans to Vicksburg and Greenville, Mississippi, took up to six days. He relaxed, he visited, and he always painted.

In December of 1869 he went on a two-month trip to Cuba, leaving New York, Thursday, December 9, 1869, on the steamship "Eagle" for 'Habana Isle de Cuba'.[11] His first move after passing through customs was to arrange for the "Galería C. D. Fredericks y Davis, Calle de la Habana 108," to handle his art work.[12] Apparently satisfied with the results there, he wrote: "Work very hard, painted 47 paintings to January 1st, 1870 [from his arrival off Morro Castle on December 14]. Working 9½ hours per day. $137.95." Every single entry in the diary for the period begins or ends with "worked hard all day" or "hard work." The diary reflects his preoccupation with fine food and interest in musical entertainments. The repeated mention of the price of everything from coffee to clay conchas reveals his concern with finances. On Monday, January 31, he recorded "87 pictures, $221.60," and his diary that day is lively with detailed descriptions of birds.

With fellow passenger W. B. Collins of New York and sometimes with an acquaintance named Kerr, Walker took in the sights of Havana, including the cock fights and the market. He frequented the various elegant hotels for tea as well as the restaurants, like the Café Oriental, the Santa Ysabel, Café "Ambas Mondas," the Hotel de Nueva York in Marianao, and Café El Ultimo Modo. The Catalán volunteers impressed him, as did the port and the bay. Evening promenades in the park appealed to him; the bands played, couples strolled, and there were señoritas sitting in carriages with dueñas.

He took excursions to Cojimar, Canula, and Chorera, and saw the city of Habana with a man named Leopoldo, the one Cuban acquaintance he mentions. He intersperses comments on fine pastry shops and parades and paseos, "walked through Parque from Calle Egido to Arsenal and along 'Alamedas' to 'Santa Ysabel'; beautiful view of the bay, Regla and Casa Blanca on the other side . . . saw some of the gunboats built in New York. Returned home at 5 for dinner. 7 P.M. went for Collins and to the 'Pastelería el Mallorquin' at Obispo (the fashionable street) between Cuba and Aguila, great place for chocolate. Took some. Walked in Park and went to bed."

Walker observed Havana closely and recorded details at length:

Streets of Havana only wide enough for 1 carriage to pass. They are obliged to go up some and come down others. Sidewalks wide enough for 2 persons, sometimes only one. Great nuisance. Coupes very cheap. Houses very open. No window glasses, iron bars instead. Carriages and Volantes going out of use. Climate as warm in January as April in South of United States. Store keepers always ask high price for goods and often much bargaining. Come down, prices very high. Clay conchas 406 Regalías $1.00. Water in the house comes from a little river not very far from the city. Very bad. Business is done in a very slow way. Make very fine ices here. Eat them with wafers. Examination in la Aduana very rigid on coming ashore, as regards letters taken in a private room. On Sunday after arrival 19 December, the city was beautifully decorated with flags and emblems and triumphal arches in honor of the Catalán volunteers arrived from Spain. Grand parade at 2 P.M. Several thousand. Very fine sight. A company of dancers accompanied them, dancing in the streets keeping time with sticks, churches rather faded in decorations. New Year's night heard singing with castenets and tambourines in St. Domingo near the palace. 'La Dominga' for Dulces, also cafe. Spain soldiers very fine looking body.

Twice he mentions special characteristics and costumes of the Negroes of Havana. He noted on the twelfth day of Christmas that the "Negroes of Havana are free . . . and begin at daylight to beat drums and blow horns and go about in all sorts of fantastic costumes in crowds cutting up antics and begging the customs of their country." He also described a Sunday morning when, after a trip to the picturesque old market where he "would like to make sketches," he went to "Yglisia Santa Teresa, corner of O'Reilly and Compostela." There "music, clarionette and violin cello was played by Negroes. Two white men singing. Struck me rather queer."

Walker often referred to and observed Havana's special qualities. "Havana is very picturesque early in the morning. The varied colors of the houses and costumes of the natives with the light and shade make a fine panorama."

Walker described his most pleasant day in Havana: "Called for Collins and Kerr at Ysabel at 10½ A.M. to take a trip in the country to Cojimar about 5 miles from Havana. Crossed in ferry boat Maria Francisca to Regla across the bay and took horse cars to Guana Bacoa, very pretty town near 2 miles distant. Cars went along the Bay."

His description of the wharves and harbor suggests that he planned to paint it. "Today two monitors and a Man O War USN came into port. The wharves present a gay scene, crowded with schooners in the sugar trade, coasters, while the beautiful bay is crowded with vessels of all nations. Ladies shopping sit

in thin carriages and shopkeepers bring out their wares to them."

Toward the end of two months, Walker's entries become shorter and he complains more: "No news. Not very well, not much to do. Nothing important. Stayed at home at night and read. Not very well." On Saturday, February 12, his complete entry is: "Collins called, spoke of going home. Think I will go. Too warm again. Unwell. Gastos 10¢." So Walker returned to New York. During his sixty days in Havana, he painted one hundred and thirty-eight paintings, sold one hundred and thirty-four of them for $369.65, and seemed pleased with the number of sales.

Of the few Walker Cuban paintings that have been located, it is noteworthy that the subject matter is still essentially Negro genre portraits and cabin scenes (figs. 4, 5), though he did capture the particular atmosphere of the Cuban countryside and attitudes of dress and customs which characterize that area. Recently an oil painting depicting a Havana family arranged on and around a burro with the bay and sailing vessels in the background was located. Painted on the wooden top of a Regalías cigar box, the signed painting is a rare example of Walker's treatment of white persons in genre. There has also appeared in New Orleans an intriguing wood and gesso frame made in Cuba with "Pelea de Gallos—Cockfight" inscribed on the back in Walker's handwriting. Walker's diary entry for February 30 records the experience which must have been the basis for the missing painting: "Una Pelea de Gallos— took a cab to Manrique to see a cockfight—25¢ entrance— curious sight. Building was round, made of slats, open with a gallery upstairs. Cockpit built of red earth pounded hard, seats rising like a theater. [He describes in detail the entire fight.] The excitement was intense . . . the crowd was a mongrel one, Spanish, Cubans, Chinos, Americans, and Negroes of all classes."

After his return to the United States in the winter of 1870, Walker spent the rest of the season in Charleston. "Girl with Pigtails" illustrates his renewed appreciation of some of the picturesque qualities of Charleston (fig. 6). Like his fellow Charlestonian Dubose Heyward, Walker continued to observe Negroes in Charleston with subject matter in mind—children selling boiled peanuts, vegetable women in the market, flower vendors with the baskets on their heads, and Gullahs peddling their produce.

There are records of Walker catching a boat in Charleston en route to New York, where he sailed for Europe sometime in 1870. On the trip North he located William Schlaus, who be-

4
Cabin and Sheds in Cuba
with Coconut Palm
L.r.: W. A. Walker
Oil on canvas, 8 x 6 inches
Present owner: W. E. Groves, New Orleans

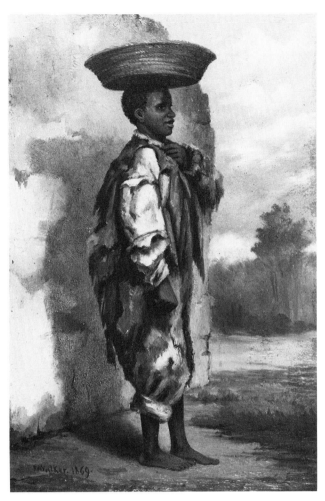

5
Negro Youth with Basket on Head (Cuba)
L.l.: W. A. Walker, 1869
Oil on canvas, 10 x 6 inches
Present owner: Jay P. Altmayer, Mobile

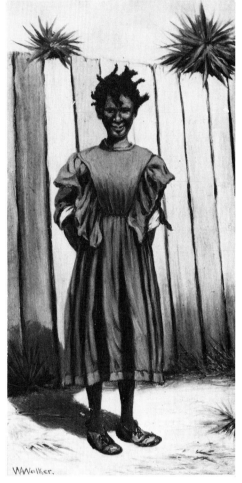

6
Girl with Pigtails
L.l: W. A. Walker, n.d. [c. 1918]
Oil on board, 12 x 6 inches
Present owner: Mrs. George A. Martin,
Columbia, S.C.

This unusual painting was done in
Charleston possibly after Walker moved
to his nephew's house.

came his New York agent. A painting of Yarmouth Harbor Lighthouse at Portsmouth, Maine—the only identified Northern subject by Walker—indicates that he included a tour of New England on this trip, or at some later date.[13]

The Baltimore *Sun* mentions the artist's 1870 European trip. "Mr. Walker, a native of South Carolina, but who has enjoyed the benefits of a lengthy sojourn in the galleries of Europe, contributed to the Exhibition two original pictures and although the paintings are small, they attract a large share of the attention of visitors to the gallery."[14]

The European trip raises some questions. It has been reported that the artist studied in Dusseldorf, but long before 1870 the popularity of Dusseldorf for Americans had waned, and Munich was the haven for artists studying abroad. The rumor that Walker studied in Dusseldorf was probably based on observation of a number of still-life paintings which reflect the Dusseldorf style and typical composition. He probably visited for a day or two at the Dusseldorf Academy or at other ateliers in the art centers of Germany and France where he saw works on which he based his own still-life paintings (Plate 9). Corroboration may be possible in the future from a stylistic analysis of presently unlocated works. One of these, "On the Lawn," is among those pictures described in the Baltimore *Sun*: "The drawings of Mr. Walker possess an exquisite sense of harmony. In gradations and variety he carefully studies nature. Feeling is conspicuous in his work, and in the marking up of his landscape world he condenses so the grand elements of the natural that one feels his ideal while recognizing the truthfulness of the actual scenery."[15] "One of the Attractions of the Sea Shore," according to the same 1870 news clipping, "represents a miss seated on a rock and indulging in lovelorn gaze over the broad expanse of ocean."[16] "Miss on the Beach" is mentioned in an 1878 news clipping, but has not been found.

George H. Clements, an artist of the set frequented by Walker in New Orleans, compared European and American art of the 1880's and commented upon the folly of our artists' looking to Europe for inspiration.

It is a curious fact that Americans should be utterly faithless in all that pertains to home art as a rule. I shared in this fallacious absurdity . . . and on leaving New Orleans for the purpose of studying abroad, believed firmly that I should find their marvelous pictures at every turn. I anticipated finding hundreds of talented artists in the schools and weekly absorb a few crumbs of knowledge and be thankful if my home-made mind could grasp anything at all. The fallacy of this reckoning became evident immediately upon my entering France and its schools and now that I have seen New York exhibitions and Louisiana landscape again, I feel impelled to cry

aloud to my fellow countrymen exhorting them to feel more confidence in the aesthetic possibilities and accomplishments of our great republic.[17]

Whatever original works Walker may have seen in Europe or in art books popular in America, his paintings reflect only a sporadic influence of European art. Those paintings based on the work of John Frederick Herring, European still-life painter, and others, often are very sophisticated and illustrate that Walker could be quite adept at painting after the style of other artists and schools. Walker's approach was sometimes experimental. Just as he tested the major cities of the South, moving from the milieu of urban sophistication to "leading a nomadic life throughout the Southern States" and camping during winters in the wilds of Florida, he tested, too, his ability to portray what he found in a variety of ways.

Georgia and Florida

The old South Carolina Railroad ran directly from Charleston to Augusta, Georgia, as early as 1833. Augusta, an inland port on the Savannah River, was a well-established social, economic, and cultural center by the time of the Civil War (fig. 1). Spared by Sherman on his march to Columbia, Augusta became a popular retreat from the war-ravaged cities of the Southeast. Walker made friends and acquaintances there before 1869, and he continued through the years to come to Augusta for rest and recuperation until about 1905.

In the sand hills, three miles above Augusta, a little community known as "The Hill" had developed in the early years of the nineteenth century. Frame cottages furnished with simple locally made furniture were built by prominent Augustans and, later, Georgians from throughout the state. These families passed the warm summer months in the dry air of the sand hills above the humid flood plain of the Savannah River. Every winter strangers began coming up the plank roads to "Three Oaks" or "Smyzers" to recuperate from illness in the pleasant climate.

A rich selection of cultural activities were presented. Meetings of the Augusta Library Society and the Deutscher Freundschaltsbund were available. Theatre had been established in 1798 and was well received. Sophisticated performances were given at the Augusta Opera House and the Grand Opera House. And the Montrose Dramatic Society gave productions of the latest Broadway hits in the old Summerville Academy.

Augusta began to industrialize when Reconstruction ended. The John P. King Cotton Mill went up in 1880 on the site of the old arsenal and confederate powder works. Sibley Cotton Mill and the Augusta Cotton Factory were new landmarks which greeted Walker as the South Carolina and Central Railroad train came through town in 1882. In 1890 the elegant Mediterranean style Bon Air Hotel opened in Summerville on Cummings Road (fig. 2). Augusta and Summerville met industrialization with sophistication, and the Yankee tourists, Walker's best clients, began flocking to the sand hills of Georgia. In quick succession, a country club, the Cranford Library replete with tea rooms, and the Partridge Inn were opened. While Augusta had been a quiet resting place for Walker, it became after 1890 part of his working circuit. The Bon Air was advertised as "a new and elegant winter resort with all modern improvements for tourists in search of health and pleasure under the management of an experienced Northerner." Tea and cinnamon toast were served by local ladies at the Cranford Club. Besides the Bon Air, Walker could make the rounds at Arnold's Globe Hotel where the rates matched those of White Sulphur Springs, fifty cents to three dollars a day.[2] The Arlington Hotel burned in 1899, but it was another example of the new look in the 1880's and 1890's. By the turn of the century, Augusta was on the way toward being the most important inland cotton market in the country, and Walker banked there at the old Planters Loan and Savings Bank.

Many interesting people wintered in Augusta and socialized with the local citizens. Alexander Graham Bell spent one winter in Augusta during Walker's day, conducting some of his experiments on the telephone. William Howard Taft, seeking a spot where he might formulate his presidential plans and write his inaugural address, also spent one winter in Augusta. Later, as Chief Justice, he made several visits, staying at the Bon Air. President McKinley was among the prominent visitors to Summerville. Augusta was the boyhood home of Woodrow Wilson, whose father was pastor of the First Presbyterian Church during the period when Walker was in Augusta. The well-known James Ryder Randall was editor of the Augusta *Chronicle*. Reverend Abram J. Ryan of St. Patrick's Church, known as the "Poet Priest of the Confederacy," was there too.

Savannah was first a train-stop city for Walker. He traveled there from Augusta by way of the South Carolina and Central Railroad. He changed trains there to go South to Jacksonville and the east coast of Florida, and he stopped in Savannah en route to New Orleans. The charms of the city must have captured him, for he painted scenes of the market and docks of

1
Broad Street in the 1880's,
Augusta, Georgia

2
Bon Air Hotel, 1890

this port city on the banks of the Savannah River much as he had done in New Orleans, Charleston, and St. Augustine. There are also cabin scenes and landscapes with the bamboo typical of the Savannah area after it was imported there in the 1880's (fig. 3). Cabin scenes with sour grapefruit trees in the yards typify southern Georgia, and paintings have come on the market with specific titles like "South Georgia Shanty" (Plate 23).

After 1885 Robert Rowlinski was Walker's agent in Savannah. Married to one of the Pacetti girls from Florida, he moved from Augusta to Savannah sometime after 1885 and opened the "Cre-Mo-Sage" cosmetic shop where Walker's paintings were displayed with Ivory Soap, beauty lotions, and rose water.

In 1898 the Georgia Historical Society had one of the South's finest libraries with 22,000 volumes, and the city had an active poetry society. Walker would have found new friends and clients among the members of these societies. The Telfair Academy, one of the South's first museums and by 1900 the most comprehensive, including an international collection, had French impressionist paintings and American works influenced by them. If Walker saw these paintings, his work seldom revealed such an influence; one of his few works reminiscent of the impressionists is "The Garden at Runnymede," painted in the early 1900's (see a companion piece, fig. 10, p. 24).

Although industrialization of the South frightened Walker and the plantation system of the Old South suited him best, his whole life style was a result of commercial expansion and the emergence of the New South. The period 1870–1900 saw rapid progress and widespread graft among the wheeler-dealer promotions of Yankee entrepreneurs building railroads. Stately hotels followed the railroad tracks through Walker's South. Disliking the commercialism, Walker could still enjoy the cultivated and interesting clientele, and there is no doubt that he reveled in the atmosphere of the picturesque, the bizarre, and the oriental in American tourist hotels built after 1880. There were Moorish castles like the DeSoto in Savannah, opened in 1899 and described in *Leslie's Weekly*, Dec. 22, 1898: "No hotel in the South can compare with the DeSoto—an artistic pile in brick and terra-cotta. It has 450 rooms and not one of them is an inside room" (fig. 4). The Pulaski House was popular there too. The Mediterranean Bon Air and the tropical version of the Second Empire architecture seen in Flagler's vast hotels must have been exciting to Walker, as was the neo-Moorish Ponce de Leon in St. Augustine.[3]

3
Forest Scene with Moss-Covered Trees and Bamboo
L.l.: W. A. Walker, Apl. 1914
Oil on canvas, 9¾ x 12 inches
Present owner: Mrs. W. H. Cogswell III, Charleston
Bamboo was brought to Savannah in great quantities in the 1880's where it was first used as a screen.

4
DeSoto Hotel, Savannah, Georgia

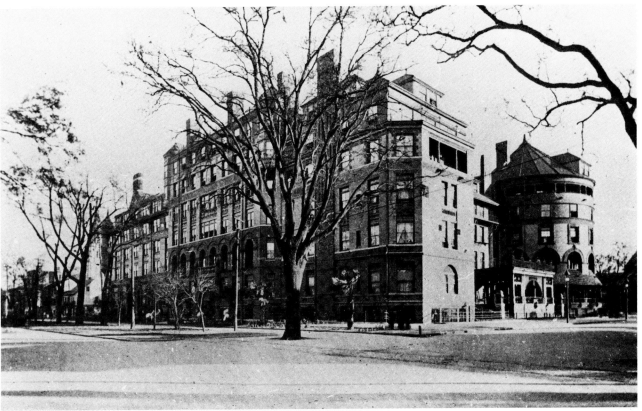

St. Augustine, Florida (Plate 5), had become a haven for artists by 1883, and Walker was one of the first to find clients there when he arrived in 1889. His arrival coincided with the opening of seven artists' studios at the year-old Ponce de Leon (fig. 5). St. Augustine had been a lazy "old tumble down place which, despite narrow streets and ancient buildings dating from the Spanish period, was sadly deficient in the picturesque," according to a visitor there in 1860.[4]

Henry M. Flagler from New York realized the potential of the little town of 2,000 as a tourist attraction when he went there in 1883. After the Florida East Coast Railroad was laid from Jacksonville directly to St. Augustine, New York was just thirty hours away. Flagler commissioned two New York architects, John M. Carrere and Thomas Hastings, to design a luxurious hotel in Spanish colonial style with four hundred and fifty richly appointed rooms. Inspired by the Ponce de Leon, similar buildings went up. Northerners who formerly stopped at the resorts of North Carolina and at their winter homes around Aiken and Camden, South Carolina—all Walker territory—now continued on the train to St. Augustine. They wintered in warmth and luxury at the Ponce de Leon, or for a more reasonable sum at the older Florida House, the Barcelona, Valencia, or Magnolia Hotels. The artists-in-residence at the Ponce de Leon in 1889 were George W. Seavy, Frank H. Shapliegh, W. Staples Drown, Robert S. German, and, best known of all, Martin J. Heade.[5] Some small oils by Shapliegh, Drown, and Heade showing the "local color" of St. Augustine and some rural Florida scenes are similar to Walker's. Southern scenes by all four are in much demand today.

Walker established himself at Thomas Tugby's in "my snug den (the old one)," and he took his meals at the Magnolia where rates were "reasonable and partners for whist" were available (fig. 6). "This little city is more beautiful than ever, many new cottages built in past three years, and many large palmetto trees set out, adding much to the picture. I have had a warm welcome from many old friends, which is pleasant. Hotel Magnolia opens on 11th and I will then take my meals there as usual and play whist: the hotel is very busy, but in fine shape."[6]

The artists who wintered in St. Augustine sketched their subjects in Florida and returned North in the spring to finish their commissions. Walker similarly painted many of his Florida subjects in Arden, North Carolina, from sketches. Seavy, Shapliegh, and Drown, all New Englanders, also migrated to fashionable resorts for the summer months where purchasers could be found. Shapliegh went to the White Mountains of New Hampshire, Seavy to Lenox, Massachusetts, and

5
Hotel Ponce De Leon,
St. Augustine, Florida

6
Magnolia House in St. Augustine
where Walker roomed and boarded.

Drown traveled the European circuit, just as Walker traveled the Southern circuit in the spring, settling down for the summer in the resorts of North Carolina.

Through the years, Walker made many friends in St. Augustine, the closest of whom was a Dr. Pacetti, a distant cousin of a family at the Ponce Park resort Walker visited. And he was always enthusiastic about the little city: "St. Augustine is more beautiful than ever," he wrote, "with the many large palmetto trees set out." [7]

As the Florida east coast developed, Walker enjoyed the charm and atmosphere of the resorts between Jacksonville and St. Augustine. Resorts on the Sea Islands of Georgia, Cumberland Island, and on the Suwannee and St. John's rivers brought wealthy tourists, potential customers for Walker. In the 1880's, when Walker began going to Florida frequently, Jacksonville was a comparatively new city of about 20,000. It developed first as a port on the St. John's River, and then as a railhead from which Southeast Florida was opened to the tourist trade (fig. 7). Having checked into the well-established Duval Hotel, Walker could also call at the St. James (fig. 8) and Winsor hotels in the city and at the Murray Hall Hotel built at Pablo Beach in 1884.[8] The Fort George Hotel on the island of that name had exceptional scenery (fig. 9). There he found swampy woodland scenes that became typical subjects for him after 1880. The coconut palms, bamboo, and palmettos mixed with cedars, cypress, flowering vines, moss, and dying vegetation are seen in his landscapes.

Wherever he was, Walker found the best cuisine available. In a letter dated April 18, 1905, he refers with pleasure to the Duval Restaurant in Jacksonville where he changed trains to return to Charleston after a very exhausting "round with tinned foods" on an extended camping and fishing trip into the wild country below New Smyrna with Gomersinde Pacetti, a young friend of Dr. Pacetti from Ponce Park.

The headwaiter at Duval in Jacksonville was profuse in his Salaams to me in seating me, and as soon as I had given my order for supper, all the electric lights went out. I presume the reckless and grandiloquent manner in which I ordered that rare and delectable delicacy, *Oyster Stew*, as if it had been my pabulum all winter must have extinguished them!!! It was very good. Candles were lighted at once, but my stew appeared with a grand burst of light once more. I imagine the spikes of my whiskers strike terror among the waiters and they take me for some distinguished traveler.[9]

He also mentioned enjoying "the good dinner and boutonniere at Lloyds very much."

Sixty miles south of St. Augustine on the sea breeze peninsula east of Daytona was Ponce Park, in the heart of the

7
River, Tree, City on Horizon
L.l.: W. A. Walker, Apl. 1914
Oil on canvas, 8 x 12½ inches
Present owner: Mrs. W. H. Cogswell III, Charleston
This may be a view of Jacksonville from the St. John's River.

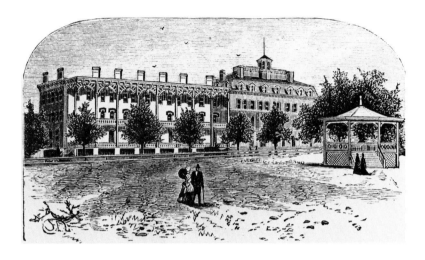

8
St. James Hotel, Jacksonville, Florida

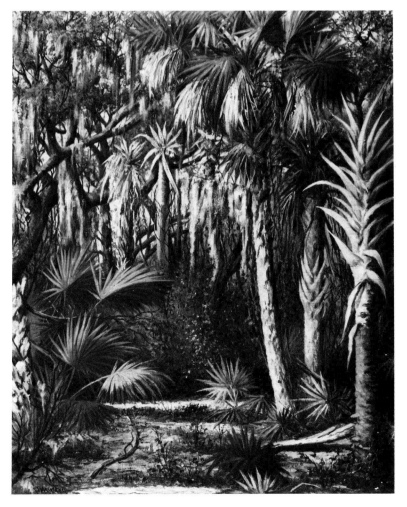

9
Palm Hammock with Epiphytes
L.l.: W. A. Walker; n.d.
Oil on board, 20 x 16 inches
Present owner: Mrs. Lucia Cogswell Heins,
Charleston

area Ponce de Leon had explored. Walker, camping in this area since 1881, had become closely associated with the Pacetti family, who had Spanish landgrant property on the point of the peninsula called Mosquito Inlet. During the winter of 1883, the peaceful camping ground on the Pacetti property was invaded by surveyors, builders, and stone masons. Bartolo and Martha Pacetti had sold part of their land to the U.S. Government for the Ponce de Leon Lighthouse Reservation (fig. 10). Their son Henry was killed in a construction accident during the building of the lighthouse, and his wife died in childbirth later that year, leaving Martha Pacetti with four grandchildren, besides Gomersinde, her son.

Walker was instrumental in convincing Martha to open a resort to Northern sportsmen who were just discovering the area.[10] He recognized the potential tourist appeal of the area. Daytona and New Smyrna were just being discovered by sportsmen, and small schooners and fishing smacks took fishermen out deepsea fishing (Plate 3). The large Pacetti boarding house (fig. 11) was built in 1886, and Mrs. Pacetti's grandchildren were able to help with the work necessary to make it efficient and comfortable. The eldest boy, Gomersinde, handled fishing trips for guests, and Walker agreed to keep the office and act as registrar. This office was to become his favorite Florida studio for the next twenty-three winters. In letters Walker often refers to the office as his "little studio" with its "cozy warmth" on chilly days.

Given room and board for his work, he also occasionally paid something to Mrs. Pacetti, and he gave her paintings. In fact, according to Mrs. Charles Moore, "Grandmother [Mrs. Pacetti] often told us about Mr. Walker, and that she wished many times that he had given her money rather than paintings."[11]

Ianthe Bond Hebel, who met Walker in 1904 when she lived with the Hiram Baxter's nearby and taught school, described a day at the Pacetti boarding house: "The men were on the river fishing every day, the women doing needlework on the porch. The evenings were devoted to cards—whist I suppose. The living room was crowded evenings and I would be in the kitchen with Netti [Pacetti] or on the porch."[12]

Pacetti House soon became known from Miami to Cape Cod for Martha's fabulous preparations of seafoods and for the fine fishing around its camp. An 1895 advertisement states: "Pacetti House, G. A. Pacetti, Manager. Rate @ $2.00 per day and $10.00 per week. Situated one-half mile north of Mosquito Inlet on Halifax River. Oldest management on the coast. Fine fishing and boating, and sail boats with or without guides."[13] Mrs. Hebel remembers "an old man 'colonel' who cooked. His

10
Ponce Light House, Ponce Park, Florida
L.l.: W. A. Walker, 1898
Oil on board, 6½ x 12½ inches
Present owner: August P. Trovaioli, Grand Bay, Ala.

11
Pacetti House, Ponce Park
Pacetti House—Ponce Park, Fla.
End of the cruise of the Orian,
17th May, 1899—W. A. W.
Crayon on paper from sketch book
Present owner: Mrs. W. H. Cogswell III, Charleston

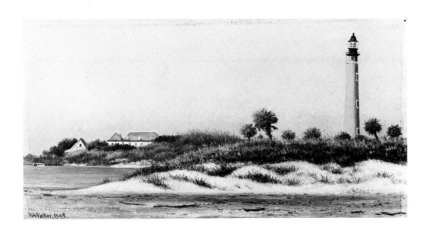

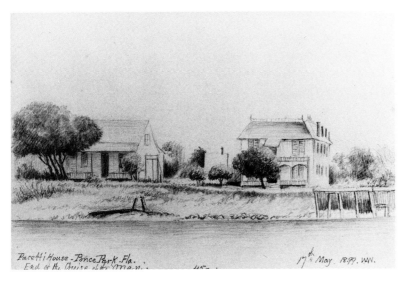

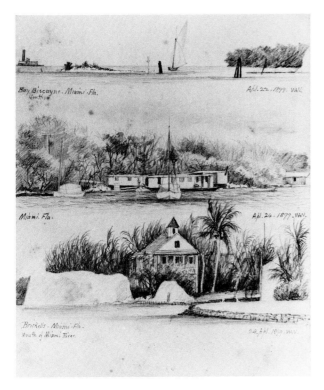

12
Bay Biscayne—Miami, Fla.
South
Apl. 22, 1899, W. A. W.

Miami, Fla.
Apl. 24, 1899, W. A. W.

Brickells—Miami, Fla.
Mouth of Miami River
24 Apl., 1899, W. A. W.

Mr. William Brickell's Indian store on the mouth of the Miami River profited from Mr. Flagler's extension of the railroad in 1896. He did better business with the new settlers than he had done with the Indians.

logs of grits, brown and crisp, went with the fish. [Mrs. Pacetti's] steamed or poached sheep head with egg sauce is long remembered."[14]

Gomersinde Pacetti knew Walker almost as a fixture in the house. The two arranged many fishing and camping trips for Northern sportsmen, and it was through these contacts that Walker was able to sell many of his Florida paintings. The artist painted the fish caught by the guests at Pacetti House—often Grandmother Pacetti was forbidden to cook the fish until the paintings were finished—and the guests bought the paintings as mementos of their catch.

Among the more notable sportsmen with whom Walker became acquainted was James Newton Gamble of Proctor and Gamble, who was later to purchase the Pacetti House and its contents—including the Walker paintings. Charles Beale, a wealthy landowner from Asheville, North Carolina, was to become host to Walker for many years at Arden Park, after a Ponce Park introduction. Stephen Minot Weld, retired general of the U.S. Army and owner of W. M. Weld Company, cotton manufacturers, commissioned Walker to do a cotton plantation scene for the office of the factory in Lewiston, Maine.[15]

Dr. Lewis Diehl, founder of the Louisville College of Pharmacy, frequented the Pacetti's and became a good friend of Walker's. Walker visited him in Louisville where he painted him standing in front of a barn with his horse (see fig. 12, p. 105). Diehl had been a pharmacist for the Union Army and was directly involved in formation of the Pure Food and Drug Administration. He was an avid fisherman and spent the winter months at Ponce Park for many years. Walker shared many fishing and painting experiences with him.

C. C. Gregg of St. Louis, manufacturer and well-known sportsman of his day, wrote *How, When and Where to Catch Fish on the East Coast of Florida* after his experiences at the Pacetti resort. His book contains a list of fishermen of the area, including "Prof. W. A. Walker," and Gregg refers to outings with the artist: "Professor Walker and I did well off Alligator Light getting Mangrove Snapper."[16] The Gregg family now has a collection of Walker paintings dating from this period.

In 1899 Gregg invited Walker to accompany him for a cruise on his yacht, the "Orian." Walker accepted gladly; for years he had wanted to make a trip along the Atlantic coast of Florida so that he might study the vegetation and land formations. He described his excitement in a letter to Dr. Diehl:

Well, the long looked for cruise begins at 6 A.M. tomorrow, when we start for Daytona to meet Mr. Gregg, and then ho! for the Florida Keys. I stowed all my traps on board in the lockers today so am

ready and glad to go for it is *sehrlangweilisch* here at night, no books only my paper and no one to discuss the world's news with.

I feel quite hilarious over the cruise for it is a very enjoyable and kind invitation and Mr. G. is an intelligent gentlemen who has seen the world and describes well what he has seen and is well informed on most subjects.[17]

Once aboard the Orian, he continued writing long, descriptive letters about the trip:

Since our start 8th Apl. the cruise has been delightful, and the weather superb, barring some rain lately, which did not last. The first 3 days down Hillsboro and Indian Rivers were quite cold, heavy N. E. wind and the Ther. reached 46° on 3rd day, but we are now in full summer, 84°. It would take a volume to describe the beautiful scenery that I have seen, far more lovely than I dreamed of, and every day is one of joy. At Gilbert's Bar we caught Blue fish trotting, and still fishing, some fine 10 lb. Groupers and Snappers, great sport. At Jupiter we got some fine Pompano, also Snappers, Groupers, and Sawfish. I got a 6 lb. Pompano, 24 in. long and 8 in. wide, a beauty. We are living well, and our cook edits the Culinary Menu in good style. We arrived at Palm Beach 18th and it is the loveliest spot I have every seen. The Royal Poinciana is a dream of beauty, but you have seen it, *verbum sap.* . . .

We left yesterday noon, and are now 11 A.M. in Hillsboro River and expect to fish at the Inlet after dinner for big Snappers. We came outside from Jupiter Inlet to Lake Worth Inlet, and were aground 2 days just inside Lake Worth on the flats, but got some Groupers there and one snapper. Snappers were as thick as Mullets, but would not bite in that clear water. Last night was the first that we have used a Mosquito bar, miserable *weather*, but the boat today is full of big horse flies, and one can imagine a saw mill buzzing aboard: they are worse than skeeters to me, and annoy me so I can scarcely write. . . .[18]

A few years later he wrote a humorous poem about the cruise that captures the spirit of the venture and demonstrates some verbal skill as an amateur naturalist.

The Cruise

Two old boys went on a cruise,
 When one was moved to woo the muse,
To tell of how they passed the time
 A fishing, humbly told in rhyme.

In Florida we made our outing,
 Many hundred pieces routing,
Fighting all that would combat us,
 Scomberomorus maculatus!

.

Ravexocoetus mesogaster,
 What a name that is to master!
Flying fish will do to name him,
 Many fish both catch and lame him.

.

I may you'll pardon Latin faulty,
 Accent take cum grano salty,
A little nonsense annent fishes
 For brother Anglers, with good wishes.

Fraternally Yours
The "Professor" [19]

Sketches made from the "Orian" in 1899 and a subsequent group dating from 1902 document the early development of the area south of New Smyrna as a tourist attraction. Walker caught the east coast at the last moment before the effects of Flagler's engineers, laborers, and planners were felt. He sketched the great overseas railroad during the first stages of construction in 1904. Number five trestle, Knights Key Bridge, and Bahia Honda Bridge, which Walker saw being built, became landmarks before the gigantic undertaking was finished in 1912 at a cost of $20,000,000 for the Key West extension alone. He sketched Flagler's new Royal Palm Hotel at Palm Beach with its colonial porticos and galleries under a mansard roof, and the new hotel at Rockledge on the Indian River. He sketched the San Sebastian and the Fort Pierce Hotel on the Indian River in 1907. He sketched the steamers as they cruised past the south end of Lake Worth. He also included the famous Brickell's (fig. 12) trading store where the Glades Indians traded. Hillsboro Inlet near Fort Pierce remained undisturbed, and only the markers for the surveyors hinted at the exciting change in store for Florida's east coast. When Walker sketched "Cocoanut Grove" (fig. 30, p. 121) in 1902, it was still a small fishing village in the Biscayne Bay Country, perhaps with a few of the coconuts planted by Commodore Ralph Monroe. Lantana on Lake Worth, later a sizable resort, had only three buildings when Walker saw it.

Besides documentation of sites on the St. Lucie, Indian, Hillsboro, Halifax, New, and Snake rivers, he made topographical studies of the many waterways of the east coast, identifying and dating each sketch. He drew the earthworks from the Spanish War in Miami, the house of refuge at Ft. Lauderdale Station at New River and the Biscayne house of refuge. In one sketch his subjects were the Presbyterian Church under construction in Miami, the Royal Palm Hotel in Miami (fig. 13) and Narres Cut at Bay Biscayne, mouth of the St. Lucie. He neglected, however, the shell mounds and middens left by Indians.

Lighthouses included are the "Mosquito Inlet Light" or "Ponce Light" near Ponce Park, "Fowey Rock Light," "Jupiter's Light 90 miles from Miami" (fig. 14), "Alligator Reef Light," and "Cape Florida Old Light" at Biscayne.

13
1st Pres. Ch. Miami, Fla.
25 Apl., 1899—W. A. W.

Miami
W. A. W. Apl. 25—1899

Royal Palm—Miami
Apl. 25—1899, W. A. W.
Flagler's Royal Palm Hotel was already under construction in 1896 when the railroad got to Miami. The Royal Palm was built in the Flagler pattern. Yellow with white colonial porticos and galleries under a mansard roof.

Narres Cut—Bay Biscayne, Miami, Fla., Virginia Key.
Apl. 25, 1899, W. A. W.

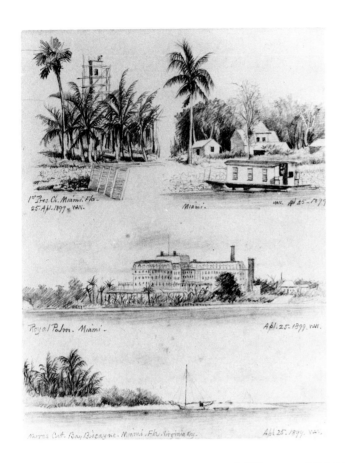

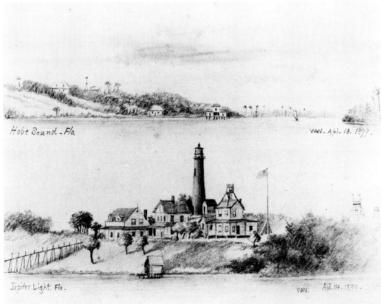

14
Hobe Sound—Fla.
W. A. W. Apl. 13, 1899

Jupiter Light, Fla.
W. A. W. Apl. 14, 1899
The red brick lighthouse at Jupiter Inlet
dominated the little settlement north of
Lake Worth.

Many sketches are interesting records of the plants and geography of the areas treated—the Everglades at Lake Wyman, the upper edge of the Seminole Country on the Indian River, and the Keys. A sketch of the Bay of Florida with small mangrove islands in the distance is annotated, "formation of Keys by Mangrove Tree Seeds." On a sketch of Gilberts Bar, Florida, May 15, 1899, Walker wrote, "Orian drifted over the bar here, 14th at night one mile from anchorage in Indian River. Mangrove tree fouled anchor." There is a series of sketches on the sponging in the Keys at Cards Sound, Arsenecker Key. Studies of sailing vessels, steamboats, and other fishing boats document the seacraft of the period (fig. 15). The vast amount of recording by Walker in his sketches is an important documentation yet to be seen or evaluated by scholars or public.

About the time of the Orian cruise, Walker began to make studies of marine life; these icthyological sketches and paintings dating from 1899 are more serious studies than the fish paintings he made from a client's catch. The annotated sketches and the language of his poem indicate a scholarly. if passing, interest in this field (figs. 16, 17).

Walker also spent some time in Pensacola and Fort Walton on the west coast of Florida. During the 1880's and 1890's, Pensacola was trying to pry some of the tourist trade from the St. John's River area. Although it had a population of only 4,000 in 1874, it was spoken of in *Appleton's Handbook of American Travels* as a place destined to become "by rapid strides the Chicago of the South." [20] The little town hardly lived up to the expectations of that optimistic prediction, partly because of repeated yellow-fever epidemics. By 1886, population had reached only 7,000. However, the Florida House, built by the Pensacola Railroad Company at Pensacola Junction, forty-four miles from the city, attracted tourists such as Mr. Gregg and Dr. Diehl, Walker's good friends. Walker spent at least one Christmas season in Pensacola, and he made sketches of the beaches there, which he sent to friends in New Orleans as Christmas cards.

Little remains today of the Pensacola that Walker knew. Gone are the City and Santa Rosa Hotels (fig. 18) and the Escambia and Kyser on Government Street, all frame-galleried buildings which, with the pleasant private residences styled like Italian Villas, made a particularly charming scene. The boarding house on Sevilla Square run by a Mrs. Hallmark was like the Magnolia, Walker's boarding house in Biloxi. The old Episcopal Church is still standing with a lovely view of the bay from Sevilla Square. Dining in Pensacola was cheap

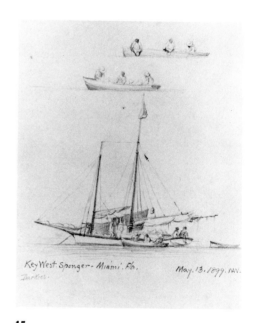

15
Key West Sponger—Miami, Fla.
May 13, 1899. W. A. W.

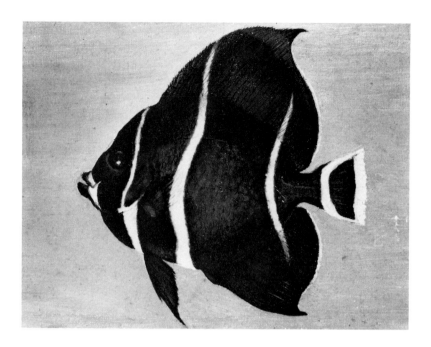

16
Juvenile Angel Fish
Unsigned, n.d. [*c. 1907*]
Oil on canvas, 7 x 9½ inches
Present owner: Jay P. Altmayer, Mobile
The artist chose this fish for its decorative markings, and he took liberties with the coloring and form for thematic purposes.

17
Bluefish
Unsigned, n.d. [*c. 1901*]
Oil on canvas, 12 x 20 inches
Photograph courtesy of Kennedy Galleries, Inc., New York
The "Bluefish" is a more serious study than that of the angelfish.

and good at the E. Sexauer Restaurant, but that building, with its Spanish style facade, is long since gone.

There was an active group of amateur artists interested in music and literature in Pensacola during Walker's day. They met weekly at the turn of the century. Mrs. Ada Wilson, dillettante musician-painter who later studied with the Woodward brothers in New Orleans, recalls the outings of the young and old in the artistic circle. The group chartered the tug "Monarch," and Ed Sparks, her cook, served fish chowder and molasses.[21] Picnics at Santa Rosa Island featured singing and violin music. Visits were made to Fort Barancas, which had been occupied by Southern troops during the Civil War, and Fort Pickens on Santa Rosa Island, once held by federal forces. These old forts were romantic sites for sketching trips. The ruins of Fort McRae with the Pensacola lighthouse nearby were especially picturesque.

Miss Emma Chandler was the most noted of the Pensacola artists. Like many local color artists of the South, she painted cabin scenes and genre portraits of Negroes.[22] Near Pensacola was a federal prison for American Indians, and among the captives was the Chiricahua Apache, Geronimo. The Indians, considered a curiosity, were painted by many of the artists. Walker neglected this interesting subject both in Pensacola and in the Everglades of Florida where there were Seminoles who came to Brickell's trading post and to Miami.

Walker went to Pensacola from New Orleans, Biloxi, or Mobile on the Bee Line returning to the east coast, or he occasionally took the train at Jacksonville to St. Marks on the Gulf transferring to the packet steamer from St. Marks to Pensacola Bay. However, after the turn of the century these trips became less regular, and Walker spent more of his time at Ponce Park. By 1904 much to Walker's disappointment the clientele at the Pacetti House had declined in number and in quality. He wrote that "Christmas was not very hilarious here —[it has] come and gone and now belongs to history. Colonel Piper and I passed Christmas evening quietly chatting in his room, too many young people in the parlor. I pass my evenings quietly in my room; and have only been in the parlor about half a dozen times."[23]

In 1911 the situation was even more bleak. "I miss some of our old pleasant friends who do not return," he wrote, "I know nothing of any more people coming, and we have only had 10 here at one time for a while."[24] By 1914 he was saying, "I pass my evenings in my room reading, and days painting as fishing has been poor. . . . I am very tired of this dull life for we used to have a pleasant crowd and jokes and good fel-

18
The City and Santa Rosa Hotels
Pensacola, Florida

19
Cottage on Beach with Palm Trees (Florida)
L.l.: W. A. Walker, dated on back *May 1899*
Oil on academy board, 6 x 12 inches
Inscribed in pencil on back: "To Mr. & Mrs. G. A. Pacetti with best wishes for health and happiness in their new home, from Wm. A. Walker, Oct. 1903, Indian Key, Fla., May 1899"
Present owner: Herman Schindler, Charleston
Gomersinde Pacetti and his wife are seen on the gallery of their cottage.

20
Sand Dunes, Palmetto (Sabal) and Steamboat
Unsigned, n.d.
Oil on canvas, 8½ x 17 inches
Present owner: Miss Edith O. Prentiss, Charleston
This painting is one of the few unsigned works on canvas. It has remained in Walker's family.

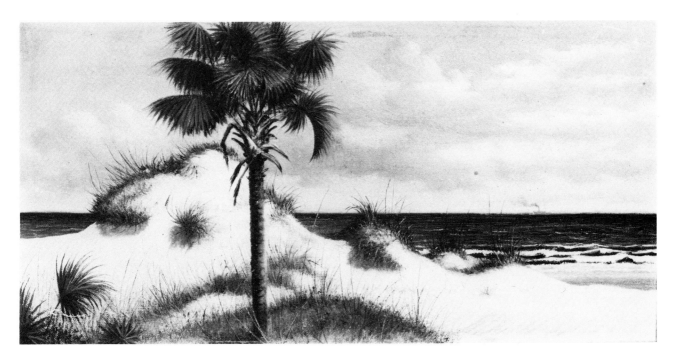

lowship, but all that now belongs to ancient history. . . . "A good many motor cars come here, some of them return after giving the occupants a view of the harbor, some remain to fish, and a few drive here sometimes, but it is not gay." [25] Nonetheless, the warmth and peace of Florida made it preferable for Walker to any other place he knew of for the winter months. "I am still suffering from a severe cold caught during a freeze three weeks ago, much pain in my back, head out of fix etc. etc. about but poorly and sleep but little, but this climate will right the latter after awhile. How glorious the white breakers and green sea look after the bare cold brown mountains [referring to Arden Park where he had spent the autumn]. Ah!" [26]

Little Florida sand dune and Coconut Palm beach scenes replaced Negro portraits, and Walker seemed to enjoy painting them again and again. He wrote Dr. Diehl, December 28, 1904, "I have made lots of new sketches and enjoyed the work very much for the scenes are lovely and the sunshine and air health giving" (figs. 19, 20). The sketches were offered at one dollar per page. Few sold.

Louisiana and Mississippi

"New Orleans will always be my second home," wrote Walker to his nephew in Charleston. He first went there in the winter of 1876, and the great port city with its European atmosphere was even more to his liking than he had anticipated. Not only was it a good place to recover financially after a summer in the mountains of North Carolina, but here he soon found a coterie of artists, musicians, and writers which would replace his friends of the Wednesday Club in Baltimore. In New Orleans he could exhibit his work at Blessing's and Seebold's art galleries and at the art exhibitions sponsored by the very active New Orleans artists. His paintings could be sold at the numerous lotteries sponsored by church groups and volunteer organizations interested in the artists of the city.

By 1878 he had established himself in the home of Miss Lottie Mitchel at 1521 Toledano Street (fig. 1). He stayed there during his winter or spring visits until sometime in the 1890's when he moved to the French Quarter. His social life in New Orleans was quite pleasant according to his letters to Dr. Diehl:

I am located on St. Louis Street between Royal and Bourbon near the Hotel Royal, very handy locale for my visiting, and for the restaurants. Antoine's celebrated restaurant 2 doors from me.

I am with my old landlady and French is our language as she is

Creole, and it is very nice to have my room well tended. I have a large comfortable room in an old French house.[1]

My stay in New Orleans was very pleasant for I met many old friends at the Clubs and elsewhere, and enjoyed the Theaters and fine dinners, and heaven knows I was in sore need of the dinners after the Florida fare. I took my coffee and coffee bread about 9:30 A.M., breakfasted near 12 and dined with old friends at 6 P.M., elegant dinner and wine. . . . They are a charming family of the old regime. Both their homes in New Orleans and Biloxi are lined with my paintings in drawing room and parlor.

An old friend, leading Portrait Painter in New Orleans took me to a fine d'hote dinner near Poydras Market, a fine place; dinner begins at 6 P.M. served seven courses, fine soup and salads, chicken every day, everything finely cooked, all the wine you chose to drink, ending with dessert and roquefort cheese and coffee—all this for 75¢. Think of it. The dining room is pretty, the company good and the kitchen a marvel of cleanliness; it is French, and I told the Madame who presides over the Kitchen (in French) that her kitchen was a picture.[2]

The old friends to whom Walker often referred in his letters were Mr. and Mrs. Aristide Hopkins. Hopkins was agent for the Baroness Pontalba and represented various foreign property owners in New Orleans. His home at 730 Esplanade was filled with paintings and sculpture by Walker, A. P. Viavant, August Perelli, and William Buck. The Hopkins family patronized the artists of New Orleans, entertaining them at their homes on Esplanade and in Biloxi (fig. 2). Among their paintings by Walker both in the New Orleans and Biloxi houses were fish paintings, cabin scenes, Florida landscapes, and Negro genre portraits, all of which have been dispersed.

Walker received his New Orleans mail at Standard Photo Supply Co., Ltd. Robert Stanley Green, its owner, became his intimate friend (fig. 3). As a favor, Walker painted portraits of Mr. and Mrs. Green, and the family retains a collection of his paintings. Their collection contains the large scene of horses in a pasture inspired by John Frederick Herring (Plate 10). When Walker died in Charleston, his nephew was in correspondence with Standard Photo about twelve paintings which were on consignment there.

Walker's cousin George Langtry, a commission merchant in New Orleans, corresponded with him.[3] In 1900 the two men were interested in their family history, and Langtry wrote Walker in Charleston that their mutual ancestor, the Reverend George Walker, was honored for feats in the siege of Londonderry in a publication dated 1689. The information, according to Langtry, was obtained from *Chambers' Encyclopedia* of 1880.

During his first season in New Orleans, Walker established contact with the New Orleans landscape artists and genre

painters. Everett D. B. Fabrino Julio, a French trained artist from St. Helena of Scottish and Italian parentage, became a close friend.[4] Walker participated with Julio in an attempt in 1876 to form an art league in the latter's studio. Julio had found it impossible to support himself with his oil paintings, and he worked at Clark's photograph shop where he oil-colored large three-quarter and full-length photograph portraits. He contracted tuberculosis and, after a trip to Europe in 1872, moved to Kingston, Georgia, for his health. When Julio's illness became terminal, Walker went to Kingston to care for him. The artist's death in 1879 was very depressing to Walker, and marked the beginning of a protracted period of serious paintings. The five years between 1879 and 1884 spent in New Orleans, in Florida, and at Arden, North Carolina, constitute his most consistent period of fine work.

Richard Clague's home on Bayou St. John near Spanish Fort was a popular retreat for New Orleans artists, and Walker joined Andres Molinary, Marshall Smith, William Buck, and others there for evenings of entertainment and conversation. Using Clague's house as a base, three or more artists at a time took a camera, their sketch books, and pens on field trips. Afterwards they painted similar scenes from photographs and sketches. One such trip to St. Bernard Parish is documented in the *Daily Picayune* of November 6, 1886, in a review of the first annual exhibit of the Artist's Association.

Three of the artists have visited the same spot for inspiration. It is the old Laronde plantation in St. Bernard, known as Versailles. E. Dantonet calls his the 'Parish Road' and the name explains his portion of the subject. Molinary calls his "At Versailles" and paints the pretty rustic scenery of the place. [Bror Anders] Wikstrom's painting deals less with the scenery, but is suggestive. It shows a party of visitors among the ruins of a plantation home, the place where General Packenham died (fig. 4).[5]

Mandeville was also a popular place for the artists to sketch, and photographs of scenes similar to those painted by Richard Clague, William Buck, Marshall Smith, and their contemporaries have been found in the collection of Blanche Blanchard, a well-known amateur artist and patron of the arts. The group caught the train at Carrollton and crossed Lake Pontchartrain to Mandeville and Covington where there were a number of popular boarding houses, inns, and summer houses for vacationing New Orleanians. Fashionable since before the Civil War, these towns were resort areas from 1870 to the First World War.

The New Orleans artists painted together and addressed themselves to the same subjects whether from photographic

1
1521 Toledano Street
The home of Miss Lottie Mitchell, where Walker roomed in the 1870's.

2
Aristide Hopkins' Biloxi home
824 West Beach

records or on-the-spot sketching forays. Walker's painting "Wooding Up On The Bayou" (Plate 1) is like the description of a painting by T. R. Tennent, dated 1882. "T. R. Tennent exhibits a bit of well-known local scenery, Clague's residence near Spanish Fort, and adds to its effects by painting a lumber schooner lazily making its way along the Bayou."[6]

Molinary gave a romantic interpretation to the cabin scene while Walker always included the human figure, sometimes in groups and with domestic animals (figs. 5, 6). The others generally limited themselves to characteristics of the landscape. A description of a Buck painting could well fit a Walker subject. "The Mandeville picture by Buck is of an irregular bit of ground and road, moss covered trees, several promenaders and an old cabin in a shady corner."[7] Lumber yards and mule-drawn wagons hauling cane or hay were a common subject of Walker and his companions, as were oak trees, cypress swamps, and Negro cabins.

The formation of the Southern Art Union in 1880 by Marshall Smith, Andres Molinary, Edward Livingston, Achille Viavant, and Charles Wellington Boyle was an effort to interest the general public in landscape and genre painting and to educate Orleanians in the arts. This was a purpose opposite to that of Charleston's Carolina Art Association founded by the citizens to attract artists. When the daguerrotype had become common and the demand for the commissioned portrait waned after the war, there were few patrons, so the New Orleans landscape and portrait painters taught painting in the Southern Art Union to 150 to 200 young ladies and gentlemen. Walker exhibited with the Southern Art Union at their annual exhibition, and he participated actively in all the social events related to the Union.

It became fashionable to take art lessons from the artists and to patronize them. Mrs. James Gallier Blanchard, Miss Virginia Blanchard, and Miss Blanche Blanchard were among the amateurs and dilettante young matrons and ladies with whom Walker worked. He and other artists spent many evenings in the Blanchard home at 2700 Magazine Street. Paintings by Walker and Claudius Giroux, a French artist in New Orleans, eventually lined the walls of the late Victorian interior (fig. 7). Apparently as part of the teaching technique, Blanche and her young lady friends would paint the background, the artist-teacher would paint the picture, and the student would sign it. More than five paintings signed by Blanche Blanchard were painted by Giroux, and a Negro portrait (fig. 8) signed by Miss Blanchard but probably painted largely by Walker, is seen with the Girouxs in the parlor of Blanche Blanchard and her husband C. Milo Williams (fig. 9).

3
Portrait of Robert Stanley Green
Unsigned, n.d.
Oil on canvas, 29 x 24 inches
Present owner: Mrs. Malcolm Monroe
(daughter of Mr. Green), New Orleans

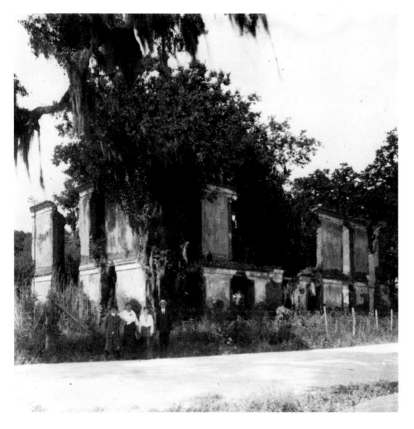

4
**Ruins of De La Ronde Plantation,
St. Bernard Parish**
The old glass negative from which this print was made came from the Blanche Blanchard house. It is one of the photographs made by a group of artists on their field trips and from which they later made paintings in Clague's studio or at the Blanchard home.

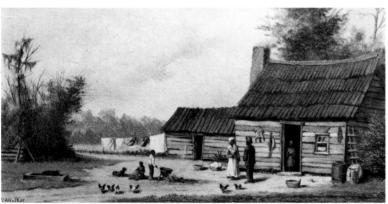

5
**Louisiana Cabin Scene with
Rear Extension**
L.l.: W. A. Walker, n.d.
Oil on canvas, 8 x 12 inches
Present owner: Mr. and Mrs. Richard Roth, New Orleans

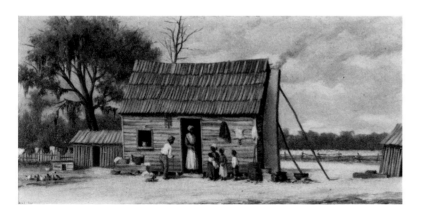

6
Two-Pole Chimney
L.l.: W. A. Walker, n.d.
Oil on board, 6 x 12 inches
Present owner: Taylor Clark, Baton Rouge

Blanche Blanchard studied art in a convent school near Washington where she copied works in the Corcoran Art Gallery. She became active in the artistic circles of New Orleans, and Claudius Giroux intermittently lived at the Blanchard house. Like Walker and the other artists in whom she was interested, Blanche considered herself accomplished in music and poetry. She played the harp, and her poetry rivals Walker's in sentimentality.

Walker's many evenings at the Blanchard's, and later at the home of Blanche and her husband, were spent playing the violin with Blanche's brother, telling stories, and singing. These occasions afforded Walker a home atmosphere, friends with whom to discuss art, music, and literature, and young people before whom he performed.

Walker also participated in the Cup and Saucer Club, which met at Andres Molinary's studio on Camp Street. There young writers and artists met for readings, book reviews, and companionship with people with similar artistic and literary interests. Walter Cox, a nephew of George Washington Cable, was a young painter who took the artists to the Cable home for evenings of conversation and whist.

The first annual exhibition of the Southern Art Union was held in 1880. Among the entries were five oil paintings and fourteen water colors by Walker. More examples of his work were included in the show than those of any other artist. "W. Walker has several cotton pickers, a wagon team, the wagon loaded high and a jolly group of Negroes on top of the piles."[8] In addition to his Negro genre portraits, there were "Servants Quarters" by T. R. Tennent, landscapes by George Coulon depicting local outing spots like the grassy height of Fort Macomb, Father Rouquette's house in Mandeville, and a "Bayou St. John scene across from the residence of the Hon. Charles Louque." From the careful identification of the sites chosen for the subject, one concludes that these local scenes were quite popular. August Norieri exhibited a marine painting, "Off Port Eads," and Bror Anders Wikstrom's views of the Baltic and the Norwegian coast were hung beside his Florida landscapes. Paul Poincy, native-born New Orleanian who had studied in Paris, was one of the few artists who could afford to be a painter. Poincy, like Clague, had been born in fortunate circumstances to a cultivated family of French descent.

Although Southern landscapes were in the forefront of the exhibition, subjects painted after European prototypes were evident. For example, J. Moise, also active in Charleston, presented a portrait of Lord Byron as a youth. Portraits, espe-

7
Blanchard Parlor, New Orleans
Parlor where Miss Blanche Blanchard entertained Walker and other New Orleans artists. The room is in keeping with the period taste for the exotic and picturesque, exemplified by Moorish decoration and oriental motifs. Walker's work fit into the decoration much as the statue of the blackamoor and the Turkish hangings.
The photograph by C. Milo Williams is from the Louisiana Landmarks Society, Special Collections Division, Tulane University Library.

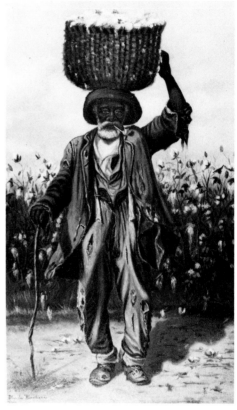

8
Cotton Picker
L.l.: Signed *Blanche Blanchard, n.d.*
Oil on board, 19 x 11 inches
Present owner: Jay P. Altmayer, Mobile

9
**Back Parlor of C. Milo Williams'
House, New Orleans**

Mrs. C. Milo Williams (Blanche Blanchard)
continued to entertain groups of friends
and artists, including Walker, her teacher.
"Cotton Picker" (fig. 8) a painting on
which they collaborated, may be seen
in this photograph.

The photograph by C. Milo Williams is
from the Louisiana Landmarks Society,
Special Collections Division, Tulane
University Library.

cially of happy young children like those by Molinary and Poincy, were popular. Perelli exhibited his paintings of dead game and fish. William Buck, Alphonse Gamotis, L. C. Girault, Poincy, Molinary, G. D. Coulon, C. W. Boyle, T. R. Tennent, Edward Livingston, and Wikstrom all presented local scenes. The one hundred paintings in this exhibition were typical of the tastes and type of work of the late nineteenth-century painters in the South.

Another organization, the Artist's Association of New Orleans, began in 1885 with Wikstrom, Poincy, Molinary, and Achille Peretti as leading figures. A school was begun by this group, and in November of 1886 the first in a series of annual exhibitions, which continued until 1905, was held. Again Walker's paintings far outnumbered entries by other artists. The *Daily Picayune* described the scene of this first annual exhibition:

Altogether the display was a creditable one, and the many who visited the exhibition yesterday praised it highly. The reception room, between the two galleries was tastefully decorated in profusion. A large bust of Ajax, whose absorbed head has been chosen as the emblem of the association, stood on a pedestal in a grove of spreading palms. Other casts of antique models did similar duties. Throughout portiers of rich hangings the spectator crammed into the rooms along the sides of which the various sketches and paintings stood in relief.[9]

Because of his New Orleans contacts, Walker was able to send "Gwine to Der Expersishun," a portrait of "Deacon Jones, Edisto Island, S. C.," to the St. Louis World's Fair, where it was exhibited in the Louisiana State Building in 1903. He had also sent "Cotton Pickers" to the Columbian Exposition in Chicago in 1893.

Although Walker participated in the New Orleans social and artistic community, it was to the stranger on the street that most of his paintings went. By the 1890's Walker was a familiar sight in New Orleans during the winter months. Tall and lean with his beard flowing, Walker dressed meticulously. He was reminiscent of more colorful painters in New Orleans like John Vanderlyn. Walker sat on the corner of Royal and Dumaine painting and selling his paintings. He wore a long frock coat and a French beret; his shoes were glistening. The careful arrangement of color on the palette, the systematic way in which he changed brushes for different textures, and the gentlemanly manner in which he spoke to the curious tourist all reflected showmanship. Walker played his role to perfection. He carried a small tripod on which were attached souvenir or postcard-size Negro studies priced from fifty cents to three dollars. On a good day he would make twenty dollars. On rainy

Plate 1
Wooding up on the Bayou
L.l.: W. A. Walker, n.d.

Oil on board, 8½ x 13½ inches
Present owner: Felix H. Kuntz,
New Orleans

This painting was exhibited in 1968 at
the Louisiana State Museum show, "250
Years of Life in New Orleans." It appeared
misnamed in the catalogue as "Wooding
up on the Mississippi."

Plate 2
The Levee at New Orleans
L.l.: W. A. Walker, 1883

Oil on canvas, dimensions unknown
Present owner: J. Cornelius Rathborne III,
San Francisco

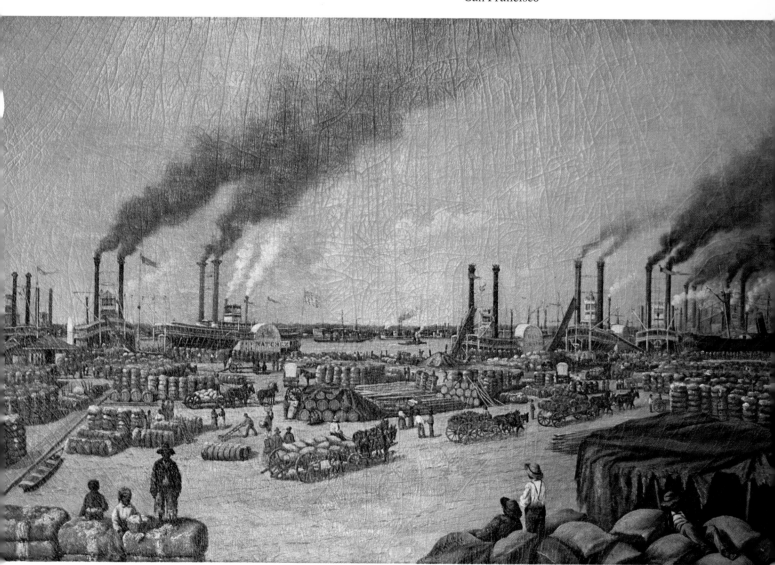

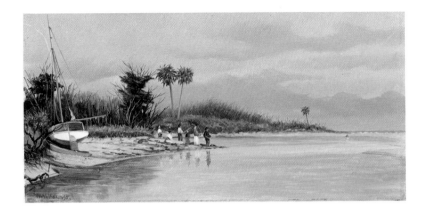

Plate 3
The Cove at Ponce Park
L.l.: W. A. Walker, 1895

Oil on board, 6½ x 12½ inches
Present owner: August P. Trovaioli,
Grand Bay, Ala.

Plate 4
The Bombardment of Fort Sumter
L.l.: W. A. Walker, April 12–14, 1861

Oil on canvas, 22 x 40 inches
This painting is inscribed "from a sketch
taken in 1864 by W. A. Walker, C. S.
Engineer Corps" (see fig. 4, p. 19), but the
painting was not executed until 1886.
Present owner: Herman Schindler,
Charleston (On loan to the Gibbes Art
Gallery, Charleston)

Shown in the painting are Mount Pleasant,
Castle Pinckney, Sullivan's Island, Fort
Sumter, Federal monitors, Battery
Simkins, Morris Island, James Island,
Battery Wagner, Fort Johnson, and
Confederate ironclads. The vantage point
is from about the intersection of E. Bay
and S. Battery Streets.

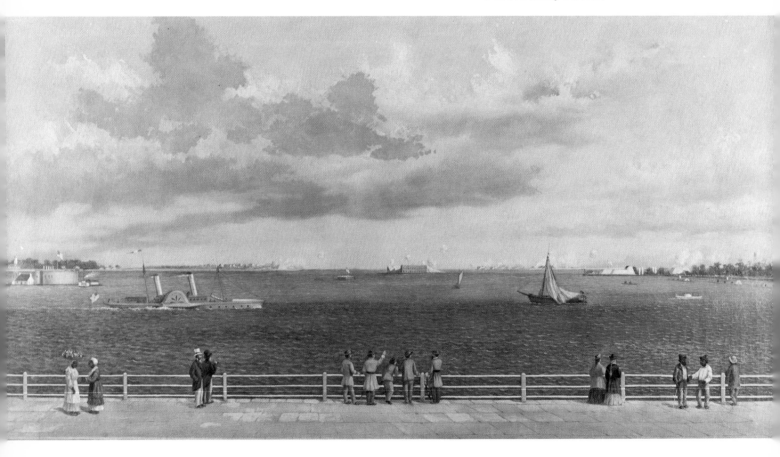

Plate 5
View of St. Augustine Harbor
Unsigned, n.d.
Oil on canvas, dimensions unknown
Present owner: J. Cornelius Rathborne III,
San Francisco

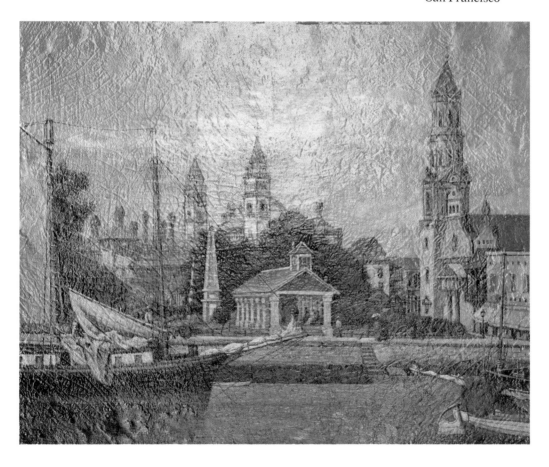

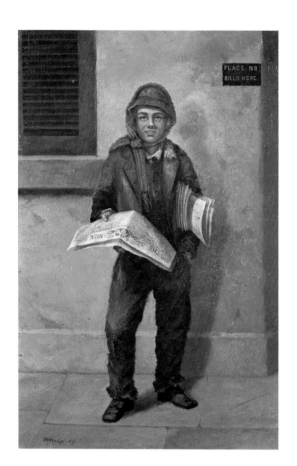

Plate 6
Newsboy Selling the Baltimore "Sun"
L.l.: W. A. Walker, 1871
On artists' slate board, 12 x 8¼ inches
Present owner: George Missbach, Atlanta

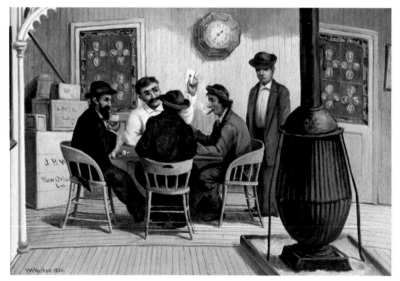

Plate 7
Cardplayers on the Steamboat
L.l.: W. A. Walker, 1880
Oil on board, 7½ x 10½ inches
Present owner: Jay P. Altmayer, Mobile
The very detailed cards of these players in
a steamboat cabin show a full house in the
winner's hand.

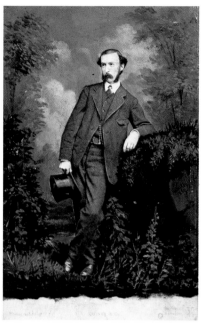

Plate 8
Oilette of the Artist
Middle right: W. A. Walker, 1869

Photograph painted with oils. Printed on front is the name of the photographer, "Quimby and Co."
Present owner: Herman Schindler, Charleston

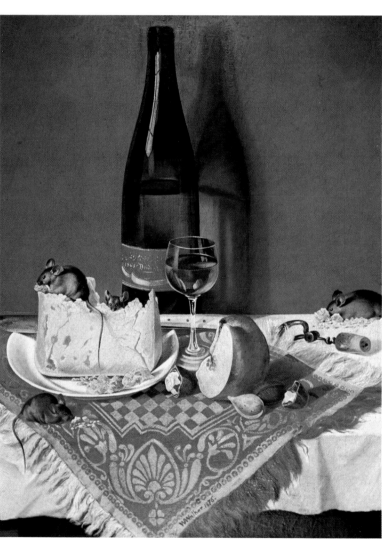

Plate 9
Still Life with Cheese, Bottle of Wine, and Mouse
Lower center: W. A. Walker, 1876

Oil on board, 20 x 16 inches
Present owner: W. P. Monroe, New Orleans

Plate 10
Horses in a Pasture
L.r.: W. A. Walker, n.d. [c. 1880]
Oil on canvas, 21 x 34¾ inches
Present owner: W. P. Monroe, New Orleans

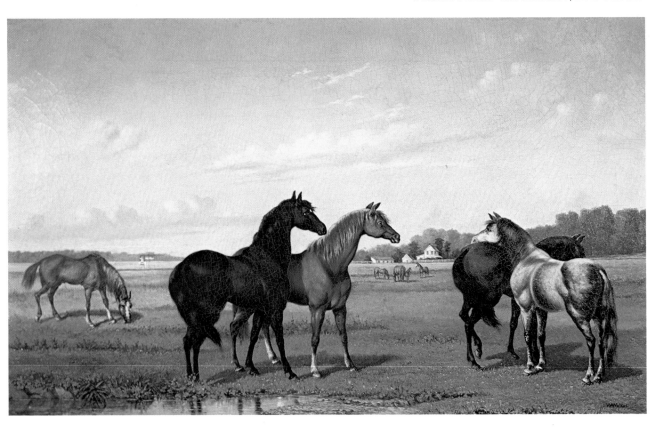

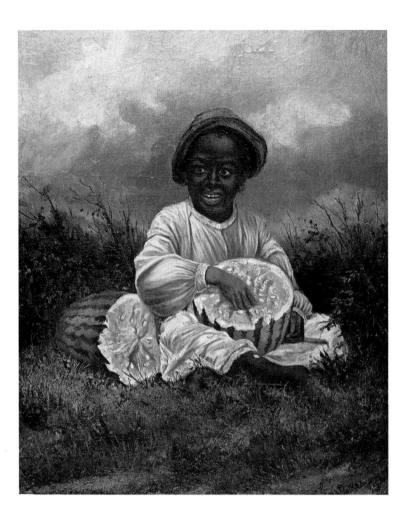

Plate 11
Little Negro Girl Eating Watermelon
L.r.: W. A. Walker, n.d. [c. 1885]
Oil on board, 16¼ x 12¼ inches
Present owner: Felix H. Kuntz,
New Orleans

Winslow Homer is said to have been
annoyed and embarrassed by the
popularity of his "stereotypical
Watermelon Boys." Certainly the subject
has been overdone in humorous paintings,
but Walker's charming "Watermelon Girl"
completely lacks the ridicule or satire of
many such paintings.

Plate 12
Wagon Scene
L.r.: W. A. Walker, 1888
Oil on canvas, 14 x 24 inches
Present owner: Jay P. Altmayer, Mobile

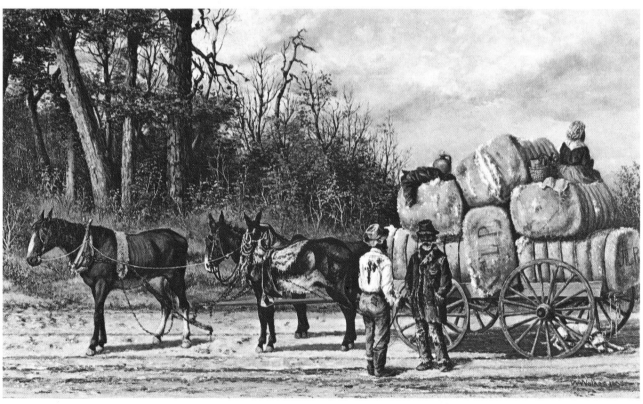

Plate 13
Hoeing Cotton
L.r.: W. A. Walker, n.d.

Oil on canvas, 12 x 20 inches
Present owner: Didier's, New Orleans

The figure with a striped hat in the lower
right is also shown in a Currier and Ives
print, "Southern Cotton Plantation." The
bonnetted woman, seen in many paintings,
is painted after an extant Walker
photograph.

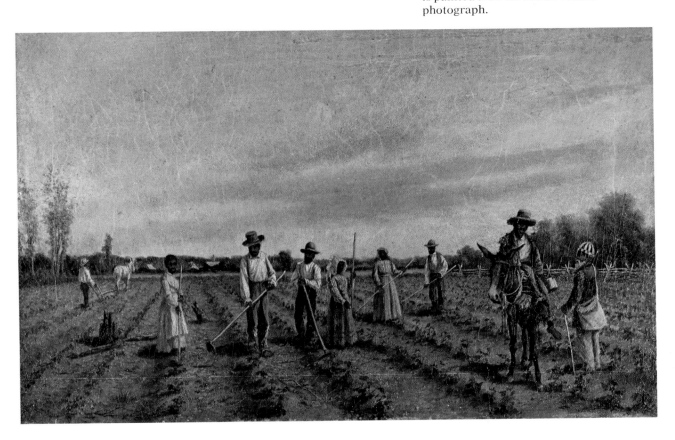

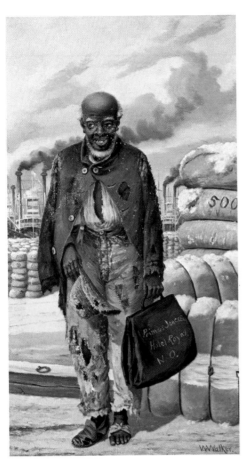

Plate 14
Wharf Scene: Primas Jones
L.r.: W. A. Walker, n.d. [c. 1886]
Oil on canvas, 18⅛ x 10½ inches
Present owner: George Missbach, Atlanta

Plate 15
Wagonload of Cotton
L.l.: W. A. Walker, n.d.
Oil on canvas, 18 x 30 inches
On original stretcher
Present owners: Mr. and Mrs. George J.
Arden, New York
This scene has been identified by former
U.S. Senator James F. Byrnes as the James
Allen Plantation near Charleston, S.C.

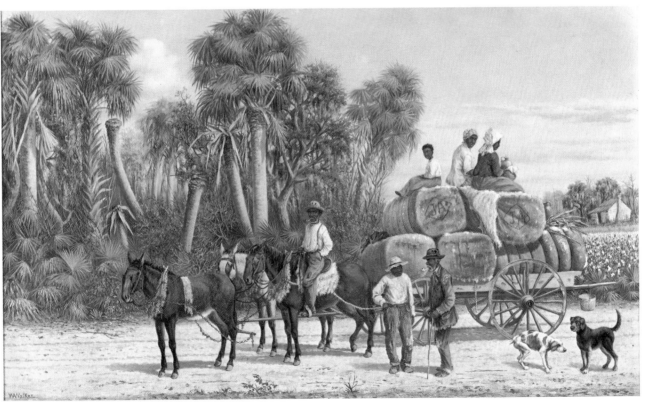

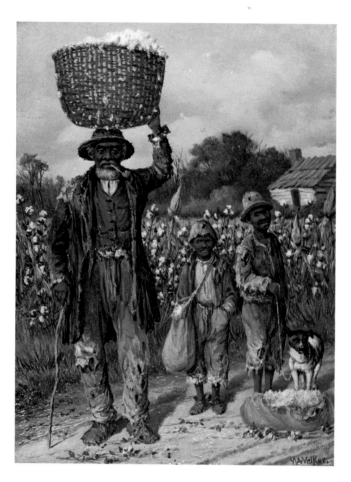

Plate 16
**Negro Man, Two Boys, and
Dog in Cotton Field**
L.r.: W. A. Walker, n.d. [c. 1885]
Oil on board, 13 x 9 inches
Present owner: Phyllis Hudson,
New Orleans

Plate 17
Plantation Wagon Scene
L.l.: W. A. Walker, n.d.
Oil on canvas, 10 x 14 inches
Present owner: Jay P. Altmayer, Mobile

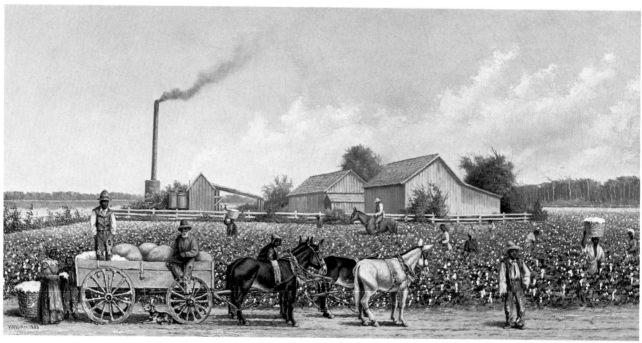

Plate 18
Cotton Plantation on the Mississippi
L.r.: W. A. Walker, 1881
Oil on canvas, 25 x 40 inches
Present owner: Jay P. Altmayer, Mobile

This painting was commissioned by
General Weld for his cotton mill office
at Lewiston, Maine.

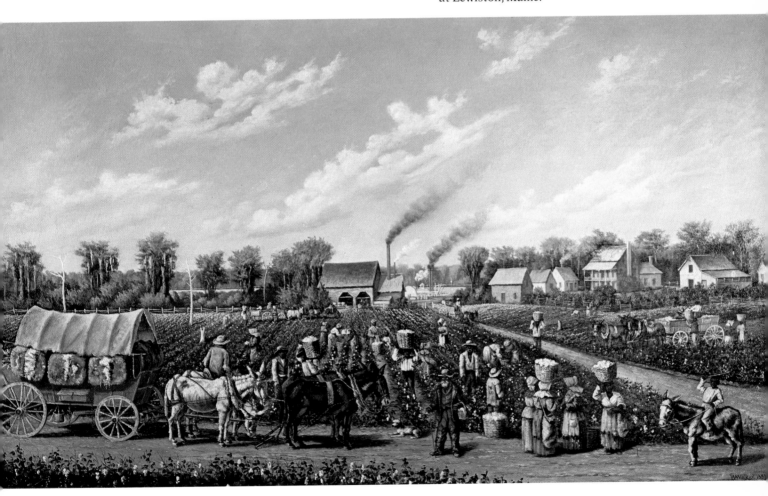

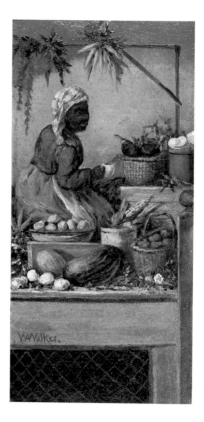

Plate 19
Charleston Vegetable Woman
L.l.: W. A. Walker, n.d.

Oil on composition board, 8 x 4 inches
Present owner: Felix H. Kuntz,
New Orleans

Plate 20
Cotton Picking in Front of the "Quarters"
L.r.: W. A. Walker, n.d.

Oil on canvas, 12 x 20 inches
Present owner: Didier's, New Orleans

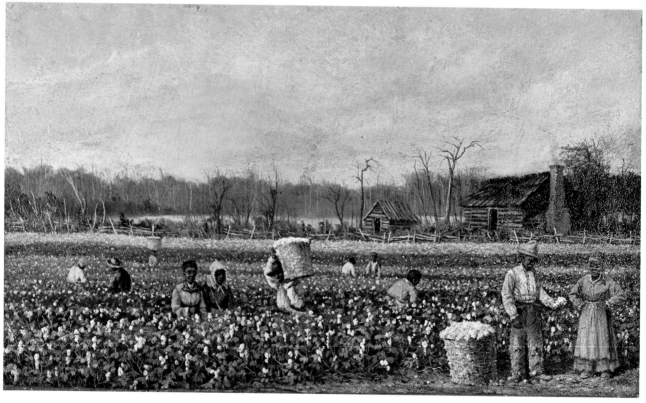

Plate 21
On the Road to Natchez
L.l.: W. A. Walker, 1888
Oil on canvas, 12 x 20 inches
Inscribed on stretcher: "On the road to
Natchez, William Aiken Walker."
In original frame.
Present owner: Didier's, New Orleans

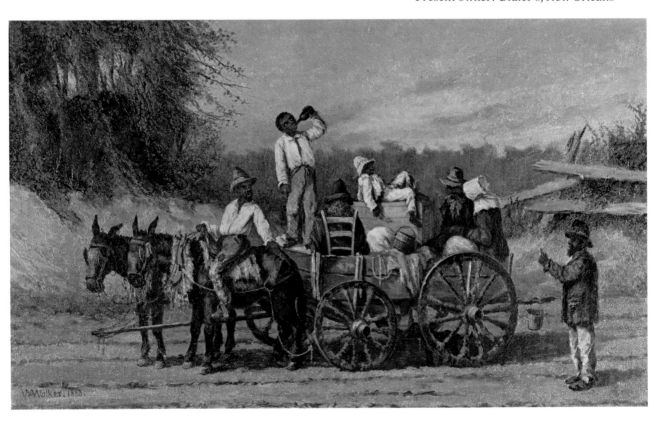

Plate 22
Tobacco Field with Five Figures
(North Carolina)
L.r.: W. A. Walker, n.d. [c. 1895]
Oil on canvas, 16 x 20 inches
Present owner: Felix H. Kuntz,
New Orleans

Plate 23
South Georgia Shanty
L.l.: W. A. Walker, n.d. [c. 1897]
Oil on board 9 x 12½ inches
Present owner: Jay P. Altmayer, Mobile

Plate 24a
Plantation Worker in Cotton Field
L.l.: W. A. Walker, n.d.
Oil on canvas, 12 x 6 inches
Present owner: Dr. D. A. Spring,
Baton Rouge

Plate 24b
Cabin Scene with Trumpet Vine
and Jasmine
L.r.: W. A. Walker, n.d.
Oil on canvas, 12 x 9¼ inches
Present owner: Dr. D. A. Spring,
Baton Rouge

Plate 24c
Negro Man in Cotton Field with
Basket on Head
L.l.: W. A. Walker, n.d.
Oil on canvas, 12 x 6 inches
Present owner: Dr. D. A. Spring,
Baton Rouge

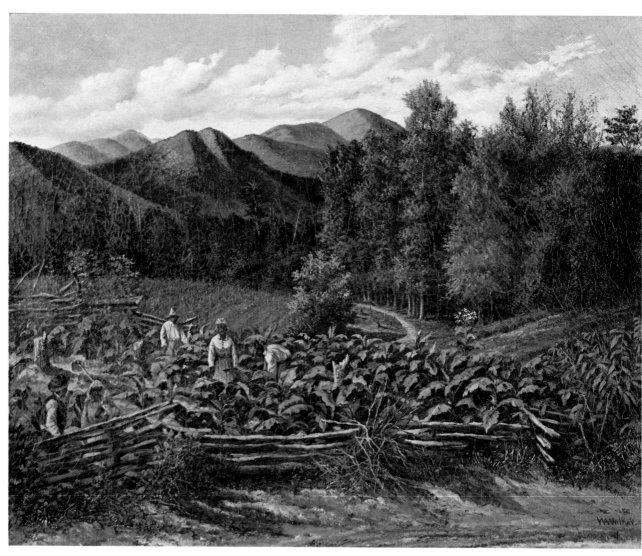

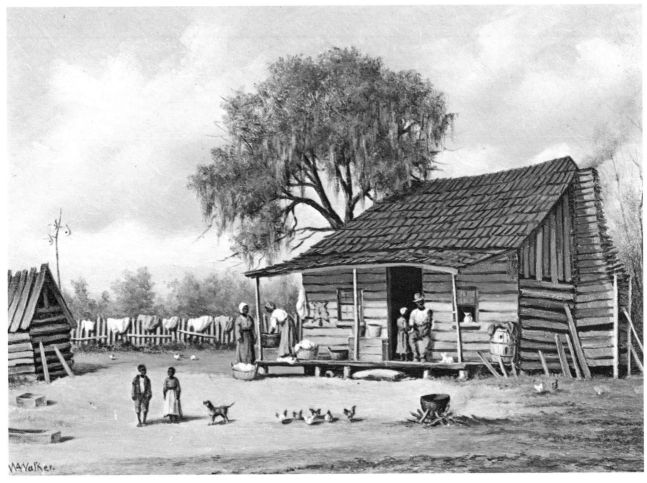

23

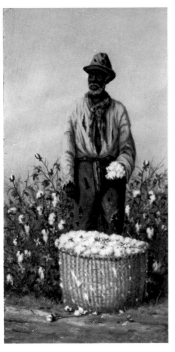

24a

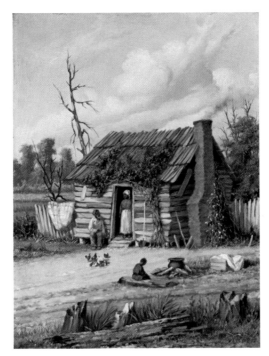

24b

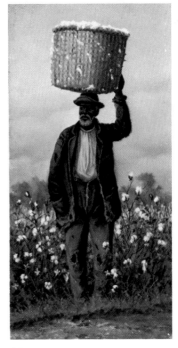

24c

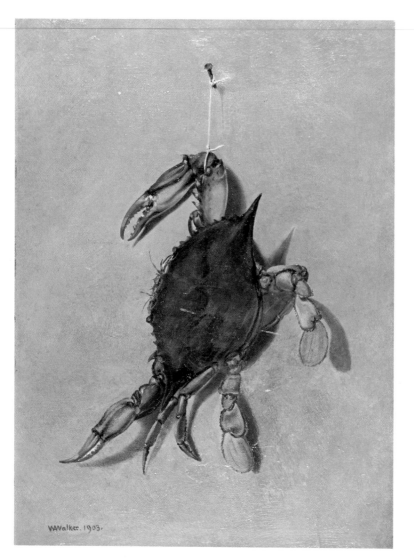

Plate 25
Crab
L.l.: W. A. Walker, 1903

Oil on board, 16 x 12 inches
Present owner: George Denegre,
New Orleans

This is one of many paintings by Walker
which hung in the home of Aristide
Hopkins on Esplanade Avenue in
New Orleans.

Plate 27
**Bedstraw (Galium), Wood Fern,
and Rose Hips**
On back: W. A. Walker, Biloxi, Miss., 1905

Oil on board, 12 x 9 inches
Present owner: August P. Trovaioli,
Grand Bay, Alabama

This same motif appeared as a dried leaf
pressing in Walker's poetry book written
in 1860. Bedstraw was pleasantly scented
and used in mattresses. Walker chose it
here for its very decorative quality.

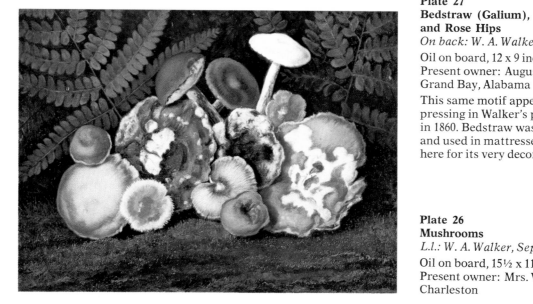

Plate 26
Mushrooms
L.l.: W. A. Walker, Sept. 1910

Oil on board, 15½ x 11 inches
Present owner: Mrs. W. H. Cogswell III,
Charleston

days he remained in his room painting many versions of the same subject taken from earlier photographs or adapted from larger compositions.

Walker had developed a quick method of painting small portraits of the cotton pickers. He prepared a strip of academy board, painting a sky across the top and a ground of sienna across the lower half. Over this ground he painted cotton ready for picking; Negro figures were then superimposed over the cotton field. Often the prepainted cotton bolls show through the figure. In many instances they were converted to tatters in the clothing of the subject. The figures were always dressed in tatters and rags, sometimes with bandanas and aprons according to traditional habits of dress in specific regions of the South. These rows of figures would then be cut into a series of postcard-size portraits. One occasionally finds two Walker portraits where the clouds and cotton fields fit as in a puzzle indicating that they were painted on academy board in a row side by side. Walker offered these on the streets for two dollars; and book stores, stationery shops, music stores, and photo-supply houses handled them on consignment. Fresh pictures were painted to replace those that were sold daily; figures were often copied from earlier serious canvasses and from Walker's own photographs. Walker signed and sometimes dated his original studies but the academy board paintings, quick adaptations of the same subject, were not always signed. His initials were used primarily on paintings dating from before 1868.

The levees at New Orleans fascinated Walker, and he painted a series of scenes depicting both serious and humorous activities in the market and on the docks. One group was painted on copper plates (figs. 10a, b). Those which he made for quick sale were painted on wooden box tops, academy board and odd-sized scraps of canvas. His conventional small portraits of Negroes have cotton fields in the background, but one very carefully done series has a background of cotton bales and steamboat stacks (figs. 11, 12). Two levee scenes painted on wooden palettes from the Robert Stanley Green collection are exceptional, and the Rathborne collection's large panoramic view of the levee at New Orleans was reproduced by Currier and Ives in 1884 (fig. 13).

He made trips upriver on Captain John Tobin's steamboats. The sumptuous meals, visits among the passengers, friendly conversation with the staff, and the opportunity to sketch on board made trips to Greenville, Natchez, and Vicksburg most enjoyable. "Cardplayers on the Steamboat" was painted aboard Captain Tobin's steamboat and was given to

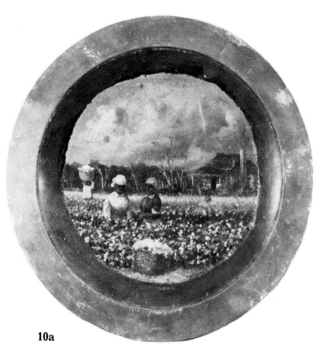

10a

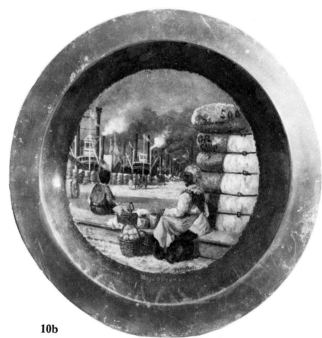

10b

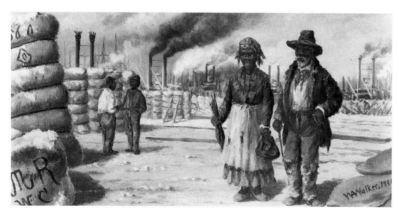

11

10a
**Cotton Field with Cotton Pickers
and Cabin**
W. A. Walker, n.d.

10b
**Negro Woman and Child Sitting on
Levee at New Orleans**
W. A. Walker, n.d.

Oil on copper plates, 10 inches in diameter
Present owner unknown; formerly
J. Cornelius Rathborne Collection
Photograph courtesy of Alonzo Lansford,
New Orleans

11
On the Levee (New Orleans)
L.r.: W. A. Walker, 1886
Oil on board, 6½ x 12¼ inches
Present owner: Jay P. Altmayer, Mobile

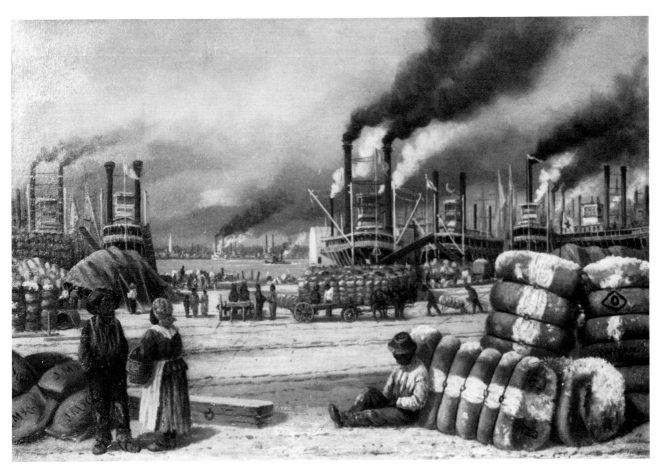

12
New Orleans Docks
W. A. Walker, 1885
Oil on board, dimensions unknown
Present owner: Samuel E. Lowe, Boston

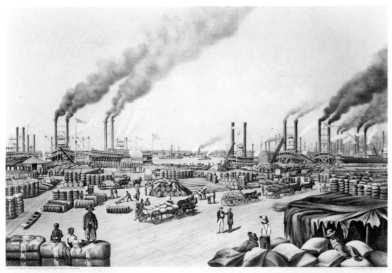

THE LEVEE - NEW ORLEANS.

13
The Levee—New Orleans
W. A. Walker, 1883
Lithograph by Currier and Ives, large folio
Photograph courtesy of Alonzo Lansford,
New Orleans

the captain as payment for Walker's fare in 1880 (Plate 7). On one of his trips, Walker visited John Orr Bradfield, a native of Baton Rouge who resided at Willow Glenn Plantation across the River from Vicksburg. As he did with the children of many of his friends, Walker photographed Bradfield's son, John Jenkins, around 1885, and made a painting after it showing the little boy fishing at Grant's Canal near the plantation (fig. 14). It was at the Bradfield's that Walker finished in oils a photograph of himself (figs. 15, 16).

When Walker visited the Bradfields, Vicksburg was much like it is today, the only urban center in the general area. Vicksburg is the capital of Warren County, which then had a population of about 30,000, almost all within the city. As early as 1874, the city was already a tourist attraction as a battle site of the Civil War.

Picturesque Vicksburg, a book to promote the city's commercial interests, describes cotton cultivation as Walker knew and painted it at the Bradfields.

The average date to begin preparation of the land in Mississippi is February 1st before the rain commences. Planting starts about April 5th and is finished by May 10th. Picking generally commences in August and frequently continues until the approach of spring. All the available hands from the gray-haired old darkey who has lost all track of his age, to the pickaniny are called into employment during the harvest. The cotton is gathered into bags suspended from the shoulders of the picker—[and] is spread out and dried—and separated from the seed. Every plantation of any importance has a gin of its own where the cotton is passed through revolving saws that separate the cotton from the seed and then pressed and baled for market. The weight of a bale of cotton is 400 to 600 pounds.[10]

The size of the average cotton plantation in the Delta ran from fifty to two hundred and fifty acres and nine-tenths of them were farmed by black tenants who rented them for from three to six dollars an acre. The total cost to make 1,400 pounds seed cotton or 450 pounds lint ready for market was twenty-two dollars and fifty cents or five cents a pound. In 1895 cotton lands that were sold before the war for fifty to one hundred and fifty dollars an acre were bought at five to fifteen dollars an acre.

The Ferguson plantation was deep in the Mississippi Delta country in Washington County. To visit there, Walker took a steamboat five hundred and thirty miles from New Orleans to Greenville, then an unimportant post village. General S. W. Ferguson had a town residence in Greenville on the corner of Broad and Central (demolished). Little "Miss Percy," the general's daughter, was named after Leroy Percy, his friend and

14
John Jenkins Bradfield
Fishing in Grant's Canal
L.r.: W. A. Walker Pinxit, n.d. [*c. 1885*]
Oil over photograph, 8⅜ x 5½ inches oval
Present owner: Mrs. James Bernard O'Keefe, New Orleans (granddaughter of the subject)

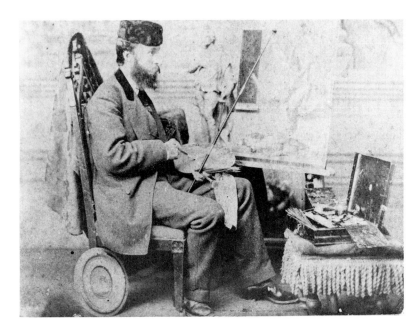

15
Photograph of Walker painting.
On back of this photograph of
the artist at the easel is written
"Vicksburg, Mississippi."

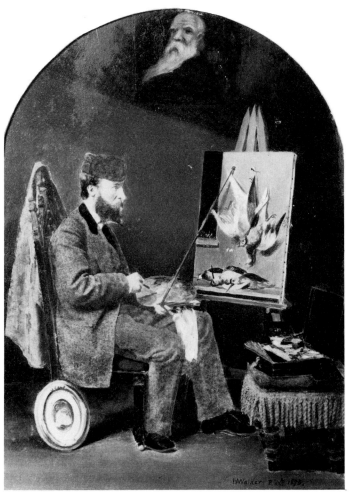

16
Self-Portrait
L.r.: W. A. Walker Pinxit 1873
Photograph with oils added,
5½ x 5½ inches
Present owner: Felix H. Kuntz,
New Orleans

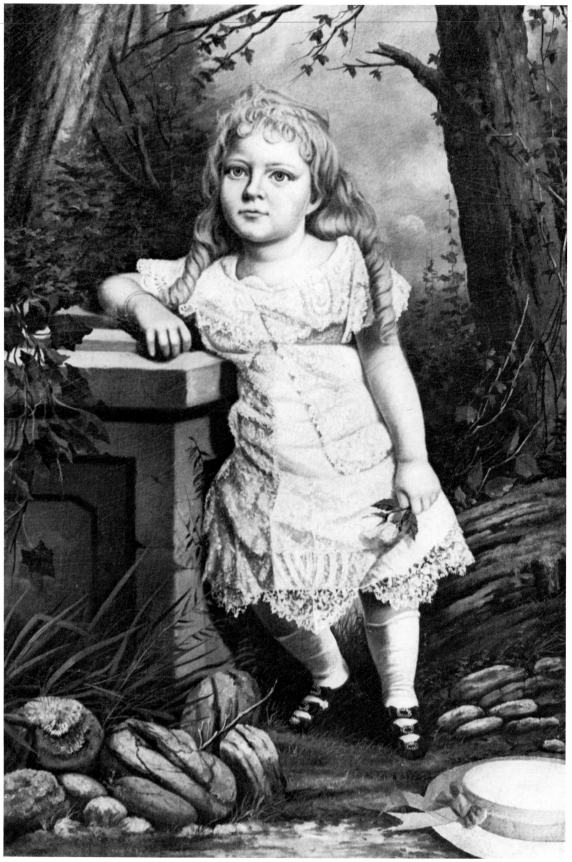

neighbor. Walker painted a portrait of "Miss Percy" at the plantation in 1882 (fig. 17). (The autobiographical *Lanterns on the Levee* by Percy's son William Alexander Percy describes the vicinity which Walker sketched and painted.[11])

Walker had other friends and acquaintances in Greenville. His painting of "Banana Peddler on the Streets of Greenville, Mississippi" found its way to Keokuk, Iowa, where it was sent to the Honorable C. F. Davis by the Reverend Joseph Bogen of Greenville in 1883.[12]

Always anxious to compare the fishing in any location to that of the Florida east coast, Walker usually went to Biloxi in the spring or early summer. Occasionally he was the guest of his New Orleans friends, the Aristide Hopkins, or he stayed at the Magnolia Hotel. He described Biloxi in April of 1905 in a letter to Dr. Diehl:

This place is very pretty and much improved also, bus, Trolley cars, Yacht Club, Theater and many lovely homes with the grand old oaks on the lawns, quite a little city. I have a fine cool room on the beach at the Magnolia—fine view of the gulf and Ship Island, 13 miles away, only rooms rented and I take my meals two doors away . . . , fine table, pleasant company. . . . I have not been fishing yet, but am now rigged up and expect an old friend soon who will keep house here to fish with, fine old sport from Charleston who has spent much time here. . . . It has been very hot here, but the seabreeze comes daily and I am content; it is pleasant now, cooler. The gulf air is softer than the Atlantic, but the lovely S. E. trade-wind at Ponce Park is a tonic and the climate there is much cooler.[13]

After the turn of the century, Walker's trips to New Orleans became less frequent, for he found urban life of the twentieth

17
Portrait of Miss Percy Ferguson (Greenville, Miss.)
W. A. Walker, 1882
Oil on canvas, 50 x 30 inches
Present owner: Dr. Luther C. Martin, Summerville, S.C.

This painting of the daughter of General Samuel W. Ferguson was painted at Ditchley Plantation near Greenville, Mississippi

18
Canal Street in the early 1900's as described by Walker.
Photograph courtesy of Tulane University Library

18

century distasteful. During his last trip to New Orleans in June of 1905, he wrote to Miss Katie Diehl:

I spent one month in N. O. Never have I seen such a great change in a city in 8 years! Improvements everywhere, Canal St. crowded all the time, people walk fast now, trolly [*sic*] cars flashing by on 4 tracks, business and bustle everywhere, skyscrapers, new hotels to be soon built and immense railway terminal to be erected, also department stores, etc. It is no longer the quiet, easy going city of a few years ago, but one of progress, and is destined to be a great city, it is now a big one. It is all fine and progressive, but alas, it was pleasanter to me in the olden time (fig. 18).[14]

North Carolina and the Final Years

The resort areas of western North Carolina attracted Walker after 1875. He liked the moderate summer weather and the outstanding scenery of the Asheville area. Always looking for clients and a comfortable living, he knew that this location appealed to the well-to-do from such diverse sections of the country as New England and the Deep South. As was his custom, Walker produced at a rapid pace substantial numbers of his small paintings of rural subjects and sold them almost as quickly. A larger plantation scene showing laborers in a tobacco field suggests continued visits to friends living on the great North Carolina tobacco farms (Plate 22). Additionally, he entertained the guests at such resorts as the Bonnie Crest Inn, which he referred to as his "camping ground." He preferred the inexpensive rates and the home atmosphere there, where even the kitchen inspired his painting, as seen in an interesting *trompe l'oeil* of a smoked ham on which is inscribed "Bonnie Crest Inn, 1878." However, he did not fail to meet the guests at the Haywood White Sulphur Springs where the quiet, more elegant groups congregated and where Woodrow Wilson and his first wife spent their honeymoon. The Battery Park Hotel opened in 1886 when the railroad was completed from Spartanburg to Asheville. It attracted such celebrities as Mr. and Mrs. Grover Cleveland. The famous Biltmore House brought more and more foreigners and wealthy people after 1895. They were often quite charmed with Walker's work, which they considered "quaint," the kind of thing to take home to remember the trip South.

Edward King, a Northerner writing for *Scribner's*, described the Asheville area as he found it in 1875. Landmarks and rivers mentioned by King are found in Walker's sketchbooks.

From [the Eagle Hotel] the Asheville stages ply over all the roads west of the Blue Ridge. In the valley where Asheville lies the capri-

cious "French Broad" receives into its noble channel the beautiful Swannonoa, pearl of North Carolina rivers. Around the little city, which now boasts a population of 2,500 people, are grouped many noticeable hills; out of the valley of Hominy Creek sombre Mount Pisgah rises. From "Beaucatcher Knob," the site of a Confederate fort, overhanging Asheville, the looker to the southwest will see half a hundred peaks. Asheville Court House stands nearby, 2,250 feet above sea level, and the climate of all the adjacent region is mild, dry and full of salvation for consumptives. The hotels, and many of the cheery and comfortable farmhouses are in summer crowded with visitors from the East and West, and the local society is charmingly cordial and agreeable. Asheville is the central and chief town of Buncombe County. At Asheville we were once more in a region of wood and brick houses, banks, hotels and streets, and although still some distance from any railroad, felt as if we had a hold upon the outerworld. The 44 miles from Asheville to Wolf Creek form one of the most delightful of mountain journeys.[1]

In the 1870's when Walker first began going to the Asheville area, he went by stage from Greenville, South Carolina, passing through Flat Rock and Hendersonville, North Carolina. Then in 1880, the railroad was finished; Walker could make the trip more easily, as could the tourists and the coterie of Charlestonians who built a colony of summer homes in the vicinity of Flat Rock. He traveled on the Southern Railroad to Fletcher's Stop where the Fletcher family had a resort farm and inn. His arrival was awaited with pleasure by the inhabitants of the area. Traditionally, he began singing operatic arias at the top of his voice as he walked up the path toward the lodge from the little country railroad station (figs. 1, 2). Sometime later the porter from Arden Park Lodge would go to the

1
Washday
L.l.: W. A. Walker, Sept. 21, 1908
Oil on board, 9½ x 12 inches
Present owner: Mrs. W. H. Cogswell III, Charleston
Walker passed this scene walking to Arden Park Lodge from the railroad station. This late North Carolina cabin scene was probably painted from life. It illustrates a new approach to his traditional subject.

2
Woodland Scene at Arden, North Carolina
L.r.: W. A. Walker, September 21, 1908
Watercolor on paper, 10½ x 7½ inches
Original frame and backing. Sticker: "Standard Photo Supply Co. Ltd. Eastman Kodak Co. Picture framing. 125 Baronne Street, New Orleans"
Present owner: Mrs. W. H. Cogswell III, Charleston
This is the path Walker took to Arden Park Lodge.

station with a cart for his luggage. Mrs. E. L. Shufford, formerly Elsie Beale, daughter of the lodge owner, recalled that although Walker had a good singing voice, it was often too loud and off key as he got older. Nonetheless, his songs were popular with the children and his entertainment added to the attractions there.

Walker had met Charles Beale of Arden, North Carolina, at Ponce Park, where they became fishing companions. In the summer of 1884 Beale invited Walker to be his guest at Beale Manor. From that year Walker became artist-in-residence at Arden Park Lodge, owned by the Beale family, and he used the lodge as a base of operations from which to seek clients among the many tourists who summered in the western part of the state. Walker described Arden Park to Dr. Diehl in a letter soon after his arrival in June, 1904:

I came here on 16th much improved in health for the dry pine laden air of Summerville [Georgia], much sleep and good *late* dinners, plenty of fresh milk from Jersey cow and good rest and fresh vegitables [*sic*] recuperated my old anatomy very much, and the pleasure of being with my folks [referring to his friends, the Beales] counted for much.

Everything is lovely here, and I am delightfully installed in my former room which is large and pretty *quiet*. The table is exceedingly good, good cooking and variety, and plenty of fresh vegitables [*sic*] which I enjoy hugely after so much tin goods [on camping trip in Florida]. It is quite cool night and morning for me and we sat by fire last night. Two of my friends are building pretty cottages very near the hotel, and another is going to build, all Charlestonians, so I will have more pleasant houses to visit at. Society is fine here, as many nice people have permanent homes nearby, all of whom I visit.[2]

Walker regularly arrived in Arden during the first week of June and left by the 10th of September, continuing his annual trips for thirty-six years until the lodge burned in the fall of 1919 (fig. 3). Then he moved back to Beale Manor with the family.

Charles Beale, Walker's good friend, was one of the better-known personalities of his time in North Carolina. Princeton educated and interested in the arts, he had one of the finest libraries in North Carolina. He was the author of several books, including *The Ghost of Guir House* and *The Secret of the Earth*. His wife Maria from Richmond, Virginia, was a renowned North Carolina hostess at Beale Manor, who also wrote a book, *Jack O'Doone*.[3] Besides enjoying the company of the senior Beales, Walker found painting companions in their daughters, Bertha and Elsie.

Many of the guests at Arden Park Lodge returned yearly, and the ledger of the lodge is interspersed with Walker's poems

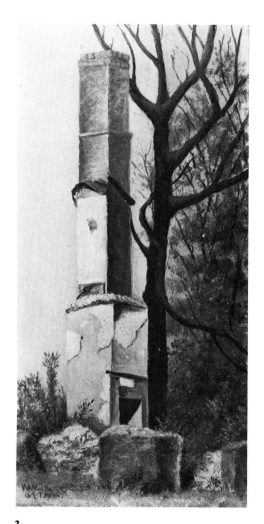

3
Ruins, Arden Park Lodge
L.l.: W. A. Walker, Oct. 1, 1919
Oil on academy board, 12¼ x 6⅛ inches
Inscribed on back: "Chimney and Charred Tree, Arden, N.C., $15.00"
Present owner: Herman Schindler, Charleston

about the various guests, written prior to their expected arrival. When the guests checking in signed the ledger, they would see the humorous description of themselves. The ledger for 1903 records Walker's arrival on June 23. At the bottom of the page are his comments on other guests to arrive soon.

> "Little Annie from the 'Inn'
> As cross as any bear,
> With Professor Moore, who's feeling sorry
> A pretty looking pair.
> There's Harold with his lady fair
> A combin' hard to beat
> Of horses black, they have a pair
> But a very little seat." [4]

Walker's longstanding friendship with the family of Captain C. C. Pinckney of Charleston also gave him pleasure at Arden. The Pinckney's had a summer cottage there, and Walker passed many evenings playing the piano for Mr. and Mrs. Pinckney, their daughter, and two sons. Sallie Pinckney Burton recalled that he "often announced his arrival at our cottage in Arden by playing the 'Monkey Dance,' and if we were playing outside, we would all dash into the house and start dancing to his music much to the delight of all." The artist left his paraphernalia at the Pinckney cottage while he traveled elsewhere, and he gave the family a number of North Carolina landscapes of subjects in the Arden area.[5]

As the years passed, Walker became more and more dependent upon the peace and quiet at Arden and Ponce Park and upon his friends in those places. The two country lodges became places of refuge from the bustling efforts of the Southern cities to make economic progress. Furthermore, the familiar old city hotels were being replaced by new ones which brought visitors whom Walker did not find attractive and who did not find his work appealing. They preferred to buy cheap reproductions of the European masters. The hurricanes of 1906 added to Walker's problems by causing some of the Gulf Coast resorts to close permanently. Others, like the Magnolia in Biloxi, remained open but deteriorated and lost the monied clientele upon whom the artist was dependent. Because by 1895 most of his Baltimore friends and some in New Orleans had died, he no longer returned to Baltimore, and he seldom went to New Orleans.

Letters written after 1900 indicate general disillusionment with twentieth-century life and specifically with the ill manners and bad taste of tourists. The letters indicate loneliness, seclusion, and despondency as he grew old and unable to travel.

I gave up my idea of visiting the St. Louis Fair [where his work was exhibited in the New Orleans section]. I spent part of October at home in Charleston and here [Ponce Park]. I am very much engaged making sketches on the beach and sand hills every day, which I want to finish before it gets too cold. It is pleasant work. But alas, it is very dull. I—the only boarder, and I miss society and many things, but business is business you know, but I call in my philosophy and bear it. I come up to my room right after supper to read my N. Y. Daily Times and remain there until bed time.[6]

Walker began to lose his hearing in 1904. He commented upon this condition in a letter to Dr. Diehl. "I can fancy the sort of *music* that Nettie [Pacetti] will extract all the time out of that instrument of torture. But deafness is sometimes a blessing. I am afraid that piano will be a great nuisance next season to one of my musical cultivation."[7] A few months later, he referred to this problem again. "Being partly deaf and having no megaphone, my conversational talent was restricted to my neighbor Col. Piper."[8] In 1908, though, his hearing began to return.

In spite of the fact that Walker limited his travels primarily to Arden and Ponce Park and a return to Charleston in the fall, there is evidence that his paintings continued to be distributed. Although they were not exhibited after 1908, he corresponded with his various agents by letter, sending them the postcard-size scenes of Florida, the Isle of Palms, and Edisto Island. William Schlaus of New York and Walker's friend Robert Stanley Green in New Orleans sold his paintings long after his death. They reached many areas of the country by means of the friends he had met in the South. "Wrote Henry Young, Providence, R.I. yesterday, enclosing 'Putting the Sallie in Commission' which I know he will enjoy."[9]

Apparently the same "H. A. Young" also received paintings in San Diego from Walker, and Walker's work has since appeared in San Francisco and Sacramento. Paintings were sent to his friends, the Diehl's, in Louisville. Sometimes Walker's friends served as informal agents and placed works in their business houses or with other friends' establishments. Acquaintances from Chicago, Knoxville, Tennessee, and San Diego whom he met in Arden Park also helped in this manner. Rowlinski continued to handle his paintings in Savannah. Paintings were displayed in galleries, frame shops, photograph stores, and even in shops selling thread and sundries and cosmetics.

After 1900 Walker continued to paint his traditional cabin scenes from sketches, but he considered them a necessary pastime as indicated in a letter to Dr. Diehl dated June, 1912:

"I have had a good rest [in Charleston] and want to get to work again. I have done some sketching on the little Cabin pictures [which] I will paint in the mountains—in my room there, but want to settle down to *real* work." [10] Besides the cabin pictures, he painted many of the small Florida landscapes in Arden, using sketches made the previous winter. Since he was spending more and more time on the Florida east coast rather than traveling through the plantation country, these small landscapes became more numerous, and he painted fewer and fewer genre portraits. Indeed, these small genre scenes were not the salable item in the twentieth-century that they had been earlier. This, combined with his relative seclusion, caused Walker to change his subject. The "real work" which he hoped to begin was a series of mountain landscapes, woodland scenes, and careful nature studies. He abandoned the human figure, and changed even his traditional cabin scenes and Florida landscapes.

There were few Negroes in the hills of western North Carolina, but Walker became intrigued with the small farms of the Southern mountaineers. These highlanders of Scottish and Irish descent lived in log cabins and barely survived on the small farms, raising just enough wheat, corn, vegetables, and livestock to supply themselves. Even in Walker's day these people were a curiosity, a separate culture whose idiom and customs were feudal. Self-sufficient, even with his limited resources, the mountaineer shod his own mules, cobbled his shoes, and made his liquor. If he needed help in building a cabin, kitchen, or outbuilding, he had a "working." But the mountaineers were isolated even from each other on their mountain farms. Walker's paintings of this subject are particularly successful (fig. 4).

Looking down on the farms from the hills, Walker painted large vistas rather than limit himself to the immediate cabin with the closest field. The highland cabins, though as rustic as those of Walker's log cabins of Negroes, often had ell wings to the rear with a kitchen and sturdy lean-to porches or galleries. Walker painted wood pickets and paths downhill to the road. He occasionally included a bonneted woman working the fields with a hoe, sitting on the front porch, or working with the laundry. There was little interest in the individual person; no studies of the physical characteristics of these unique people were done by Walker; and he never painted them at play.

At the same time, after 1912, a series of North Carolina landscapes reveal an intensification of colors. He also began

to apply paint with more freedom. More frequent scenes of woods, forest, and trail indicate long lonely walks through the woods (fig. 5).

North Carolina flower and nature studies of the same period from 1910 until his death also reflect Walker's fresh viewpoint. They show continued interest in the visual image, but there is a new, more sensitive use of color and line and an originality of composition in the oil paintings. Groups of leaves, flowers, and seeds were selected for their visual impact; exaggerations and derivations from nature were made for design (fig. 6). Always a painter of the particular rather than the general, Walker concentrated on the smallest and most obscure details from nature—the ferns, mushrooms, and epiphytes. An interest in the secret, quiet depths of the woods reflects, perhaps, the loneliness of the old gentleman in the swift new life of the twentieth century.

Throughout his life, Walker's work had reflected the wide range of his interest and versatility. But there was never a maturation of style; rather intermittent bursts of more serious and sophisticated work, the quality of which depended largely on the purpose of the painting—whether it was a commission or a quick sale, whether it was a new subject which intrigued him or a version of an earlier study. The body of work done after 1904 can be considered a genre separate and apart. For the first time, Walker was relieved of the necessity of making a living. He chose pictorial material for its own sake, and his painting became freer and more relaxed. Love of nature had always been evident in the pictorial detail of each canvas; but these late paintings reflect more clearly the artist's intimate involvement with nature.

He did some of this late work in Charleston, where in 1912 he made his home with the family of his nephew George (figs. 7, 8), who lived a block and a half from the Ashley River. He found his new living arrangements quite satisfactory according to correspondence at that time.

My time has been most pleasantly passed here as I am living in a beautiful house with large rooms, electric lights throughout and gas for cooking, and my nephew and his wife are devoted to me and so are his nice children, and vie to make it pleasant. We go to bed at 12 o'clock or after, quite a change from Pacetti House, breakfast at 8:30 (Sundays at 10) and dine after 3, suits me fine. The lot is over 100 ft. wide and 270 feet deep, flower and vegitable [*sic*] gardens and fruit and shade trees, one of the largest lots in the city, one block and a half from the Ashley river so get all the breezes. I had my three pretty nieces and the father and mother of two of them for a Theatre party one night and felt pleased to escort such a pretty, beautifully dressed party.

I have two *good* games of whist a week which I enjoy heap

4
**North Carolina Homestead
with Mountains and Field**
L.l.: W. A. Walker, n.d. [c. 1897]
Oil on board, 10 x 12 inches
Present owner: Mrs. W. H. Cogswell III, Charleston

This landscape with cabin was painted from life and is completely different from Walker's commercial cabin scenes. The unusual cabin has two connecting wings and two chimneys. The barn is a distinctive feature, and the straight chimneys and the particular location of figures in the scene are also unique.

5
Forest with Ferns and Mushrooms
L.l.: W. A. Walker, Sep. 17, 1910
Oil on board, 7 x 12½ inches
Present owner: Edward Hall Walker, Charleston

This late painting illustrates the artist's use of pure color in the last years of his life. The forest does not recede into earth-colored shadows, but remains bright.

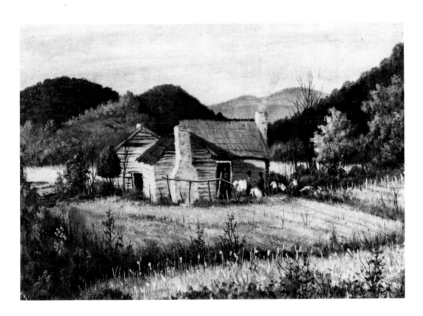

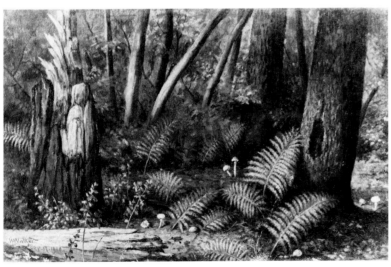

6
Still Life Acorns and Oak Leaves
On back: W. A. Walker, Biloxi, Miss., 1905
Oil on board, 12 x 9 inches
Present owner: August P. Trovaioli,
Grand Bay, Ala.

This painting was hung by Walker in the
Magnolia Hotel in Biloxi. Leaves of the
mountain maple and red oak and red oak
acorns were chosen for their decorative
quality. The acorn cups are exaggerated
for visual impact as are the decorative
aspects of the leaves and acorns.

much. My nephew's eldest boy is a cadet at the S. C. Military Academy—the "Citadel"— a fine institution and the Col. Commandant is a friend of the family so we have him in our whist games, a very agreeable gentleman.

My niece and I went to view the dress parade of the cadets Friday afternoon and saw it from the window of Col. Bond's office in the Citadel who entertained us. I was much interested as they are a fine body of young men, over 200, and stand very high in their drill. Their band is composed of cadets, 25 in number, and the boys get a splendid education at the Academy. . . . We have had a delightful month of May, and the flowers and shade trees made the old city look lovely and the many magnolias perfume the air, we have the latter in our garden.

As long as he could, he continued his sketching trips.

I made three trips to Isle of Palms the seashore resort just beyond Sullivan's Island, via ferryboat and Electric railway, and made a lot of sketches of scenery very similar to that of Ponce Park that I painted last season only far greater number of Palmetto trees on the hills and the beach and surf is fine. I can sell them next season, thereby inflating my purse. We had a picnic there one day, a fine dinner, and staid [*sic*] until 10 P.M. at the Friday Night Stop.

Sullivan's Island is a mass of fine fortifications, and fine new officers quarters and new barracks have been erected, and soldiers much in evidence, looks quite military.[11]

A letter dated June 4, 1919, describes what were to be his last days at Ponce Park. The address he left with Mrs. Pacetti showed a temporary change from George Walker's home to that of another nephew for the short stay. He was also looking forward to the summer in Arden and the lodge. After the fire later in 1919, his trips were confined to short visits at Beale Manor or to see Captain and Mrs. C. C. Pinckney.

I will leave for Charleston, S. C. #9 St. Michael's Place tomorrow 5th on the 10:13 A.M. train and Mr. Linquist will take me over to New Smyrna. Next week I will go to Arden for the summer.

My table board for last four weeks will be due tomorrow so I send you my cheque for the amount $40.00 and hope this will reach you safely.

We have had a great deal of heavy rain and wind since you left, clear this morning at last, but clouded up again [at] 3 P.M. The breeze is cool, East or SE but not out of it and the mosquitos have arrived. I hope you are having a pleasant time. I have just heard from a friend near Arden that the Spring has been quite cold and I have ordered some wood for my room at Arden.[12]

In 1919, Mrs. Pacetti died and Walker discontinued his trips to Ponce Park completely; that same fall Arden Park Lodge burned to the ground. He had spent thirty-one winters in Florida and thirty-six summers at Arden. Walker was still corresponding with his dealer in Savannah in 1919. But work slowed surely. His last sketch was a North Carolina landscape dated October 15, 1920, painted when he was eighty-two years

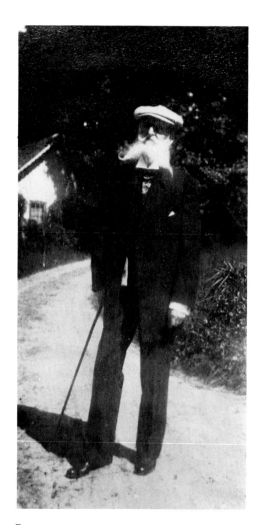

7
Photograph of Walker in Charleston where he lived comfortably with the family of his nephew George. A self-portrait (fig. 8) done soon after this photograph was taken demonstrates the increased skill of the elderly artist.

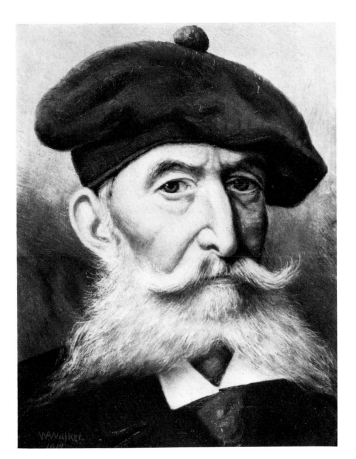

8
Self-Portrait
L.l.: W. A. Walker, 1913
Oil on board, 12¼ x 9½ inches
Original frame and backing with
Lanneau Art Store sticker
Present owner: Mrs. W. H. Cogswell III,
Charleston

9
Arden
Unsigned, Oct. 15, 1920
Present owner: Mrs. W. H. Cogswell III,
Charleston
This is the last documented
drawing by Walker.

old (fig. 9). He became ill in Charleston three months later, died on January 3, 1921, and was buried at the Magnolia cemetery.

Walker left an estate of over $12,000 to his nieces and nephews, and distribution of his effects reflects the way he lived.[13] Cash was deposited in the Atlantic Savings Bank in Charleston and in the Planters Loan and Savings Bank of Augusta. Trunks and paintings were left in Ponce Park and in Charleston, and there were thirty-six paintings on consignment at the Standard Photo Company in New Orleans. George Walker, his nephew and estate administrator, appraised the one hundred and ten paintings left to the family by Walker at $684.

The modest sums Walker received for most of his work and the amount of money he had at his death attest to the vast numbers of paintings he did during his long career. In the following sections many of these paintings are organized in terms of three major aspects of his work.

Walker's intense interest in using Negroes at home on the land as subjects for his paintings is completely understandable. The world of the black man was a strange, foreign, and mysterious subculture in the South of Walker's day—a fascinating subject in its own right. And Walker, a native Southerner who found himself fighting in a brutal war caused, in part, by the problem of race, found attractive subject matter, both before the war and afterward, in the blacks he saw occupied in a peaceful and pastoral agrarian existence. While still aware that a world had collapsed that would never be put together again, Walker sought out the one area, the land and its workers, where, as soon as the stirring was over, there was a quiet time and things went on as before. Painting this stable force within the Southern tradition afforded him a comforting continuity needed to counteract his loneliness and confusion in the postwar South.

Walker could capture a feeling of belonging only on the land and among the unchanged workers of the soil. Certainly the status of Negroes had changed and was changing, but in fact their daily lives on the large plantations where Walker went was altered very little. They continued living close to the earth, their manners and tastes evolving very slowly as the urban areas of the New South emerged. As Walker disliked more and more the hustle and bustle of crowds on city

The Negro in Walker's Art

streets, his affection for the land and the families who worked the land increased. Walker's cheerful disposition helped him seize every chance for joy and pleasure and forget sorrow and hardship by substitution. His world was indeed "magnificent," and to him the paintings were suggestive of pleasant times.

Showman that he was, Walker also clearly understood and took advantage of the mystique of blacks as subjects for his paintings. The Southern composers Stephen Collins Foster and Edward Moreau Gottschalk were similarly aware of the unique qualities of Negro music and incorporated these into formal compositions. For comparison, a survey of Walker's predecessors who painted Negroes and a look at the variety and quantity of Walker's work will help us appreciate his unique contribution.

Walker's most noted predecessors were not Southerners. William Sidney Mount was from Long Island, New York, and James Goodwyn Clonney painted in Binghamton, New York. Eastman Johnson of Lovell, Maine, painted "Old Kentucky Home" in 1859, one of the most popular paintings of American Negroes. However, most of these paintings and similar genre treatments by Americans were painted within the framework of the European art vocabulary. The rustic American subject, whether painted in the style of a Dutch seventeenth-century work, composed in the mode of Gleyre's Paris studio, or rendered in the Dusseldorf and Munich manner, is not as forthright and effective a statement as a painting by Walker.

Thomas Hovendon, Thomas Waterman Wood, who painted in Baltimore, David C. Blythe of Pittsburgh, F. T. Merrill in New England, and somewhat later, Henry Ossawa Tanner included Negroes among their subjects.[1] There are scenes beginning to reappear in the United States and abroad by J. Malchus, Harry Roseland, Edward Lamson Henry, Edwin Forbes, and Frank Buchser. John Pemberton and Charles Le Sassier are relatively undocumented artists whose primitive genre scenes painted in the 1890's are housed in the Louisiana State Museum in New Orleans.

The works of many Southern artists who painted Negroes have not yet been recognized and remain undocumented and in private hands. Among known paintings, George David Coulon's portraits are notable;[2] he is one of the few New Orleans painters whose sensitivity to the subject approached Walker's. Andres Molinary's "Servants of Jefferson Davis"[3] recalls Walker's "Calhoun's Slaves." Both Coulon and Molinary were friends of Walker. Although they did numerous paintings of Negroes, they are best known for their landscapes.

Auguste Norieri, noted for his steamboat subjects and marine paintings in New Orleans, was also among Walker's contemporaries and acquaintances who painted portraits of Negroes. A painting by Everett D. B. Fabrino Julio in the W. E. Groves Collection in New Orleans is perhaps the most sophisticated treatment by a New Orleans artist yet documented. Charles De Lesseps and Bror Anders Wikstrom illustrated Negro scenes in New Orleans in *Arts and Letters Magazine,* and both William and Ellsworth Woodward were painting and making prints of rustic subjects around the turn of the century. Amy Bemiss and William Buck, the Norwegian-American landscape artist active in New Orleans, also have Negro studies in *Arts and Letters.* Charles Wellington Boyle, who exhibited with Walker in New Orleans, included blacks in his landscapes. Leon J. Fremaux's New Orleans character studies in watercolor were published by Peychaud and Garcia in 1876. Francisco Vargas, a Mexican who had traveled to New Orleans for the great Exposition in 1883, remained there, executing wax figurines of the various types of blacks on the streets. Emma Chandler was painting Negro cabin scenes and small Negro portraits in the 1890's in Pensacola, Florida, an infrequent stop on Walker's circuit. Even Andrew John Henry Way of Baltimore did small paintings of Negroes. Way's private scrapbook, housed at the South Carolina Historical Society, is an important source for Walker material since Way kept clippings from the Baltimore *Sun* about Walker.

Of the nineteenth-century artists who painted Negro genre scenes, the one whose works most patently resemble Walker's is an obscure illustrator for a book published in Edinburgh in 1891, *Wild Sports in the South* by Charles E. Whitehead. P. Frenzeny, as the illustrations are signed, painted cabin scenes in watercolor, but the characteristics of the cabins and the inclusion of figures, laundry, possum hides, and palmettos are so close to treatment by Walker that contact between them or Frenzeny's familiarity with Walker paintings is almost a certainty.

Among Walker's contemporaries who painted Negroes, Winslow Homer is the best known and most outstanding. He became interested in Negro life when he traveled South as a reporter during the Civil War. His preoccupation with the subject parallels Walker's in that he studied it over an extended period of time. While Homer's concern was broader in scope and his talent greater, Walker, of course, painted a far wider range of the life of the black American.[4]

Numerous paintings have been sold through the years as Walker's work and otherwise attributed to him. Small por-

traits with a "W. A. W." signature have appeared on the market. Because the artist ceased to use his initials after 1868, many twentieth-century pieces dated later and signed "W. A. W" are clearly fakes. Walker's small Negro portraits were also copied during his own lifetime and during the decade after his death. One group of these is inferior in quality. One way to detect them is to notice whether the dress and anecdotal characteristics extend beyond Walker's treatment as based on his own photographs. Some direct copies of Walker's work were made, but the copyists failed to use Walker's method of laying a ground of sienna, overlaying an agricultural field and sky, and adding figures afterward. Paintings done in New Orleans by the amateur artists with whom Walker worked and painted are also often erroneously attributed to him. These works were painted purposely in the style of Walker by his admirers like Blanche Blanchard, and only careful comparison to Walker's painting makes clear that the works are not Walker's. Some scenes in this category even have characters sporting the same hat and dress appearing in the paintings by Walker (figs. 1, 2).[5] Unfortunately paintings of Negroes by noteworthy American artists like E. L. Henry are not recognized for their own value, but are sold as Walkers, sometimes with a new Walker signature and at times by incorrect stylistic attribution (fig. 3).

The well-known illustrators of the Negro subject for Currier and Ives include Louis Maurer of New York, one of the first to have his Negro genre scenes reproduced. It may well be that neither he nor Arthur Fitzwilliam Tait had serious knowledge of the subjects they painted. Maurer said that neither he nor Tait, with whom he did a series of American Indian prints, gathered any firsthand knowledge of Indians. Instead, they researched at the Astor library. The same may be true of their prints showing Negroes. John Cameron is noted for his propaganda prints like "Re-Construction" printed in 1868. Fanny Palmer was one of the most prolific artists to work for Currier and Ives. English by birth, she came to New York and never left the area, although she is responsible for more of the Mississippi River and steamboat treatments than any other artist who was published by the company. "Low Water on the Mississippi," a typical print, features a Negro cabin and a celebration taking place with children dancing to banjo music.[6] One wonders where Palmer found her inspiration. Thomas Worth, Walker's New York contemporary, was responsible for the famous Darktown comics in which the artist showed many aspects of Negro life and dialect, sometimes with comic treatment and sometimes

with more realism. Never a full-time employee of Currier and Ives, Worth was an illustrator for *Harper's.*

He and other illustrators for the great publishing houses of New York helped to popularize Negro subjects. A. B. Frost and E. W. Kemble, illustrators for D. Appleton and Company and *Harper's,* are best known for their illustrations of Joel Chandler Harris's "Brer Rabbit, Uncle Remus and Others," "Daddy Jake, The Runaway," "The Chronicles of Aunt Minervy Ann," and others.[7] Frost was a Philadelphian born in 1851; his illustrations are synonymous with Southern local color literature. Kemble, born in California in 1861, also illustrated works by Mark Twain, Irwin Russell, and Sherwood Bonner, making numerous notable drawings of country Negroes. Suzanne Gutherz, another interesting illustrator of dialect tales of the early 1900's, illustrated Mrs. James H. Dooley's *Dem Good Ole Times* (New York, 1906). F. L. Fithian of Philadelphia illustrated covers for *Puck, Judge, Colliers,* and *Saturday Evening Post;* his oil paintings are little known.[8] Of

1
**A Cotton Plantation near
Charleston, South Carolina**
L.l.: W. A. Walker, 1883

Chromolith, 21 x 29 inches
Present owner: Herman Schindler, Charleston

This print was published by Kitson Machine Company in Charleston as an advertisement. It is made from the same Walker painting used by Currier and Ives for their print, "Southern Cotton Plantation."

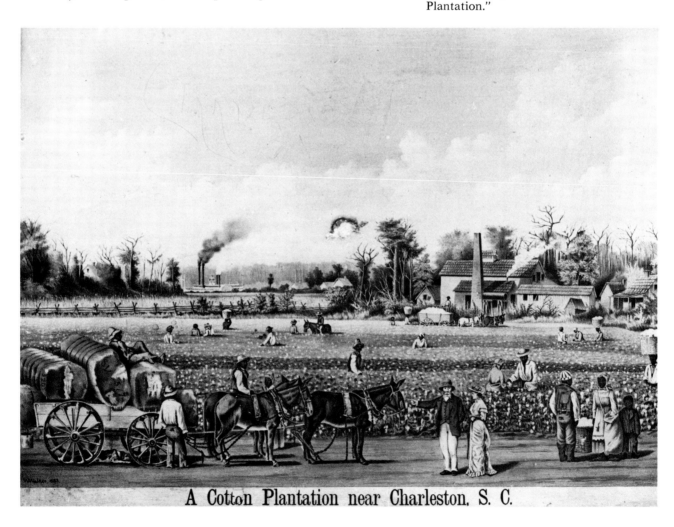

A Cotton Plantation near Charleston, S. C.

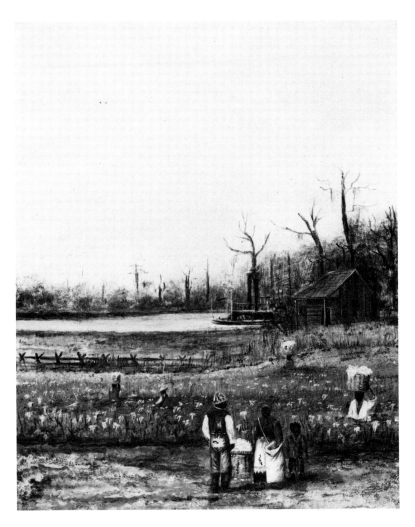

2
**Cottonfield with Bayou, Steamboat,
Road, Cabin and Fieldhands**
Unsigned, n.d.

Oil on canvas, 21¾ x 15½ inches
Present owner: Mr. and Mrs. Ray Samuel,
New Orleans

Compare this group of figures and the
background of this painting to a similar
group in the Currier and Ives Print of "A
Cotton Plantation" and "A Cotton Planta-
tion near Charleston, South Carolina"
(fig. 1), a chromolith in the Schindler
Collection.

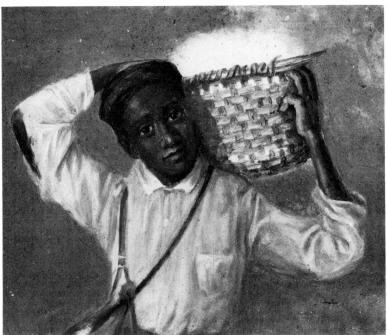

3
**Young Boy with Cotton Basket
on Shoulders**
Unsigned, n.d.

Oil on board, 4¾ x 6¼ inches
Present owner: Jay P. Altmayer, Mobile

This painting has been attributed to
Walker, but specialists have indicated
that it is probably the work of E. L. Henry.

a striking similarity to Walker's cotton plantation and levee scenes are two anonymous prints dated 1873 illustrating "A Phosphate Company Works" and "Chickens Crated for Shipping at the Levee in Cairo, Illinois," in *A Pictorial History of the Negro in America*.[9]

The Civil War brought the reporter-illustrators South, and these men often became intrigued with Negro subjects. After the war, the Northern public clamored for news of the South and its struggle for life and adaptation to an economy without slaves. *Harper's* before the war and *Scribner's* and *Lippincott's* after the war sent illustrators and reporters South; the latter two publishers were the first to seek out Southern authors, and their articles were illustrated by woodblock prints. David Hunter Strother was among the first traveling artists to capitalize on the rural Southern scene and Negroes in his articles which were illustrated by wood engravings made from his own sketches. Working under the pen name Porte Crayon for *Harper's Monthly*, he traveled in and wrote about the South from 1853 to 1858. He also illustrated books by Charlestonian William Gilmore Simms. Alfred and William Waud, Theodore Russel Davis, Lloyd Mifflin, James E. Taylor and Horace Bradley, illustrators for *Harper's Weekly*, made drawings similar in subject to Walker's "Charleston Vegetable Woman" (Plate 19).[10]

The vast amount of art depicting American Negroes for propaganda purposes, for anti-slavery publications, or to show later injustices, comprise a separate field and seldom bear relation to Walker's thought or work. The many prints on Negro life in the South, published to over-emphasize the bizarre or comic aspects of Negro life and physical appearance, such as the postcards copyrighted by J. H. Bufford's Sons, 1882, are also a separate genre.[11]

Color was Walker's forte; it is the effects of color that make his paintings successful. Using the methods of the portrait photographer, he symbolized the laborers' activity by presenting their fields, their tools, transportation and homes; the people are static, iconographic presentations, standing posed as for a time exposure (fig. 4). There is seldom communication between the figures in the scenes, but Walker tended to group entire families or husband and wife together in paintings and photographs. This tendency reflects, perhaps, his appreciation of the family unit among the tenant farmers (fig. 5).

Walker's genre painting is generally closer in spirit to the literary work of his period than to the paintings by his contemporaries. The dialect authors and poets were Southerners of background similar to Walker's, and like him they were sin-

4
I'll Stick to Cotton as Long as It Sticks to Me
L.l.: W. A. Walker, 1886
Oil on canvas, 48 x 24½ inches
Present owner: Herman Schindler, Charleston

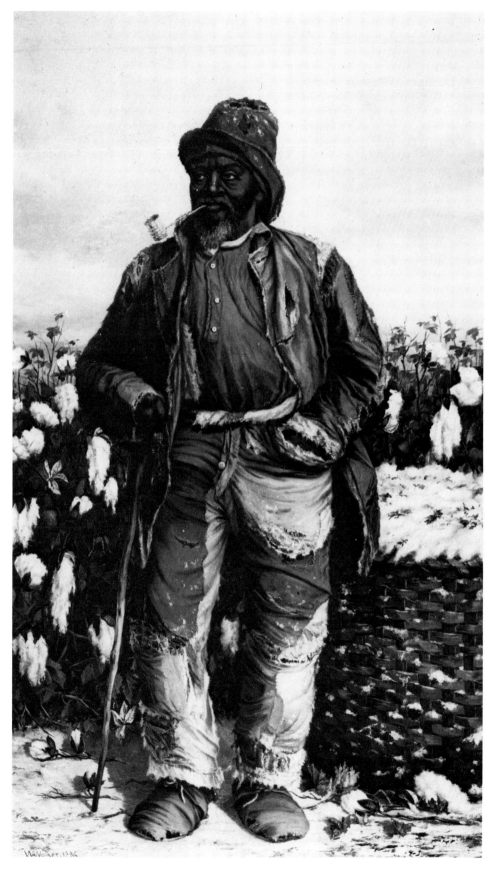

cerely interested in and fascinated by Negroes. Irwin Russell, in fact, treated Negroes in literature much as Walker was approaching them. Born in 1853 in Port Gibson, Mississippi, Russell was among the first Americans to capture Negro dialect and character in American literature. His work caught the attention of the New York publishing houses in the 1870's, when Walker's Negro character studies were at the height of their popularity.

Both Russell and Walker presented the "old time darkey," the free Negro who, having been trained in slavery, retained much of the apparent deference to the old regime in his behavior. The peccadillos of the Negroes were treated by artist and author with the same gentle humor, revealing their indebtedness to Dickens (fig. 6). Both also reproduced what they considered the innocent spirit and considerable amiability of their subject.

Walker's Negroes reflect the times of Virginia Frazer Boyle's "darkey" in "How Jerry Bought Malvinny." Tatters, rags, and labor seemed not to affect the overall pleasantness of Walker's presentation. Thomas Nelson Page wrote of "a goodly land in those old times," suggestive of Walker's attitude. The works of Sherwood Bonner, Mary Noailles Murfree, Joel Chandler Harris, and even George Washington Cable reflect an appreciation of the Southern homeland. A theme of nostalgia throughout lends charm to the literature. Walker's paintings are appealing in much the same manner; artists and writers alike seem to accept reconciliation of North and South wholeheartedly.

Scribner's, Puck, and *Appleton's* published Russell's dialect operetta and his poems. More important, the New Orleans *Times* published his work while Walker was in the city, and Russell returned to New Orleans in 1878 after working as an editor for *Scribner's.* At that time Walker was living in rented lodgings on Toledano Street, not far from George Washington Cable and Lafcadio Hearn. Cable's nephew, Walter Cox, was a member of the Southern Art Union with Walker. Samuel Clemens and Joel Chandler Harris came to New Orleans in April of 1882 to visit Cable when Walker was in residence. If Walker read Cable's "The Grandissimes" in *Scribner's* in 1880, he probably felt, like Russell, that the New Orleanian had overstepped the boundary of propriety in his treatment of Negroes.

Walker was an inveterate reader. Nearly every letter mentions that he spent some time each day reading. "I have never lost the art of entertaining myself (which few possess) and I find myself and reading, pretty good company."[12] He con-

5
Negro Family on Cabin Steps
L.l.: W. A. Walker, 1885
Oil on board, dimensions unknown
Present owner: Anonymous collection
Photograph courtesy of Alonzo Lansford, New Orleans

6
Policeman Spies Darkies Pilfering Cotton from Bales (New Orleans Levee)
L.l.: W. A. Walker, 1883
Oil on canvas, 6⅞ x 12¾ inches
Present owner: Anonymous New Orleans Collection

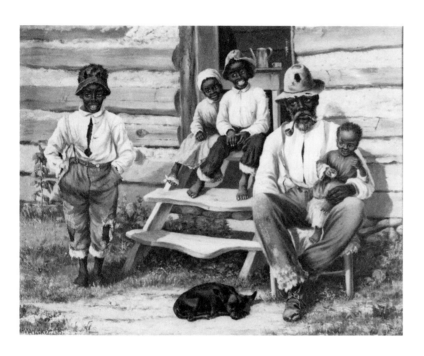

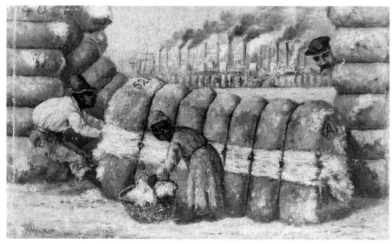

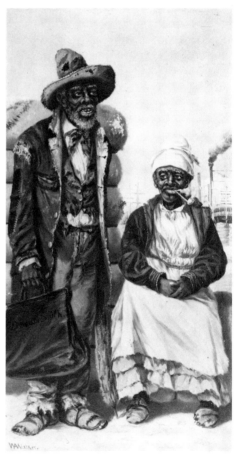

7
Whar am Dat Expersision? (New Orleans)
L.l.: W. A. Walker, n.d.
Oil on board, dimensions unrecorded
Photograph courtesy of
Frick Art Reference Library, New York

sidered himself abreast of the times in all aspects and prob-
ably enjoyed the dialect tales as they were published.

Sometimes he gave dialect titles to his own work. Occa-
sionally he wrote a title in oil across the painting itself, like
"Whar Am Dat Expersishun?" (fig. 7), which he sent to the
St. Louis Exposition in 1903, and "Whar Am De St. James?"
"Deacon Cuffy" is written on the suitcase held by one char-
acter in a portrait (fig. 8). When the names of the subjects
were especially colorful or meaningful, he inscribed them on
the backs of the paintings. Typical were "Old Uncle and
Auntie" and "Euphemia." One of his better-known titles is "I'll
Stick to Cotton as Long As It Sticks To Me," which he inscribed
on the back of the painting. On one of Walker's photographs
of Negroes is the notation which refers to the painting made
after the photograph, "Way Down South in the Land of Cotton,
32½ x 60, Sep. 1892 in La. State Building Exhibit, Chicago,
1893." Another painting inscribed "Chums Befo de Wah" sold
in Charleston, February, 1913, for $50.00. Walker's playfulness
surfaces in the caption "Primas Jones, Esq., Hotel Royal,
N. O.," for the Hotel Royal was Walker's own boarding house
(Plate 14).

Walker's paintings have been labeled as caricatures and
examples of condescending paternalism. These comments were
occasioned by the artist's choice of the preacher and deacon
types, his emphasis on the tattered clothing, and his use of the
corn cob pipe smoked by men and women alike. He also
painted Negroes holding the possum and the watermelon con-
sidered by some a symbol of ridicule (Plate 11). His inclusion
of Negroes in "The Bombardment of Fort Sumter" was con-
sidered by some critics a composition prop, and his portrayals
of Negroes in humorous situations disenchant some of today's
viewers. One reporter filed his interview from early 1950 con-
cerning the artist's Charleston work at the Gibbes Art Gallery.
A comment from this interview refers to a major Negro por-
trait which has been exhibited at the Metropolitan Museum of
Art. "——— has a dreadful one [painting] of darkies—quite
large."

Paul Laurence Dunbar, the Southern Negro author whose
dialect poems and stories were published in Boston in the
1880's and 1890's, emphasized the same sardonic or tragi-comic
aspects of Negro life in writing that Walker treated in his
painting.

> Whah's ol' Uncle Mordecai an' Uncle Aron?
> Whah's Aunt Doshy, Sam and Kit,
> An' all de res'?
> Whah's de gals dat used to sing an' dance de bes'? [13]

Dunbar's books were illustrated by photographs taken by the Hampton Institute Camera Club, in Hampton, Virginia. Any number of these photographs could be confused with those from which Walker made his paintings. There are in the group representations of men and women smoking corncob pipes in the cotton fields, doing the wash in front of leaning and collapsing Negro cabins; there are also photographs of the "deacons" and "Brudders" and the "Pahsons," as well as old men and women dressed in tatters and rags more outlandish even than Walker's paintings of the same types.

Essie Collins Matthews likewise wrote about the types of Negroes painted by Walker. *Aunt Phebe, Uncle Tom and Others*

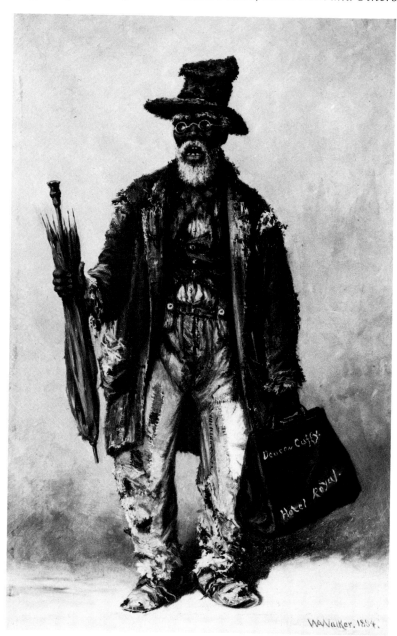

8
Gwine to Der Expersision
L.r.: W. A. Walker, 1884

Oil on board, 16½ x 11 inches
Present owner: Jay P. Altmayer, Mobile

The title is inscribed on the back by the artist. "Hotel Royal" refers to a fashionable boarding house in the French Quarter, New Orleans, frequented by Walker. Also, there is an advertisement for Green River Whisky with this same figure, Deacon Cuffy, standing by a mule. The saddle has a bottle of whiskey hanging from it; the ad is inscribed "Born and bred in Kentucky."

was published by the Champlin Press, Columbus, Ohio, in 1915 and was illustrated with her own photographs. Beside a photograph of "Aunt Charlotte," an old Negress dressed in rags, is the following interview with her on the docks of Savannah: " 'Is your old master living?' I asked. 'Lan' sakes alibe, no. Do you suppose if my ol' marster was living, I'd be standin' heah beggin for sumpin t'eat? no indeed. As long's he libed I had all I needed.' 'Didn't you leave him after the surrender?' 'Leave him aftah de what? I never left him aftah nothin, I stay wid my ol' marster till he died.' " [14]

In the tenant share-cropping system, the Negro worked the crop in return for housing, seed, and credit at the commissary store. A description of Georgia Negro shanties in a mill town in 1890 illustrates that life of the industrial South was rural in character, and there was little difference between Walker's sharecroppers' shanty and the mill's company-owned shanties. "Rows of loosely built, water stained frame houses . . . buttressed by clumsy chimneys, lined a dusty road. No porch, no doorstep even admits to the . . . quarters." "Outside was the inevitable martin pole with its pendant gourd," inside were "a shuckling bed, lucked out in a gaudy, patchwork, a few defunct 'split-bottom' chairs, a rickety table, and a jumble of battered crockery." [15] These were Walker's subjects and with his portrayal of them and interest in them, he preempted the entire sociological wave soon to follow.

If, under these conditions, the black peasant became bound to the soil, it was not from Walker's point of view an unattractive way of life. The Negroes had a home, family ties, and a living from the soil they tilled. Walker commented favorably on their "happy existence" in letters to C. H. King in Atlanta, and he invariably presented life in the Southern countryside as picturesque and charming. Walker's paintings reflect a quiet emotional involvement with humanity, primarily seen in the Negro genre portraits and cabin scenes, but also in his poor newsboys. His interest in hardship is also seen in the picaresque paintings like "Ruffles and Rags" and "Policeman Catching Darkies." His humor was always gentle and a look at any group of genre scenes like "Negroes on Cabin Steps" illustrates that the artist was sensitive to the shyness and reticence of some of his subjects. More importantly, he seemed to have a compassionate understanding of this Southern subculture, a vision not unlike that of Thomas Grey in his contemplation of English peasants. Throughout, Walker's restraint is notable. Even though he was active during the carpetbag period, his art remained apart from the currents of emotionalism. His involvement was underplayed, and his pictures leave interpretation to the beholder.

When Reconstruction was over, Negroes were still there, and they continued as farmers without land. Many systems of sharecropping were developed, and there were regional customs and variations. On Edisto Island the Negroes Walker painted worked the "two-day system" by which the tenant worked two days of the week for the landlord. When one Alabama planter furnished animals, and feed, as well as the land, his share was one-half of all the crops; when he furnished only the land he took one-quarter of the cotton and one-third of the corn. Arrangements for the sharecropping system were numerous, and often one planter would use several systems at once. The Montgomery *Advertiser* of 1881 described this: "to one, he [the Planter] rents, to another he gives a contract for working on shares, to another he pays wages in money, and with another he swaps work, and so ad infinitum." Landlords used various wage systems; monthly wages in 1880 for a man's work were eight to fourteen dollars in Alabama; six to ten in Florida; five to ten in Georgia (four to six for women); six to fifteen in Louisiana; eight to twelve in Mississippi and South Carolina.[16]

Walker indicated in letters to C. H. King of Atlanta that he was impressed with the ability of Negroes to adjust and expressed his fascination with the way they adopted the dress of the white man, using it in a colorful and original manner. At the same time Russell wrote: "Without education or social intercourse with intelligent and cultivated people, his thought has been necessarily original . . . I am a Democrat, was a rebel, but I have long felt that the Negro, even with his submission and servitude, was conscious of his higher nature and must some day assert it . . . [the Negro] treasures his traditions, he is enthusiastic, patient, long suffering, religious, reverent. Is there not poetry in his character."[17] Walker painted such Negroes on the docks at Savannah, Charleston and New Orleans.[18] Some of these paintings were found in Negro homes in Savannah in the 1940's, where they came perhaps as gifts or discards from employers.[19] There are similar significant instances of Walker paintings appearing in Negro homes in New Orleans.

By 1911 Walker began to note what he considered unpleasant developments in the deportment of Negroes in the twentieth century. He wrote Dr. Diehl from Ponce Park: "Old Bill, the Col's 'motor' as we call him, who has been taking us out since the middle of November in his skiff fishing, suddenly deserted him without any notice a few days ago and went to work for Mr. Rhodes, and we have not seen him since. Scipio Africanus of the 20th century is not very dependable and gratitude is not his strong point, for the Col. had him

hired all during the dull season when Bill had no job. *So Geht is in die weldt."* [20]

Walker's view of the Southern Negro is similar to that of Bernard Baruch, who describes in his autobiography the lives and habits of the Charleston Negroes that Walker knew so well.[21] Baruch was a fellow Charlestonian; but of a generation younger than Walker. His early life and his career, like Walker's, was influenced by the effects of the war on the South. It is coincidental that in the 1930's one of Baruch's New York offices was near the Bland Gallery, and Harry Bland spoke of Baruch's interest in Walker's paintings displayed at the Gallery. Walker painted the Negroes about whom Baruch was concerned. Both of them knew a common reality in common terms, and each in his widely separate way has contributed to knowledge and understanding of the black American in the last half of the nineteenth century.

Naturalism in Walker's Art

The naturalistic trend in the visual arts was an international one, but each country had independent manifestations of this point of view. After mid-century, those American artists who chose not to seek out the grandiose and magnificent in the landscape of this continent brought a particularly individual and literal naturalism to American art. Some of the artists successful in the naturalistic approach to landscape painting rejected academic traditions to develop a more personal, intimate style. Others had no academic training, but, like Walker, were drawn to rural America and the outdoors by personal taste. As the romantic element went out of American painting, a freshness, honesty, and authenticity appeared to be often combined with the primitivism associated with Southern landscape painting. This was the period when Walker's enumerative, analytical view of nature emerged. His quiet, sober approach to the landscape belies the flamboyant personality that his youthful daily life and rather trite letters suggest.

An exponent of the naturalistic movement whose work relates to Walker's in terms of time and subject is Winslow Homer. The two men painted the Southern black man and the Florida landscape at the same time, in the 1860's and 1870's and again in Florida in the early 1890's. Both approached the Florida landscape with a point of view unfettered by precedents and rules (figs. 1, 2). There can be no comparison between Martin Johnson Heade and Walker as to background

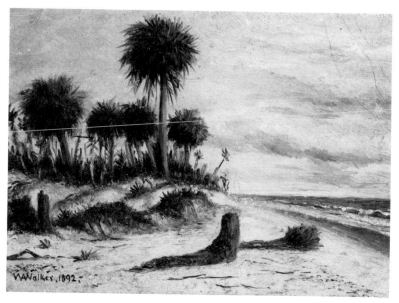

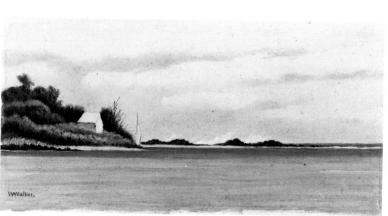

1
Bay, Cards Sound, Fla.,
Fishing for Barracuda
L.r.: May 9, 1899, W. A. W.

2

Palm Trees on the Beach at Fort Walton
L.l.: W. A. Walker, 1892

Oil on board, 5½ x 7 inches
Inscribed on back: "Fort Walton"
Present owner: Jay P. Altmayer, Mobile

Homer's "Palm Trees, St. Johns River,
Florida, 1890" (Cummer Art Gallery,
Jacksonville) relates to Walker's work
of the same period in choice of subject,
small canvas, and personal approach to
the broad Florida horizons.

3

Breakers in Florida
L.l.: W. A. Walker, n.d. [c. 1907]

Oil on paper, 5 x 10 inches
Present owner: August P. Trovaioli,
Grand Bay, Ala.

Some of Church's very personal paintings
have the casual and indirect documentary
approach of Walker's work. See "View of
Olana from the Southwest" (c. 1880) and
"Study of A Forest Pool," cat. 55,
"Frederick Edwin Church, Catalogue of
an Exhibition Organized by the National
Collection of Fine Arts, Smithsonian
Institution, Washington, D.C., 1966."

and training, but they were in St. Augustine, Florida, in the 1880's, and there the two painted similar subjects. Throughout their lives, both men were footloose, worked in numerous places, and had in common a love of nature and the wild outdoors. Both attempted the role of artist-naturalist: Heade was in Brazil in 1863 drawing and painting a series of flower studies with hummingbirds against a landscape background; Walker was concentrating on a study of Florida marine life in the 1890's.

The romantic Frederick Edwin Church is exemplary of Northern artists who painted the great "public paintings" of America, the great virgin continent in all its grandiloquence, but who, living on into the 1880's, reacted to the discoveries of Darwin and the industrialization of the country with a turn in art toward the very intimate and the very personal. It is in this personal response to the *fin de siècle* that Church relates to Walker and the Southern landscape painters (fig. 3). The literalist Jasper T. Cropsey is another of the Hudson River school who took time out from great canvasses and lofty compositions to take a quiet and sure look at nature. His drawings are reminiscent of Walker's in their naturalistic and documentary effect. Albert Bierstadt's version of the bombardment of Fort Sumter, painted in the 1860's, is the impersonal, dramatic, and improvised approach to the landscape popular with the German and Northern artist of the period.[1] A comparison with Walker's "Fort Sumter" underscores Walker's tranquil and pleasant interpretation of the landscape. He never attempted the heroic or emotional interpretation of any subject.

The mystic Joseph Rusling Meeker was another of the Northern painters who found the South and adapted his romantic style to the regional characteristics of the swamps. Traveling extensively in the South, especially in Mississippi and Florida, Meeker may well have encountered Walker in New Orleans. One of the few painters, like Walker, whose Currier and Ives prints were actually taken from paintings done in the South, he had a singular interest in the eerie atmosphere of the cypress swamps. There are Florida swamp scenes evocative of the damp, dangerous, heavy feeling of the swamps. In comparison, Walker's scenes are much more forthright; he was concerned with representing the complete natural environment. To him, the mood was incidental to the objects, whereas Meeker emphasized the moss, the twisting tree trunks, and other particular aspects of the scene which create mood. Although Meeker remains a romantic, his personal and intimate approach relates him to the naturalistic movement and

to Walker. Furthermore, his preference for the Southern subject and his absorption by it link him to the Southern landscape artists who lived in New Orleans.

This group of artists, whom Walker knew well, were painters like John Genin, August Norieri, George David Coulon, Marshall Smith, William Buck, Richard Clague, Paul Poincy, Everett D. B. Fabrino Julio, and Andres Molinary. They came from both the South and from Europe, but their cultural and artistic heritage was French, and they had no contact with the art centers of New York or the American schools of painting. Their social and artistic contacts outside the South were largely with Paris, and the lingering neo-classic traditions of the studios of Gleyre and Julien, and the École des Beaux Arts. These artists worked out of the mainstream of Anglo-American thought and tradition in painting, and their work was not subject to the intellectualism of the East. Walker shared their Southern viewpoint and the hardships of the artist's life in the post–Civil War South. Although Walker's Charleston origins were based on British cultural traditions, he was an outspoken Francophile and was in his element among the French oriented artists of New Orleans.

These artists, including Walker, had in common their subject matter—the port and the river, the cypress and oak trees, the swamps and bayous of the Deep South. They had a direct, simplistic approach to the subject and a strong feeling for light and atmosphere, but their sophistication in conveying this feeling varied. Some, like John Genin, gave a glimpse of the kind of work done by the Barbizon groups. Coulon and Julio followed neo-classic rules of composition. Poincy's use of color was somewhat like Walker's, but Poincy knew more of texture and paint application.

Association with the New Orleans landscape painters reinforced the regionalist characteristics of Walker's art. Their common bond of fascination for the landscape of the deep South and their exposure to the thought and life of the area resulted in an art which is naturalistic both in the wider sense of the national and international, but also in the narrower sense of the regional. No section of the country has been more conscious of its regionalism than the South, and the New Orleans artists, like the writers of the dialect tales and poetry, and like the Southern composers, were cognizant of the uniqueness of the land and life of the Deep South. They were among the first Americans to understand the character of the Mississippi Delta region, the swamps of Louisiana, and the Gulf Coast in esthetic terms.

Naturalism in the visual arts preceded naturalistic fiction

in America by at least a generation; the New Orleans artists, then, relate not to Stephen Crane or Edgar Watson Howe, but to the regional literature of Ruth McEnery Stuart, George Washington Cable, Lafcadio Hearn, and others whom they knew in New Orleans and whose work they read. Certainly by the 1870's, the popular magazines *Scribner's* and *Appleton's*, in which the Waud drawings were reproduced, had taken up the controversy of Darwinism, but the concern for everyday life and the traditional anti-intellectualism of Walker's New Orleans friends account for the lack of consideration of these problems. The naturalism in New Orleans art, of which Walker was a part, remained independent, a development removed from the Northern literary, scientific, and artistic manifestations of the movement.

During the early 1880's, Walker made some contact with Currier and Ives. They published two of his paintings in color, folio-size (approximately twenty by thirty inches), in 1883 and 1884. How Walker received these commissions is not known, but it was probably through social contacts with his Northern friends at the resorts of Florida or North Carolina. "The Levee, New Orleans" was published in 1883 and sold for three dollars, the standard price for Currier and Ives folio-size prints.[2] "Southern Cotton Plantation," after a painting by Walker, was one of Currier and Ives' first ventures into chromolithography. The print lacks the delicacy of the best of the firm's handcolored examples. The painting and the print show the plantation "going full tilt," as a friend of the artist described it. The cotton mill has smoke coming out of the stack, cotton baskets are full, and wagons are loaded. There are also Walker's usual anecdotal touches, the dog asleep under the wagon, the small Negro peering wide-eyed from the protection of his mother's skirts, and the ragged clothing of the workers (see Plate 18).

One wonders why more of Walker's work was not published by Currier and Ives and why they were not included among the illustrations of *Harper's*, *Leslie's*, *De Bow's*, and other publications. Since he received his large commissions from chance social contacts at the resort areas, he probably had little opportunity to contact the New York editors. His letter describing efforts to have a short story published indicate that he would not know how to promote his paintings at the publishing houses. Not interested in black and white illustration as an end product, he was never trained in the preparation of the wood block, a craft within itself. The artist-illustrators often drew the sketch upon the wood block for the engraver to finish. A few lithographs of Southern origin have appeared,

and more may be found. A lithograph of a Southern cotton plantation printed for Johnson & Johnson Surgical Supplies is similar in concept and composition to Walker's work.[3] "The Sunny South," a chromolith copyrighted 1882 by H. C. Tunison of the Central Map and Chart Company, also has characteristics indicative of Walker's work.[4]

"St. Finebar's Church, Charleston," painted by Walker in 1868, is a distinct approach to the landscape (fig. 4). It is one of two documented Walker subjects of monuments which were burned in the 1861 bombardment of Charleston during the Civil War. Were these, like the drawing of Fort Sumter from the East Battery, prepared by Walker from drawings for the Engineer Corps of the Confederate Army? If so, more of this kind of landscape may yet be found. In "St. Finebar's Church" the style is tight and the draftsmanship accurate. Walker this time approached stark drama by placing the church against a great expanse of sky with little foliage and by the manneristic treatment of the foreground. There is conscious abstraction in the use of inverted V's in the banquette shapes and triangular spacing of the six minute figures presented in the foreground to give scale to the ruins. This sophisticated execution surpasses much of the rest of Walker's work.

It has been shown that throughout his career Walker exhibited interest in the characteristic atmosphere of each region in which he worked, and he had an innate ability to capture these qualities in the Negro cabin scenes and later in the scenes along the Florida coast and in the North Carolina mountains. His interest and skill in handling light to great effect align him with the early French naturalistic painters; his use of color to create atmosphere is reminiscent of the impressionists. However, there is in his work or private writings no studied development of any of the ideas which produced these schools of painting. Rather, he unconsciously used these methods as the simplest means by which he could best represent what he saw.

He achieved a special effect of spaciousness through the comparative absence of shadows. In the nineteenth-century paintings, little figures were arranged in the foreground to create scale and an illusion of depth. In most works the sameness of lighting over the entire painting results in a flooded light effect. These features, along with the absence of a focal point in the landscape, may reflect Walker's awareness of what was happening in French art. If so, they also reflect his ability to adapt new ideas to his own special ends.

After the turn of the century, Walker developed a completely new approach to landscape. It was as though he were

having a delayed reaction to the things he may have seen in ateliers in France or in New Orleans. The Florida scenes after 1904 became broader and simpler, more selective and abstract. Retaining naturalistic subject matter, they exhibit a new interest in the two-dimensional visual image, a development preceding, it would seem, twentieth-century abstract painting. Interest in anthropomorphic forms and two-dimensional compositional effects became more pronounced. Arden cabin scenes reflect this fresh approach to his traditional subject (fig. 5). Cabins are hidden by foliage and not presented as the subject of the scene. An addition of abundant foliage, flowers, and grass in works of the period shows a growing interest in the natural world and its presentation on canvas. The views of

**4
St. Finebar's Church,
Broad Street, Charleston**
L.l.: W. A. Walker, 1868
Oil on canvas, 19¼ x 16¼ inches
Present owner: Carolina Art Association,
Gibbes Art Gallery, Charleston, S.C.
The painting shows the ruins of the church after its burning during the Civil War.

Mount Pisgah and numerous woodland scenes also reflect this. Always aware of the value of repeated shapes and rhythms in the construction of a painting, Walker went much further in late years toward developing a rhythm of growing forms like tree trunks, trumpet vine (fig. 6), moss, and other foliage. As was his custom, he continued to put a great deal of subject matter into his compositions, crowding them. Also included in his landscapes were more details of specific flowers and plants. Small nature studies of subjects like "Mushrooms" (Plate 26), "Yucca and Palmettos," "Hibiscus and Orange Blossoms," and "Bedstraw, Woodfern, and Rosehips" (Plate 27), and "Allamanda and Pyrostegia" (fig. 7) reveal an intimate involvement with the smallest details of nature. The charm of

5
North Carolina Cabin with Scalloped Trim on Roof and Wild Cannas
L.l.: W. A. Walker, n.d.
Oil on canvas, 12¼ x 18¼ inches
Original frame with sticker on back: "Lanneau's Art Store, 238 King St., Charleston. Artist's Supplies, Pictures, Frames, Kodaks and Kodak Supplies." Present owner: Mrs. W. H. Cogswell III, Charleston

This late North Carolina cabin scene exhibits unusual architectural details. The scallops under the roof, the laundress cut in half by the porch rail, and the heavy foliage obscuring part of the cabin are indicative of the camera's recording.

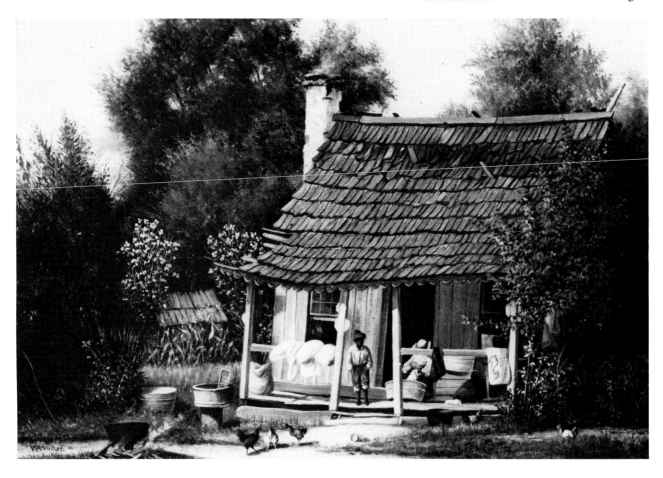

his subjects captivated him, but the visual image was most important; he was only an incidental naturalist.

Through years of painting great numbers of canvasses quickly, Walker had already reduced his stroke and color selection down to the strictly essential, but he began to change his palette and his method of paint application entirely. He eliminated underpainting with earth colors. Black, umber, and sienna disappear except when forced as a color of the actual landscape. Shadows became extensions of colors; whereas in an earlier forest scene the dense forest would recede into dark earth colors, now he began to use more intensity in the foreground with complementary colors of less intense tones of the pigment in the background. Space was created by overlapping shapes and by intensity change rather than by the old Dusseldorf and Munich formula he had always used. In the nineteenth-century paintings, bright, pure color was used to accent tatters and patches, steamboat stacks, or vegetables at the markets; now he began to use pure unmixed primary color in Florida landscapes. A chimney might be pure red; a distant mountain, orange; or a wheat field, Naples yellow. His brush strokes become heavier, thicker, and he drew directly on the canvas with the brush. Now trees were no longer a series of minute brush strokes so indicative of the German school. The artist was satisfied with his canvas much sooner.

The common denominator between Walker's nineteenth- and twentieth-century landscape was his primary interest in realistic effects. Throughout his work he sought to reproduce what he saw, like the camera, yet he would use impressionistic techniques reminiscent of the early Barbizon painters like Courbet or Boudin if they served what he thought was real. As he spent more time in Florida and North Carolina he felt that the landscape itself demanded a new palette to create a more convincing space. The results are often a cinematographic panorama of light and color.

Walker's naturalistic landscape and nature studies give insight into the character of the artist in his old age. His clientele had diminished, and he no longer painted to please tourists. These paintings were done because Walker enjoyed painting them. The result was an increased sophistication of concept and execution. In this later work the artist's talent, latent and utilized, plus his skill as craftsman, can best be assessed. Few of these subjects have been viewed other than by members of the artist's family, much less gathered together with his well-known work, so that here for the first time evaluation of the entire oeuvre of the artist can be made. These groups of

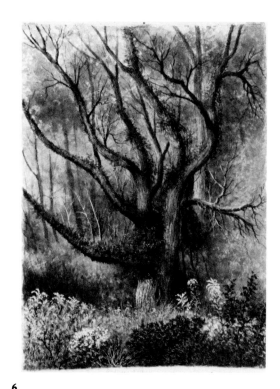

6

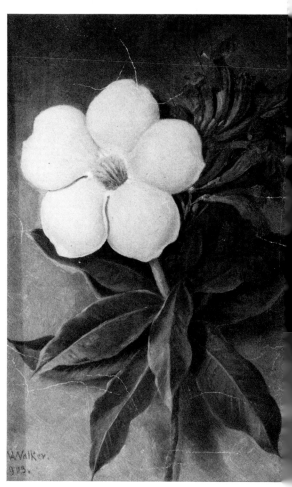

7

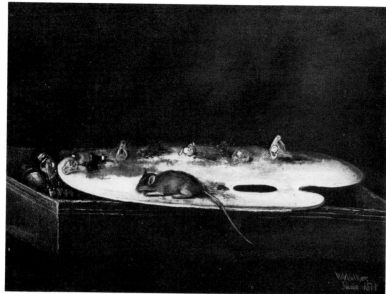

8

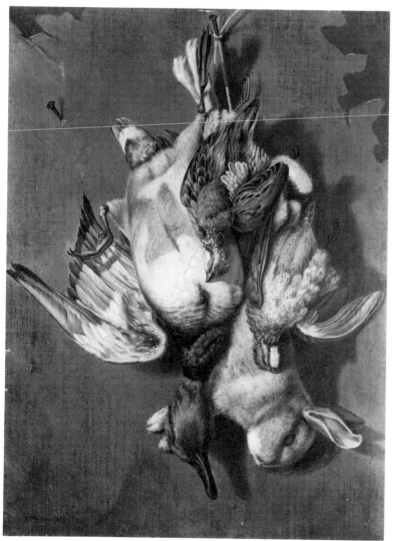

9

6

Dead Tree with Trumpet Vine at Arden
L.l.: W. A. Walker, n.d. [c. 1899]
Watercolor on paper, 8 x 10¾ inches
Written in pencil at bottom: "Arden, N.C."
Present owner: Mrs. W. H. Cogswell III,
Charleston

7

Allamanda and Pyrostegia
L.l.: W. A. Walker, 1903
Oil on board, 13 x 9½ inches
Present owner: Herman Schindler,
Charleston

Walker and Heade did nature studies of
flowers in Florida. Perhaps Walker's
treatment of the Allamanda and Pyrostegia
is somewhat fresher than Heade's treat-
ment of a similar subject because Walker
omitted the traditional drapery and folds.
Neither plant is native to North America.
They are Brazilian, and Walker's work
is possibly an adaptation of Heade's
canvas which Walker could have seen in
Florida. It is also possible that the plants
were drawn from live examples in the
gardens of Dr. Pacetti in St. Augustine.
(See Heade's painting, cat. 157, Karolik
Collection of American Painting.)

8

The Surprize
L.r.: W. A. Walker, June, 1871
Inscribed on back: "William Aiken
Walker, artist, $15."
Oil on board, 12 x 16 inches
Present owner: August Trovaioli,
Grand Bay, Ala.

This painting was found by the present
owner in Ponce Park. Artists like Rosa
Bonheur, John Chapman, and other stylish
painters made similar paintings of their
palettes. Heade painted his palette with
a rose lying on it, whereas Walker chose a
humorous interpretation, using the mouse
seen in numerous still-life studies.
The colors on the palette are chrome green,
Van Dyke brown, Vermillion, black,
crimson, and two yellows, with a big glob
of white. The mouse has walked through
the vermillion and his tail is covered
with it.

9

Hanging Rabbit, Duck, and Quail
L.l.: W. A. Walker, 1869
Oil on canvas, 27 x 20 inches
Photograph courtesy of
Kennedy Galleries, Inc., New York

paintings serve further to establish Walker as an unusual intimist of the outdoors who appreciated and understood the quiet details of nature and of daily living that were considered beneath consequence by most.

Anecdotal still-life paintings like "The Surprize" (fig. 8) and "Mice with Boot" reflect somewhat this interest in the insignificant as well as Walker's quiet sense of humor. The artist's *trompe l'oeil* game and fish studies beginning in the early 1860's antedate the extreme popularization of the subject by the 1880's. There is a very curious difference of technique employed in similar subjects. Some canvasses are quite sophisticated in terms of composition (fig. 9), overlapping of shapes, total shapes and forms; textures are most effectively varied, and the brushwork is loose and facile. At other times the charm lies in the very primitivism of the attempt where forms are stiff and brushwork often crude, with textures varying only ac-

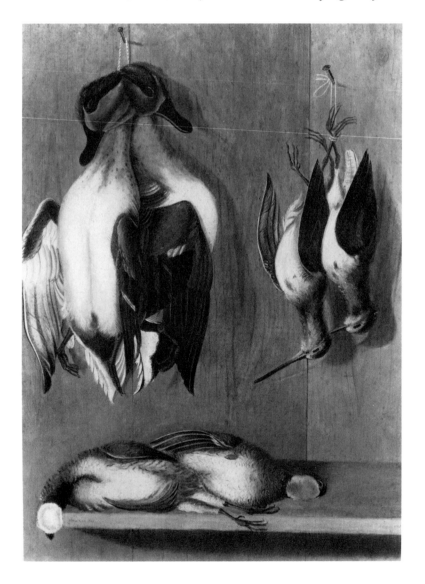

10
Ducks, Bobwhites, and Woodcocks
L.l.: W. A. Walker, 1866
Oil on canvas, 24 x 18 inches
Present owner: Jay P. Altmayer, Mobile
See a similar study painted into the
self-portrait oilette, fig. 16, p. 67.

11
Dog Head
L.l.: W. A. Walker, Apl. 1902
Oil on board, 17¾ x 11¾ inches
Present owner: Herman Schindler,
Charleston

cording to accepted formula for a *trompe l'oeil* subject (fig. 10).

Like most artists of the last half of the nineteenth century, Walker painted dogs and horses. Although the horse paintings reveal exposure to formal horse portraits, the dog portraits remain crude and primitive, related more perhaps to works by the New Orleans artists. The dogs are usually part of a hunting scene painted with an anecdotal approach. Some dog portraits are particularly interesting because they appear cut off at the neck, painted on the side of the canvas with no attention given to formal elements of composition (fig. 11).

The painting of Dr. Diehl's horse (fig. 12) and "Horses in a Pasture" from the Robert Stanley Green collection indicate that Walker had seen horse portraits, perhaps the works of Edward Troye who went to Charleston to paint Wade Hampton's horses. The single swayback horse among the thorough-

12
Dr. Diehl and Morgan Horse in Louisville, Kentucky
L.l.: W. A. Walker, 1879
Oil on canvas, 24 x 26 inches
Present owner: August P. Trovaioli, Grand Bay, Ala.

breds in "Horses in a Pasture" (Plate 10) is reminiscent of the work animals painted by John Frederick Herring, and it also reflects the artist's constant gentle humor. The horses and mules in the plantation and genre scenes are more carefully executed than the human figures, although the artist never demonstrated an understanding of the principles of foreshortening.

No matter how derivative these groups of paintings may be, they become the artist's individual subject, an expression of a quiet but steady interest and delight in the world around him. His work as a whole reflects a sensitivity toward the small intimate aspects of daily living and the natural world. Loving detail in plantation and cabin scenes, in nature studies, and in genre paintings reflects a humanism and a poetic nature that belie the rather routine facts of life for a provincial individual living and painting in what is considered the least inspiring period in the history of America and the South.

Chronicler of the South

The camera was the one continuous influence in Walker's work. Photography must have seemed a godsend to early documentary painters, and it served as an unsurpassable teaching device to others. It was not realized widely until after the Civil War that the camera limited the artist's vision. For Walker, however, the photograph remained an asset; it helped make him what we have called an American intimist of the outdoors; it allowed him to attempt a variety of subjects which he would scarcely have assayed without some lasting reference; and it made possible a great increase in output. Unlike the impressionist, who sought to record what the eye saw in a fleeting instant, Walker enumerated what the more comprehensive lens of a camera could catch. Yet, sketching and painting outdoors, he was able to preserve in his canvasses the qualities of outdoor illumination. He collected information with the camera; and the camera reinforced his tendency to concentrate on details—to be intrigued with the particular rather than the general. Because he limited himself to the recording ability of the camera, he used it to develop a personal approach to his art. It is to his credit that he adapted the camera to his style and needs rather than adapting himself to the camera's mechanism.

Negroes had always been available as subjects for his photographs, and they posed for him on the docks of Charleston or at the plantations of his friends. A series of photographs

of Charleston Negroes can be compared with paintings done from them to illustrate his use of the camera (figs. 1, 2). Interested in special physical characteristics of different groups of blacks in different locations, he wrote descriptions on the borders of the prints. Tribal names like "Fanti," "Hausa," "Mandingo," and "Gulla" appear on the backs of old faded photographs from Walker's effects. He annotated unusual names, and occasionally he named paintings after the notations on the photograph from which the painting was made, such as "Euphemia" or "Simon's Cabin." Physical effects of age and hard work interested him, and these elements were transposed from the photograph to paintings (figs. 3, 4, 5).

Some of Walker's portraits were exact copies of the photographs used as sources, but he often selected the characteristics of a figure or scene which were most picturesque and in so doing created a completely new composition. Peculiarity of dress was emphasized throughout, and he relied on the tatters and rags of makeshift clothing to add color and interest to the composition (fig. 6; Frontispiece). Although the artist's intent was not documentation in the single and double portraits of Negroes, his composite characterizations are a notable record of that people before the forces of the New South had penetrated their lives.

The cabin scenes depict regional building customs and suggest the general life style of the inhabitants. Walker attempted no wide presentation of activities. There are no known paintings of religious scenes, no interiors, and no music or dancing scenes. Yet within this limited subject—the cabin with its specific characters, plants, animals, and props—there appears a vast range of locale. A collection of Walker cabin scenes presents a great variety in building and fence types, building material, species of plants and animals, kinds of terrain, farming and hunting implements, and local traditions.

His South Carolina cabins are usually board and batten with small shakes on the roof (fig. 7). If a porch is added, it is roofed by an extension of the cabin covering. There were numerous brick factories near Charleston, and some of Walker's cabins have chimneys made from salvaged brick covered with clay; others are made of mud-covered sticks. In the Edisto Island paintings, the cotton field often extends almost to the cabin door where the high ground was good for cultivation. The extra cotton was supplemental income for the tenant (fig. 8). Edisto and Sullivan's Island scenes are characterized by palmetto and quince trees. Cabin scenes painted throughout the state differ little in planting, but the cabins vary in sturdiness, sometimes having no windows, sometimes one or two (fig. 9).

1
Negro in Charleston
Photograph by W. A. Walker
Collection of Mrs. W. H. Cogswell III,
Charleston

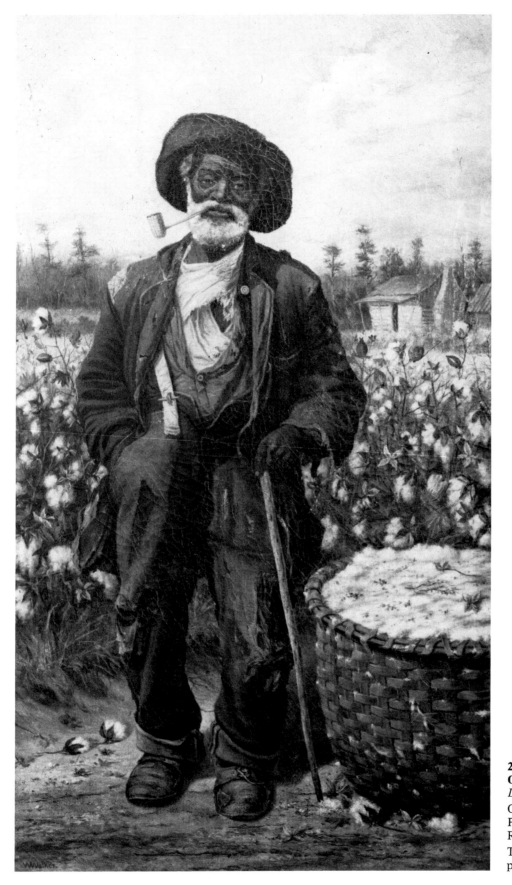

2
Old Cotton Picker
L.l.: W. A. Walker, n.d.
Oil on canvas, 48 x 24 inches
Present owner: John D. Blake,
Rockford, Illinois
This is one of the few large
portraits of a Negro.

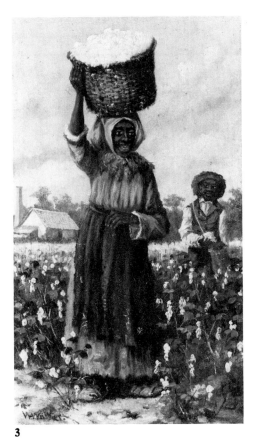

3

3
Champion Cotton Picker, Emma
L.l.: W. A. Walker, n.d.
Oil on academy board, 13 x 7½ inches
Photograph courtesy of Kennedy
Galleries, Inc., New York

4
Photograph from Walker's effects
Written in pencil on back: "12 x 20
P. Park, for Mrs. Brooks"
Collection of Mrs. W. H. Cogswell III,
Charleston
Walker often used a particular stance
from one photograph with different faces.
He used family groupings repeatedly,
changing only the background.

5
Negro Couple in Cotton Field,
Woman with Yellow Bonnet
L.r.: W. A. Walker, n.d. [c. 1889]
Oil on canvas, 12¼ x 7 inches
Present owner: Jay P. Altmayer, Mobile
Walker used the bonneted woman seen
in a photograph (fig. 14) in several
compositions.

4

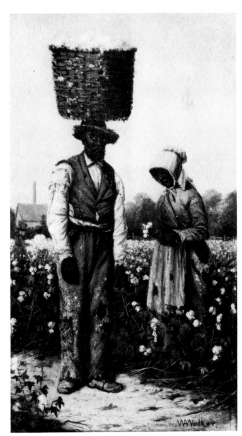

5

Walker's south Georgia cabins are built of wide cypress boards laid horizontally; they have wood chimneys covered with clay lean-to porches (fig. 10). Occasionally there is a grapefruit tree in the yard. The more substantial construction of the North Carolina cabins indicates the colder climate of the area. Made of logs chinked with clay, they have chimneys of log and stone, only partially covered with clay. There is seldom a porch or windows, and split-rail fences predominate. Trees and shrubs are usually more abundant and typical of western North Carolina; sometimes a lean-to with a sod roof sheltering stacked hay is shown. Walker's Louisiana cabin scenes are more often distinguished by their bald cypress trees and live oaks than by special building materials. The wide shake roofs are made of cypress, and the cabins are made of horizontally laid cypress boards. Often, instead of cotton fields, there is swampland in the background (fig. 11).

6
Photograph of Calhoun's slaves by Walker
Collection of Mrs. W. H. Cogswell III, Charleston

Among the Negro genre portraits are some which reflect sophistication of intent and a superior handling of color and form. In "Portrait of a Mammy with her Corn Cob Pipe," Walker achieved a monumentality and feeling of solid mass which is not found in most of the souvenir size Negro portraits. Another outstanding example of the type is "Calhoun's Slaves" (Frontispiece) painted after Walker's own photograph. The painting hung in the Common Room of Calhoun College (at Yale University), a part of the Garvan Collection until Mr. Garvan's death.

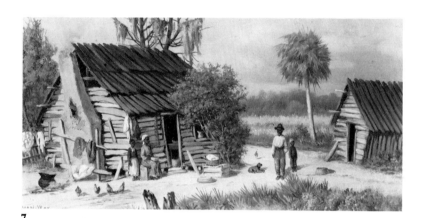

7

7
Cabin with Hole in Plaster-covered Chimney, Edisto Island
L.l.: W. A. Walker, n.d. [c. 1888]
Oil on academy board, 6 x 12¼ inches
Present owner: Unknown
Photograph courtesy of Kennedy Galleries, Inc., New York
The bush at the corner of the cabin is an unusual feature.

8
Log and Clay Cabin with Moss-covered Oak Tree and Palmetto
L.l.: W. A. Walker, n.d.
Oil on academy board, 9 x 12½ inches
Present owner: Herman Schindler, Charleston
The cotton is growing into the front yard. Every spare patch of ground was planted by some tenant farmers. This cabin is a curious combination of North Carolina building techniques and the South Carolina palmetto and picket fence.

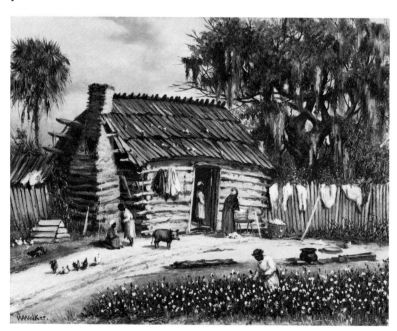

8

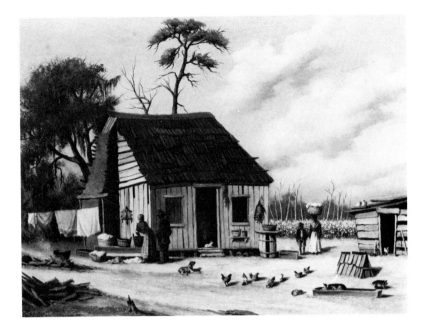

9
**Board and Batten Northern
South Carolina Cabin**
L.l.: W. A. Walker, n.d. [c. 1886]

Oil on canvas, 8¾ x 12½ inches
Present owner: Mrs. W. H. Cogswell III,
Charleston

This two-window, well-built cabin is finer
than most. Compare this simple orderly
composition to the tumbledown cabin
scene in figure 8. Here the clay-covered
stick chimney has been topped.

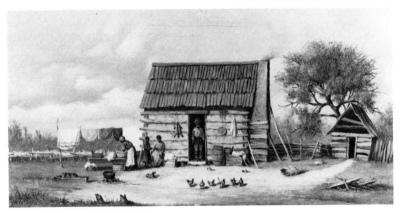

10
Log Cabin with Stretched Hide on Wall
L.l.: W. A. Walker, n.d.

Oil on academy board, 6 x 12¼ inches
Present owner: Herman Schindler,
Charleston

This log cabin chinked with clay is quite
sturdy. The close shakes on the roof, solid
ridge pole, and absence of windows
indicate the colder climate of North
Carolina.

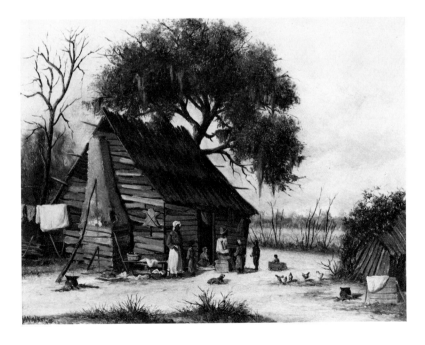

11
**Louisiana Cabin Scene with Stretched
Hide on Weatherboard and Stick
Chimney Covered with Clay**
L.l.: W. A. Walker, n.d. [c. 1878]

Inscribed on back "$15 or two for $25"
Oil on board, 9 x 12 inches
Present owners: Dr. and Mrs. Roy
Ingraffia, New Orleans

This painting was purchased by the
present owner's grandmother during the
artist's lifetime. The same cabin painted
at another season of the year, a common
practice of the artist, is in the collection
of Alonzo Lansford, New Orleans.

Among general characteristics of all cabin scenes are possum, racoon, skunk, badger, or rabbit skins stretched and nailed to the cabin wall for drying. Dried peppers and gourds used as martin houses and fruit trees like quinces in South Carolina, grapefruit in Georgia, and oranges in Florida are evident. Present in almost every scene are chickens with a laying house; a sow, usually with piglets; a dog scratching fleas or sleeping; a rain barrel with a hole in it; a black iron wash pot; and water troughs. A juniper pole usually props up the chimney and there is a pen with a door opening and a chicken in front of it. Washing is hung on a line or laid out on a fence, drying in the sun (fig. 12). Although cotton is most often growing in the background or foreground, there are cabin scenes with corn fields, vegetable gardens, rice fields, tobacco, wheat, sugar, or swamp. Picket, log, and split-rail fences are shown. The more sturdily built cabins have a door and one or two windows as well as a ridge pole on the roof (fig. 13), but the majority have only a central door opening without door or windows. Roofs are patched with sod and moss or with cowhide.

Walker's larger plantation scenes, based in part on photographs, record life on plantations in different areas (figs. 14, 15). Most of the panoramic landscapes illustrate life on a cotton plantation, but there are also scenes of tobacco, rice, corn, sugar, and wheat fields being worked by the laborers. Plantation houses, overseers' houses, barns, sheds, and outbuildings document building types, some of which exist only occasionally on back-country roads today. There are inland plantations and others on rivers with the everpresent steamboat coming in to load the cotton and sugar (figs. 16, 17, 18). One painting of hoeing in a Louisiana rice field documents methods and practices in the culture of that crop (fig. 19). An early hand-operated combine is worked by field hands including children and old men (fig. 20). Both cotton sacks and hand-woven willow strip baskets are seen (figs. 21, 22). There are mule operated sugar mills and sawmills, silos, cotton gins, and barns for hay and cotton. Smoke houses and steamboat landings are included, as are saws, pitchforks, horsewhips and other tools.

While the large commissions are scenes depicting plantation life in all its aspects, the small agricultural scenes with double figures, a field and a shack or barn with a fence in the distance are vignettes of that life. All of the paintings have their prosaic and humorous details: quixotic hats, a dog scratching fleas, a dressed-up woman perched atop a broken-down hay wagon holding a parasol and a bunch of turnips.

The economy of the South moved through the steamboat, the mule, and the wagon. One group of Walker paintings records such transportation in the rural South. Bayou boats and

12
South Carolina Cabin Scene with Split-rail Fence and Rock Gable Ends
L.r.: W. A. Walker, n.d. [c. 1889]
Oil on academy board, 9 x 12¼ inches
Present owner: Unknown
Photograph courtesy Kennedy Galleries, Inc., New York

13
T-plan Cabin with Porch
L.l.: W. A. Walker, n.d. [c. 1903]
Stamped on back: "Lanneau's Art Store, 328 King St. Charleston. Artists Supplies, Pictures, Frames, Kodaks and Kodak Supplies." In original frame.
Oil on canvas, 12¼ x 18¼ inches
Present owner: Mrs. W. H. Cogswell III, Charleston

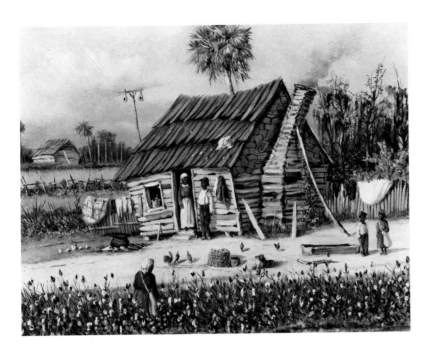

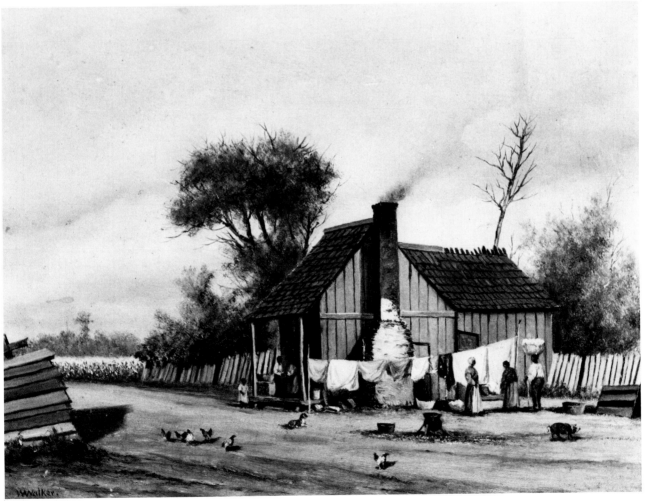

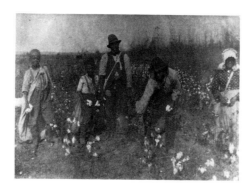

14
Cotton Pickers
Photograph by W. A. Walker
Collection of Mrs. W. H. Cogswell III,
Charleston
Woman with bonnet is shown in fig. 5.

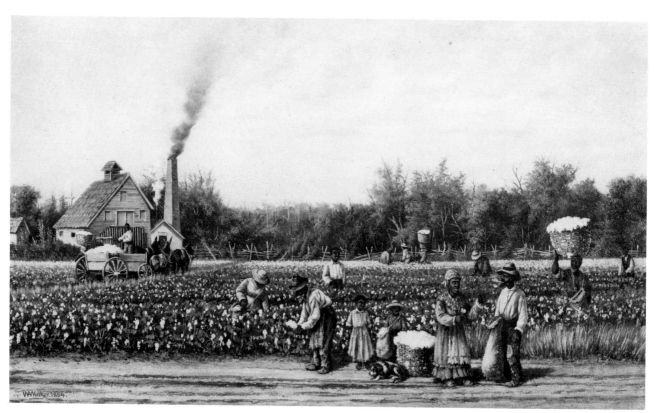

15
Negro Cotton Hands with Wagon
L.l.: W. A. Walker, 1884
Oil on canvas, 14 x 24 inches
Photograph courtesy of Kennedy
Galleries, Inc., New York

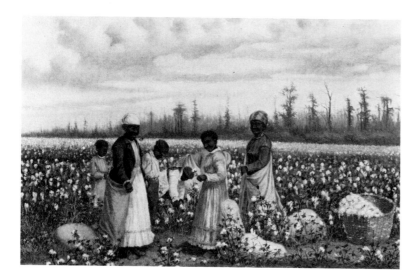

16
Cotton Pickers
L.l.: W. A. Walker, n.d. [c. 1887]
Oil on board, 12 x 18 inches
Present owner: Unknown
Photograph courtesy of Kennedy
Galleries, Inc., New York

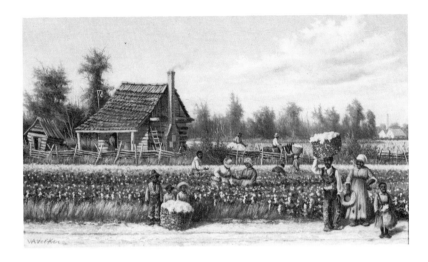

17
Tenant Farmers in Cotton Field
L.l.: W. A. Walker, n.d. [c. 1887]
Oil
Present owner: J. Cornelius
Rathborne III, San Francisco

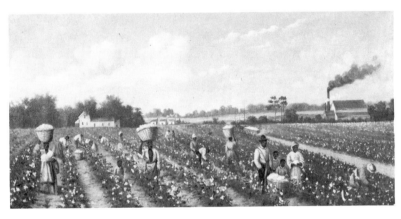

18
Cotton Plantation with Cotton Gin
L.l.: W. A. Walker, n.d. [c. 1885]
Oil on canvas, dimensions unknown
Present owner: Anonymous Collection
Photograph courtesy of Alonzo Lansford,
New Orleans

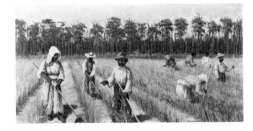

19
Rice Field with Bald Cypress in Louisiana
L.r.: W. A. Walker, n.d.
Oil on canvas
Present owner: J. Cornelius
Rathborne III, San Francisco
Photograph courtesy of Alonzo Lansford,
New Orleans

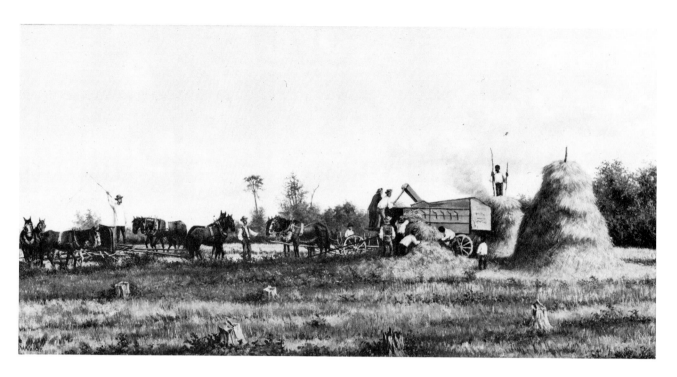

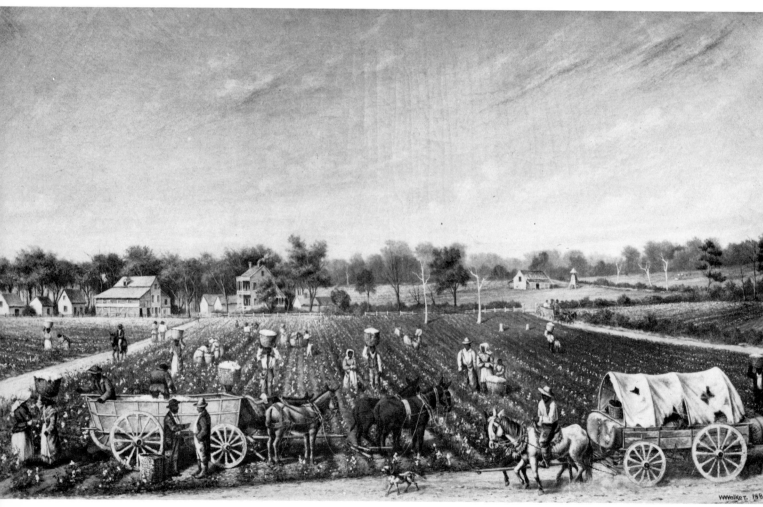

20
Winnowing Wheat (Louisiana)
L.l.: W. A. Walker, n.d. [c. 1897]
Oil on canvas, 13 x 26 inches
Present owner: Unknown
Photograph courtesy Kennedy
Galleries, Inc., New York

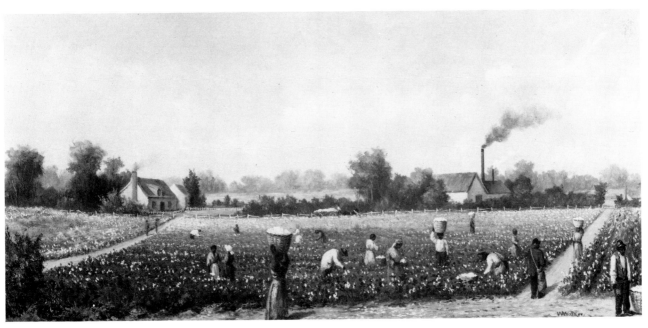

22
Cotton Plantation in South Carolina
L.r.: W. A. Walker, n.d.
Oil on canvas, 9 x 20 inches
Photograph courtesy of Kennedy
Galleries, Inc., New York

21
**Cotton Plantation with Wagons,
Plantation House, Barns, Slave
Quarters, and Feed Shed**
L.r.: W. A. Walker, 1881
Oil on canvas, 22 x 36 inches
Photograph courtesy of Kennedy
Galleries, Inc., New York

23
Mule and Wagon
Photograph by W. A. Walker
Collection of Mrs. W. H. Cogswell III,
Charleston

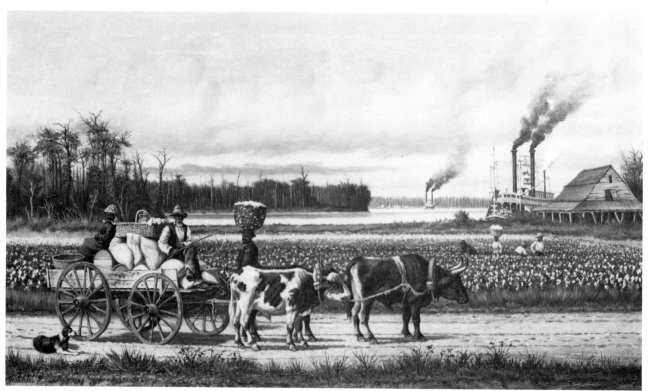

24
Comin' from the Market
near Baton Rouge
L.l.: W. A. Walker, n.d.
Oil on canvas, 14 x 20 inches
Photograph courtesy of Kennedy
Galleries, Inc., New York
This same group of figures was painted
repeatedly with different backgrounds.

steamboats are seen transporting lumber and cotton. Yoked oxen and cows, harnessed mules, and work horses transport field hands and poor farmers as well as the cotton in decrepit cotton wagons (Plates 12, 15; figs. 23, 24, 25). These wagons with large rear wheels and smaller front wheels are covered with cotton canvas. They were used, as portrayed by Walker paintings and photographs, to transport produce from farm to market and to transport families cross country. An occasional two-wheel rig is evident in addition to the usual farm wagons for hauling.

The paintings of Negro life have common characteristics, many of which relate to the artist's use of the camera. The panoramas have no focal point; they contain figures in a frontal posed position with the landscape as a backdrop. The effect is iconographical. The fixed frontal pose conveys a

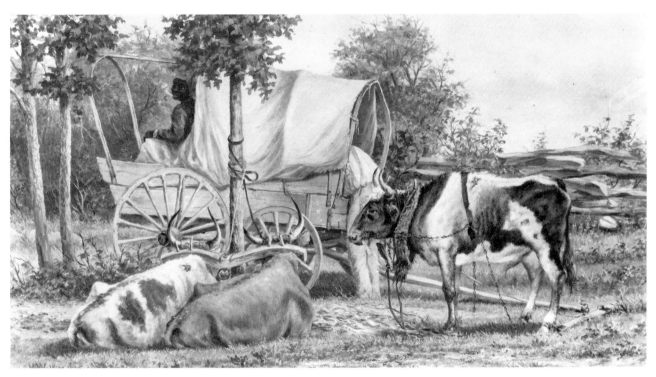

25
Auntie in Wagon with Oxen
L.l.: W. A. Walker, 1885
Oil on canvas, 10 x 18 inches
Photograph courtesy of Kennedy Galleries, Inc., New York

special mood of permanence and endurance and imparts a dignity more notable when compared to the immediate, transitory, and momentary facts of contemporary illustrations of *Harper's Weekly*, *Appleton's*, *Leslie's*, and other journals. After 1875 these publications began to send photographers South in place of and in addition to the artists who had prepared their drawings and sketches for the wood block. These photographers used the camera to capture the figures in action; published engravings made after the photographs reveal a difference in approach from Walker's work in which the action is symbolized and actual labor is seldom shown; Walker seemed uninterested in using the camera to freeze action. Nor did he see it as a device to capture unusual perspective.

Walker was conveying information in his Southern scenes, whereas Russell, Remington, and the artists of the Western scenes recorded action in progress. These men were highly subsidized by the magazines they worked for and were paid to be where the action was. They told a story by portraying action relating to the West at an exciting time of its development, while Walker in effect was quietly reporting a way of life which had been almost unchanged for over a hundred years.

A series of one hundred and four topographical sketches of the east coast of Florida from New Smyrna through the Florida Keys, dating from 1898 to 1902, gives an entirely new dimension to Walker and his contribution to American art. They document the area during the beginnings of its development as a major tourist attraction. These sketches, never before exhibited or recorded, may place Walker among the foremost topographers of the South during the nineteenth century. Sketches and the paintings made from them record the appearance of the Atlantic Coast of Florida prior to the ecological changes brought about by modern technology and the shifting population. Here are representative pieces of that sensitive, accurate, and intimate record of another part of the South gone forever (figs. 26–30; see also figs. 10–15, pp. 44–50).

By 1860 Walker had begun to paint his fishing catch and the game he shot. These fish and game studies were well within the Victorian taste of his age. In 1890 he began to make a series of marine life studies in which his intentions were definitely scientific and documentary. These were often done on odd scraps of canvas; many were never stretched, but there are holes where Walker tacked them to a board. On the backs of such scraps are notations by the artist of the common and scientific names of the subject, data about where the fish was taken, the weather, and the tide. The specimens were primarily

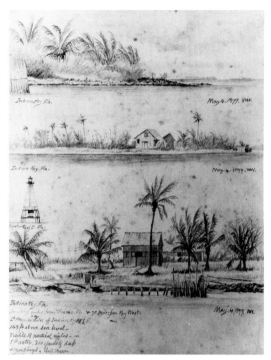

26
Indian Key, Fla., May 4, 1899
(detail of Alligator Reef Light)
Inscribed "about 70 miles from Miami, Fla. and 70 miles from Key West. Lt. house 4 miles off Indian Key E.S.E. 143 ft above sea level, visible 18 nautical miles in 5 ft. water, 200 yards of deep soundings, Gulf Stream."

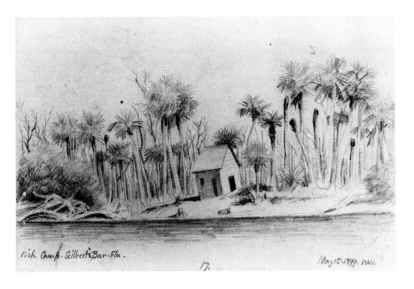

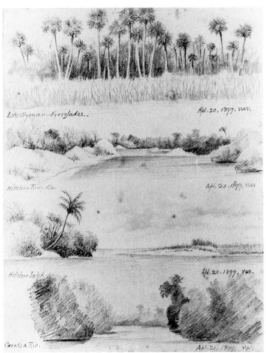

27
Fish Camp, Gilbert's Bar, Fla.
May 15, 1899. W. A. W.

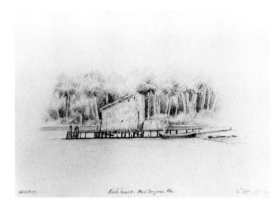

29
Fish-house—New Smyrna, Fla.
W. A. Walker. 16th Oct. 1902

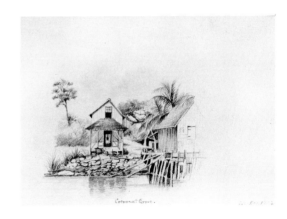

28
Lake Wyman—Everglades
Apl. 20, 1899. W. A. W.

Hillsboro Riv., Fla.
Apl. 20, 1899. W. A. W.

Hillsboro Inlet
Apl. 20, 1899. W. A. W.

Crooked Riv.
Apl. 21, 1899. W. A. W.

Walker's sketches point out that from
1888 to 1908 the country up and down the
east coast was extremely primitive despite
the railroad and Flagler's elegant hotels.

30
Cocoanut Grove
24 Nov., 1902

Crayon on paper
Present owner: Mrs. George Archie
Martin, Columbia, S.C.

from the Florida east coast, but there are examples with annotations from Fort Walton, Pensacola, and Biloxi. Whether or not Walker had hopes of making a complete scholarly study of this marine life is not known, but he apparently lost interest in the project after 1912 because of old age, bad health, and inability to travel throughout the coastal areas of the South.

What inclined Walker to present these subjects as he did? He had no conscious motive for documenting a region or a way of life. He attempted, rather, to portray accurately what he saw without any effort to tell a story beyond that visually contained within the framework of the composition. There is nothing to indicate that he was a man of strong philosophical temperament. His available correspondence gives no indication of concern for political or sociological themes. Like so many Southerners of his generation, he was largely passive and apart from postwar politics and philosophies. More important to Walker was the struggle to live, to conduct oneself well, to avoid unpleasant reminders of war, and to enjoy his "magnificent world." He was simply painting the subjects which he knew best and which most appealed to him. His paintings reflect a documentary approach to the natural world and a special interest in portraying the Negroes he saw on the land. It is through the collection of numbers of these paintings produced over a seventy-year period that one sees an unconscious sense of historical preservation. Walker's work is the presentation of a world which was disappearing even as he painted it.

Notes

Introduction

1. As reported in an interview with Ianthe Bond Hebel, director of the Volusia County Historical Society, Daytona Beach, Florida. Walker repeatedly made this statement to Mrs. Hebel when she was a young school teacher at New Smyrna.
2. "Old Man on the New Orleans Docks," in the Jay P. Altmayer Collection, is one of the few genre paintings of white subjects. But Walker's cabin scenes of the mountaineers of western North Carolina depict an occasional white mountaineer family; the colonel and his lady are included in the Currier and Ives print of a Cotton Plantation; and paintings with white Cuban subjects have appeared.
3. Walker (Ponce Park, Florida) to Dr. C. Lewis Diehl, undated, in Ann Katherine Caldeway Estate, Louisville.
4. See the November, 1971, issue of *Antiques*, p. 702.
5. New Orleans *Daily Picayune*, October 25, 1885, p. 5.
6. *Ibid.*, November 30, 1884, p. 2.
7. *Ibid.*, October 25, 1885, p. 5.
8. Exhibition of Southern Genre Paintings by William Aiken Walker (Catalogue published by Harry Bland Galleries, Inc., New York, February, 1940).

Charleston and the Civil War

1. Paul Hamilton Hayne, "Carolina," Charleston *Daily News*, 1871, in *The Literature of the South*, ed. Montrose J. Moses (New York, 1910), 387.
2. Family records are incomplete, and the relationship of Walker through his mother to the well-known family of William Aiken, after whom Aiken County and the city of Aiken were named, is unrecorded. Jane Flint is recorded erroneously as Walker's mother in birth records from the collection of Mrs. W. H. Cogswell III, the artist's grandniece.
3. Charleston *Courier*, November 27, 1850.
4. *Ibid.*, October 21, 1845.
5. The exhibition was described in detail in *Russell's Magazine*, Vol. I., 1857.
6. Interview with Mrs. W. H. Cogswell III.
7. Charleston *Mercury*, June 12, 1858.
8. *Ibid.*, February 16, 1859.
9. William Aiken Walker, "Map of Charleston and Its Defenses," November 28, 1863 (Map Plate CXXXI in *Atlas to Accompany the Official Records*, Union and Confederate Armies, 1861–1865).
10. William Aiken Walker, *Mes Pensires* (personal scrapbook of the artist with twenty-six poems and various illustrations dating 1861 to 1866 in the Cogswell Collection).
11. Active as a Confederate cartoonist, Volck signed his work V. Blada. He practiced dentistry in Baltimore after the war, where he was prominent in social and art circles.
12. Unpublished records of the South Carolina Historical Society, Charleston.
13. Accept *Mes Petites Pensées*, culled in leisure hours. Garland bearing incense plucked from mem'rys bowers

Seek not here for roses full blown, roses fair
These are "simple blossoms" still to me they are dear
Judge them kindly Reader for they tell of those
With whom I've shared in joys alas "shared my woes"
They grow not in a garden decked with Floras pride,
Content amid these leaves their modest hues to hide.
And as my little blossoms unfold their petals bright,
O daily each flower finds a welcome in thy sight.

Dediées A Belle Ange

14. *XIX Century*, I (1869), p. 65.

15. *De Bow's Review*, III (1867), p. 216.

16. See *Russell's Magazine* (1857–1860). To date most of the art teachers who participated in the Carolina Association are relatively unknown. A "Miss Ferry, a French lady" was employed by the Art Association to work for six months for one hundred dollars per month, but she stayed on to teach in Charleston from 1887 until 1894. Other such teachers remain anonymous, but we know of one artist who lived in Charleston consistently throughout the post–Civil War period. Johann Stolle had been brought to Charleston from Germany after the Civil War by Gabriel Wesley Dingle of the Charleston City Council. Dingle felt that the city was in need of a painting restorer, and Stolle occupied himself making copies after portraits by Malbone and others at his studio for Charlestonians wanting reproductions of their family portraits. About the turn of the century, Alice Ravenal Huger Smith (1876–1958) began painting scenes of the riceland of South Carolina. Both in subject and size her work parallels Walker's, but Miss Smith, also an author, illustrator, and printmaker, was a conscientious historian. Her paintings reflect the early twentieth-century regionalist point of view when important historic landscapes and architecture which characterized an area were recorded.

17. See Roulhac B. and Ben C. Toledano, *Charles Hutson* (New Orleans, 1964).

18. Unpublished files of Gibbes Art Gallery; interview with the relative conducted by A. W. Rutledge.

19. The catalogue of the Fifth Annual Exhibition of the Artist's Association of New Orleans, 1890, lists five works by Walker as "sketched from Ediston [*sic*] Island."

20. The dated manuscript is in the Cogswell Collection.

Maryland and Cuba

1. Ottolie Sutro, "The Wednesday Club," *Maryland Historical Magazine*, XXVIII (March, 1943), 60–68. Some of these members were George B. Coale, Henry M. Wysham, B. W. Chase, Archie B. Coulter, William M. Petram, and Leonce Rabillon.

2. Undated clipping from the Baltimore *Sun* in A. J. H. Way's scrapbook, in the Charleston Library Society Collection. See advertisements for tutoring and teaching post in Way's scrapbook, p. 19.

3. Augusta, Georgia, was a popular resort area and social center after the Civil War. Walker's friends and activities there have not been documented, but at the time of his death $4,818.55 was in his account at the Planter's Loan and Savings Bank, Augusta (from his estate, Probate Court, Charleston).

4. Interview with Mrs. W. H. Cogswell III.

5. Mrs. E. Milby Burton, Charleston *News and Courier*, Sunday, July 16, 1961.

6. Walker (Arden Park Lodge, Arden, North Carolina) to Dr. C. Lewis Diehl, June 19, 1904, in Caldeway Estate, Louisville.

7. *Ibid.* (Charleston, South Carolina), May 26, 1912.

8. *Ibid.* (New Orleans, Louisiana), April 18, 1905.

9. *Ibid.* (Charleston, South Carolina), May 26, 1912.

10. *Ibid.* (Ponce Park, Florida), undated.

11. Undated clipping, Way's scrapbook.

12. Cuban Diary in the Cogswell Collection.

13. August Trovaioli Collection.

14. Clipping from the Baltimore *Sun*, 1870, from Way's scrapbook.
15. *Ibid.*
16. *Ibid.*
17. George H. Clements, *Arts and Letters* (August, 1887).

1. Advertisement of Bon Air Hotel inscribed on illustration at the Augusta-Richmond County Museum.
2. Illustrated brochures at the Augusta-Richmond County Museum.
3. Ianthe Bond Hebel to August Trovaioli, September 11, 1967: [his trips] "included the Indian River Hotel at Rockledge, the Ocean House, New Smyrna, the Hotel Ormond and the hotels at St. Augustine."
4. *Antiques* (August, 1966), 220–222.
5. *Ibid.*
6. Walker (Biloxi, Mississippi) to Dr. C. Lewis Diehl, June 3, 1905.
7. *Ibid.*
8. Daniel Pleasant Gold, *History of Duval County* (St. Augustine, 1929).
9. Walker to Dr. C. Lewis Diehl, April 18, 1905.
10. Interview with Mrs. Mercedes Pacetti Cates, of Centre, Alabama.
11. Interview with Mrs. Charles Moore, New Smyrna, Florida. These paintings were on the walls when the Pacetti House was sold to Mr. James Newton Gambel. They remained there with a Negro caretaker until the 1960's when they were removed to a private collection in Daytona Beach.
12. Interview with Ianthe Bond Hebel, Daytona Beach, Florida.
13. Letterhead, Pacetti House Stationery.
14. Ianthe Bond Hebel to August P. Trovaioli and Roulhac B. Toledano, September 11, 1967.
15. This painting is in the J. P. Altmayer Collection, Mobile, Alabama.
16. C. C. Gregg, *How, When and Where to Catch Fish on the East Coast of Florida* (Buffalo, New York, 1902), 5, 87.
17. Walker (Ponce Park, Florida) to Dr. Diehl, April 4, 1899.
18. *Ibid.* (On the Canal, near Hillsboro Inlet, . . . Yacht Orion), April 20, 1899.
19. Papers in the Cogswell Collection.
20. *Appleton's Handbook of American Travels*, 1874.
21. Abercrombie, Lelia, "When the Century Turned," a pamphlet published by the Pensacola Historical Museum (n.d.).
22. Paintings in the Pensacola Historical Museum Collection and the private collection of Mrs. Ada Wilson, Pensacola.
23. Walker (Ponce Park) to Dr. Diehl, December 28, 1904.
24. *Ibid.*, February 8, 1911.
25. Walker (Ponce Park, Florida) to Katie Diehl, February 1914.
26. Walker (St. Augustine) to Dr. Diehl, December 7, 1905.

Georgia and Florida

1. Walker (New Orleans) to Dr. Diehl, Louisville, Kentucky, April 18, 1905.
2. William Aiken Walker (Biloxi, Mississippi) to Dr. Diehl, June 2, 1905.
3. Walker to his nephew, George Walker (n.d.). MS in the possession of Mrs. George A. Martin, Columbia, S.C.
4. See *250 Years of Life in New Orleans*, The Friends of the Cabildo, 1968, for biographical sketches of New Orleans artists.
5. New Orleans *Daily Picayune*, Saturday, November 6, 1886.
6. New Orleans *Daily Picayune*, 1882 (from private scrapbook).
7. *Ibid.*
8. New Orleans *Daily Picayune* (undated clipping from private scrapbook).
9. New Orleans *Daily Picayune*, November 6, 1886.
10. *Picturesque Vicksburg* (Vicksburg, Mississippi, 1895), 38.
11. William Alexander Percy, *Lanterns on the Levee* (New York, 1941).
12. Rev. Joseph Bogen to Hon. C. F. Davis, January 26, 1883, in collection of J. P. Altmayer, Mobile, Alabama.
13. Walker (Biloxi) to Dr. Diehl, June 2, 1905.
14. Walker (New Orleans) to Miss Katie Diehl, June, 1905.

Louisiana and Mississippi

North Carolina and the Final Years

1. Edward King, *The Great South*, illus. J. Wells Champney (Hartford, Conn., 1875), 505, 507.
2. Walker (Arden Park) to Dr. Diehl, June 19, 1904.
3. Beale Fletcher interview, Asheville, North Carolina; this information also appeared in a newspaper article about the Beale family.
4. Arden Park Lodge Ledger Book, Beale Fletcher Collection, Asheville, North Carolina.
5. Interview with Mrs. E. Milby Burton, Charleston, November, 1971.
6. Walker (Ponce Park) to Dr. Diehl, November 18, 1904.
7. *Ibid.*, December 28, 1904.
8. *Ibid.*, February 11, 1904.
9. Walker to Dr. Diehl, undated.
10. *Ibid.*, June, 1912.
11. *Ibid.*
12. Walker (Ponce Park) to Mrs. B. J. Pacetti, June 4, 1919.
13. Last Will and Testament of William Aiken Walker, Records, County Courthouse, City of Charleston.

The Negro in Walker's Art

1. "The Banjo Lesson" by Henry O. Tanner, Hampton Institute, Hampton, Virginia; "Whoa Emma" by David G. Blythe, Mrs. James Hailman Collection.
2. "Sweeper at Whitworth College" by G. D. Coulon, Felix Kuntz Collection, New Orleans, Louisiana.
3. "Servants of Jefferson Davis" by Andres Molinary, Louisiana State Museum, New Orleans, Louisiana.
4. Homer went to Petersburg, Virginia, in 1876, where he painted a series of Negro paintings. Then in the 1890's he spent some time on the St. John's River in Florida, when Walker was also there. The two have sketched and painted similar subjects.
5. The groupings of a Negro man, woman, and child in an unsigned painting in the Ray and Martha Ann Samuel Collection, correspond exactly to a group of figures in the cotton plantation scene published by Currier and Ives (figs. 1, 2).
6. Harry T. Peters, *Currier and Ives, Printer to the American People* (New York, 1943), 21. One of the more interesting of Tait's sports illustrations is "Catching a Trout" (Peters, Plate 15) with two white men and one black man in a boat. The black man is the most carefully done and least caricature-like figure in the print. The Cameron print appears in Peters, Plate 158. See also Plate 56.
7. A notable scene is in Joel Chandler Harris' *The Chronicles of Aunt Minervy Ann* (New York, 1907), 9, 163.
 Joel Chandler Harris, *Daddy Jake the Runaway and Other Stories by Uncle Remus* (New York, 1889).
8. "Painting of Negro" by J. L. Fithian, J. P. Altmayer Collection, Mobile, Alabama.
9. Langston Hughes and Milton Meltzer, *Pictorial History of the Negro in America* (New York, 1956), 222.
10. Very related in spirit to Walker's work is "Peanut Seller at the Savannah Market" illustrated in *Harper's Weekly*, July 16, 1907, from a sketch by Lloyd Mifflen. The photographic point of view and the picturesque quality of the woman amid the vegetables recalls Walker's "Charleston Vegetable Woman," James E. Taylor's "Southern Scenes," and Horace Bradley's "In a Cotton Field" (*Harper's Weekly*, August 20, 1887, p. 592).
11. In the Ben C. Toledano Collection, New Orleans, Louisiana.
12. Walker (Ponce Park) to Dr. Diehl, dated December 28, 1904.
13. Paul Laurance Dunbar, *Poems of Cabin and Field* with photographs by the Hampton Institute Camera Club (New York, 1896).
14. Essie Collins Matthews, *Aunt Phebe, Uncle Tom and Others* (Columbus, Ohio, 1915).
15. C. Vann Woodward, *Origins of the New South, 1877–1913* (2nd ed.: Baton Rouge, 1971), 223.
16. *Ibid.*, 206.
17. Irwin Russell's poem "Christmas Night in the Quarters" describes the parson and the deacon types as recorded visually by Walker:

> See Brudder Brown—whose saving grace
> Would sanctify a quarter race—
> Out on the crowded floor advance
> To beg a blessin on dis dance.

18. One such is begun in a pencil Sketch, "Savannah Market," Robert Stanley Green Collection, New Orleans.
19. Interview with Alonso Lansford, former director, Telfair Academy, Savannah.
20. Walker (Ponce Park) to Dr. Diehl, dated February 17, 1911.
21. Bernard M. Baruch, *My Own Story* (New York, 1957), Chap. XXI.

Naturalism in Walker's Art

1. The Bierstadt "View of Fort Sumter" is illustrated in a catalogue by the Cummer Art Gallery, Jacksonville, Florida, for an exhibition of American Port views.
2. The New York printers published few prints of the Louisiana scene not including the many Mississippi River boat scenes by Fanny Palmer, which were largely imaginary and could have portrayed generally any point south of St. Louis. "J. Bufford" is the signature on the stone of "The Metairie Race Track" in 1855. Louis Maurer of New York did "Ruins of the Planters Hotel, New Orleans, which fell at two o'clock on the morning of the 15th of May, 1835." This was a record of the fire at the first St. Charles Hotel. There are two views of the city of New Orleans and three Civil War battle prints of engagements in Louisiana. Thus the South's international port during the nineteenth century received comparatively little attention by Currier and Ives, who printed well over 4,317 illustrations.
3. Ray Samuel Collection, New Orleans.
4. The Historic New Orleans Collection contains a lithograph, "The Sunny South," copyright 1882 by H. C. Tunison, Central Map and Chart Company, which has characteristics of a Walker scene.

Chronology

1838 Born, March 23, 1838, in Charleston, South Carolina
1843 Baltimore, Maryland
1850 Exhibited at Fair in Charleston at age 12
1858 Exhibited in Charleston
1860 Painted "Blue Winged Drakes," "Crabs and Prawn," "Bobwhite and
 Rails"
1861 Enlisted in Confederate Army, Hampton, South Carolina
1862 Mother died, January
1863 Drew map of Charleston and defenses
1864 Made sketch of Fort Sumter from East Battery for Confederate
 Records
 Wilmington, North Carolina, July 4
 Wrote "My Love is Far Away," a poem dedicated to Mlle. Frankie
 Myers
 Composed "La Manola Polka Redova," July 21
 Was dropped from Confederate list, December 31
 "Sheepshead"
 Hand painted deck of cards (Jay P. Altmayer Collection)
1866 Began book of poetry, *Mes Pensires*, Charleston
 "Snipes and Quails" (Kennedy Galleries, Inc.)
1868 "St. Finebars Church," Charleston (Herman Schindler Collection)
 Lived in Baltimore 1868 to 1869
 "Negro Peddler," Charleston (Altmayer Collection)
1869 Baltimore, W. A. Walker, Artist and Teacher of Languages
 Cuban Trip, December 9 to March 13, 1870
 Cuban diary: December 14 to January 1, 1870—painted 47 paintings
1870 European Trip in the spring
 "Vegetable Woman," Charleston (Altmayer Collection)
 Baltimore, Artist Exhibition, "One of the Attractions of the Sea-
 shore" and "Colored Boy Walking Across Plantation"
1871 "Newsboy Selling the Baltimore *Sun*"
1872 Baltimore
1878 New Orleans; Charleston; Bonnie Crest Inn, North Carolina
 Wrote "O Salutaris Hostia," August, Sullivan's Island, South
 Carolina
 "The Banquet," and "The Banquet Interrupted," Augusta, Georgia
1879 New Orleans; Charleston; Kingston, Georgia; Arden, North
 Carolina
 Richard Clague died in North Carolina
 Everett D. B. Fabrino Julio died in Kingston, Georgia
1880 New Orleans; Charleston; Arden, North Carolina
1881 Ponce Park, Florida
1883 New Orleans; Charleston; Arden
 "New Orleans Levee" (reproduced by Currier and Ives)
 "Cotton Plantation on the Mississippi" (Mrs. Whitney Porter
 Collection)
1885 First Annual Exhibition of the Artist's Association of New Orleans
 (Walker exhibited each year through 1905)
 Arden
1887 "Ruffles and Rags," "Two Negro Boys Fighting" (Altmayer
 Collection)

1888 New Orleans; Charleston; Arden
 "Calhoun's Slaves," "Wagon and Negroes"
1889 New Orleans; Florida; Charleston; Arden
 15 sketches (Sketchbook in collection of Mrs. Elizabeth W. Will-
 ingham) including sketches signed Edisto Island, March 16;
 Nantahala River, N.C., August 17; Tuckaseege River, N.C.,
 August 23; Balsams Gap, N.C., August 23; Battery Park Hotel,
 Asheville, August 23; Runnymede, S.C., October 3
1890 Florida; Arden
 11 sketches (Sketchbook, Willingham Collection)
 "South Battery, Charleston"
1891 Florida "Lighthouse" (Sketch in Willingham Collection), January
 "North Carolina Landscape," October 17
 "Simon's Cabin," "Davis' Cabin," "Pond Edisto"
 "Palmettos," South Carolina and North Carolina
1892 St. Augustine, Florida, March 5; Fort Walton, Florida, "Palm Trees
 On Beach At Fort Walton"
 "A Cotton Picker," "Coastal Scene" (Altmayer Collection), Charles-
 ton; New Orleans
1893 New Orleans, "Chums Befo Dah War" (Dr. William H. Frampton
 Collection)
 Exhibited Chicago Fair, Louisiana State Building
 "Way Down South in the Land of Cotton"
 Arden; Biloxi, Mississippi, September 26
 12 sketches of Florida (Sketchbook, Willingham Collection)
 Matamassas, Florida
1894 Arden; New Orleans; Edisto Island, South Carolina
1895 Charleston; Ponce Park, Florida, "Florida Landscape"
 Arden; New Orleans
1896 Arden; New Orleans
1897 New Orleans; Arden
1899 Ponce Park, Florida, Cruise along the east coast on the Orion,
 April 8 to April 21 (80 sketches)
 Charleston; Arden
1900 New Orleans; Charleston; St. Augustine, Florida; Arden
1901 "Indian Key, Florida" signed "66 Miles from Miami, Early Morn-
 ing, December 6, 1901"
 "Sponge Kraal in Ocean" (George Missbach Collection)
 "St. Lucie, Florida" (sketch), November 16
 Arden; New Orleans; St. Augustine
1902 Ponce Park, Florida, April
 "Fish Study," November 28
 Wrote poem, "The Cruise"
 St. Augustine; Charleston; Arden
1903 Arden Lodge, June 23
 Charleston; New Orleans
1904 Signed in from Ponce Park at Arden Lodge, June 16
 Augusta, Georgia
 "Isle of Palms, South Carolina," October 6
 "Ponce Park, Florida," November 8
 "Ponce Park, Florida," December 28
 Seven sketches of "Palms, Dunes, and Sea Oats," Ponce Park
 Charleston, October
 Arden, June 19
1905 Ponce Park, Florida, February 2
 One week at the Magnolia, St. Augustine
 Jacksonville, Florida
 New Orleans, April 18
 Biloxi, Mississippi, June 3
 Arden, September
 St. Augustine, December 2
 "Putting the Sallie in Commission," December 25
 St. Augustine; Arden
 Ponce Park, December 26
 Charleston

1906 "Turtle Mound," February 8
　　　Arden Lodge, June 5
　　　Ponce Park
1907 Fort Pierce, Florida, November 6
1908 Arden, August 5
　　　Ponce Park, April 17 (6 sketches)
1909 Arrived at Arden Lodge from Ponce Park, June 17
1910 "Carolina Toadstools"
　　　Ponce Park, January 21
　　　Arden
1911 Ponce Park, January 29
　　　Arden
1912 Charleston, May 26
　　　Arden, June
1913 Ponce Park, November
　　　Arden
1914 Ponce Park, February 8
　　　"Palmettos," April (Cogswell Collection)
　　　Arden
1915 "Spanish Daggers," "Edisto Island," South Carolina, May
　　　　　(Collection of Floyd A. Walker)
　　　Arden
1916 Savannah, Georgia; Arden; Charleston; Augusta, Georgia
1919 Ponce Park
　　　"North Carolina Mountain Scene," October
　　　Charleston
1920 Arden, October 15
　　　"Old Cabin" (Sketch)
1921 Died January 3; buried in family plot, Magnolia Cemetery,
　　　　　Charleston.

Works Consulted

Adams, Edward C. L. *Congaree Sketches*. Chapel Hill, 1927.

Allen, W. *Slave Songs of the U. S.* New York, 1867.

Appleton's Handbook of American Travels, Southern Tour. New York, 1874.

Armstrong, Orland Kay. *Old Massa's People: The Old Slaves Tell Their Story*. Indianapolis, 1931.

Artwork of Augusta, 12 folios, Chicago, 1894.

Artwork of Augusta and Savannah, Georgia, 12 folios, Chicago, 1902.

Asbury, Herbert. *The French Quarter*. New York, 1936.

Atlas to Accompany the Official Records of the Union and Confederate Armies 1861–1865.

Baruch, Bernard. *My Own Story*. New York, 1957.

Nichols, R. F., ed. *Battles and Leaders of the Civil War*. 4 vols. New York, 1956.

Becker, M. *Golden Tales of the Old South*, New York, 1930.

Blackburn, Mary Johnson. *Folklore from Mammy Days*. Boston, 1924.

Bonner, H. C. "A. B. Frost." *Harper's New Monthly Magazine*, LXXXV (1892), 699.

Bonner, Sherwood. *Dialect Tales*. Illustrated by A. B. Frost. New York, 1883.

Boyle, Virginia Frazer. "How Jerry Bought Malvinny." *Century Magazine*, XL (1880), 892.

Bruce, P. A. *The Rise of the New South* (Philadelphia, 1905), Vol. XVII of Guy Carleton Lee (ed.), *The History of North America*.

Buck, Paul H. *Road to Reunion, 1865–1900*. New York, 1938.

Cason, Clarence. *90° In the Shade*. Chapel Hill, 1935.

Chipley, W. D. *Pensacola and Its Surroundings*. Louisville, 1877.

Clarke, J. T. *Songs of the South*. Philadelphia, 1896.

Cline, Dr. I. M. *Art and Artists in New Orleans During the Last Century*. New Orleans, 1922.

Clowes, Sir William Laird. *Black America: A Study of the Ex-Slave and His Late Master*. London, 1891.

Cocke, Sarah Johnson. *Old Mammy Tales From Dixie Land*. New York, 1911.

Cohen, Lily Young. *Lost Negro Spirituals*. Illustrated by Kenneth K. Pointer. New York, 1928.

Coit, Margaret. *Growing Years, 1789–1829*. New York, 1963. Vol. III of *The Life History of the United States*.

Conningham, Frederic A. *Currier and Ives Prints, An Illustrated Check List*. New York, 1949.

Couch, W. T., ed. *Culture in the South*. Chapel Hill, 1935.

Coulter, E. Merton. *The South During Reconstruction, 1865–1877*. Baton Rouge, 1947. Vol. VIII of *A History of the South*. Baton Rouge, 1947–1971.

Cram, Mildred. *Old Seaport Towns of the South*. Illustrated by Allan G. Cram. New York, 1917.

Crandall, Marjorie Lyle. *Confederate Imprints; A Check List Based Principally on the Collection of the Boston Athenaeum*. Boston, 1955.

Craven, Avery O. *The Growth of Southern Nationalism, 1848–1861*.

Baton Rouge, 1953. Vol. VI of *A History of the South*. Baton Rouge, 1947–1971.

Culbertson, Ann Virginia. *Banjo Talks*. Photographs by Mary Morgan Kiepp and Heustis Pratt Cook. Indianapolis, 1905.

Daniels, Jonathan. *A Southerner Discovers the South*. New York, 1938.

Davidson, Donald. *Still Rebels, Still Yankees*. Baton Rouge, 1957.

Davis, Allison; Gardner, Burleigh B.; and Gardner, Mary R. *Deep South, A Social Anthropological Study of Caste and Class*. Chicago, 1941.

Dooley, Mrs. James H. *Dem Good Ole Times*. Illustrated by Suzanne Gutherz. New York, 1906.

Douglas, Marjorie Stoneman. *Florida: The Long Frontier*. New York, 1967.

Dowd, Jerome. *The Negro in American Life*. New York, 1926.

Dunbar, Paul Laurence. *Poems of Cabin and Field*. Photographs by the Hampton Institute Camera Club. New York, 1896.

———. *Folks From Dixie*. Illustrated by E. W. Kemble, London, 1898.

———. *Lyrics of Lowly Life*. New York, 1899.

———. *When Malindy Sings*. New York, 1903.

Elliot, E. N. ed. *Cotton is King and Pro-Slavery Arguments: The Writings of Harper, Hammond, Christy, Stringfellow, Hodge, Bledsoe, and Cartwright*. Augusta, 1860.

Fremaux, Leon J. *New Orleans Characters*. New Orleans, 1876.

Fulton, W. Joseph, and Toledano, Roulhac. "New Orleans Landscape Painting of the Nineteenth Century." *Antiques*, April, 1968, pp. 504–510.

Gielow, Martha S. *Mammy's Reminiscences and Other Sketches*. Illustrated by Clara Weaver Parrish. New York, 1898.

Gold, Pleasant Daniel. *History of Duval County*, St. Augustine, 1929.

Gonzales, Ambrose E. *The Captain: Stories of the Black Border*, Columbia, S.C., 1924.

———. *The Black Border: Gullah Stories of the Carolina Coast*. Columbia, S.C., 1922.

———. *With Aesop Along the Black Border*. Columbia, S.C., 1924.

Goodrich, Lloyd. *The Great American Artist Series*. New York, 1959.

Gregg, William H. *When, Where, and How to Catch Fish on the East Coast of Florida* (assisted by Capt. John Gardner of Ponce Park, Mosquito Inlet, Florida), Buffalo, 1902.

Groce, George C., and Wallace, David H. *Dictionary of Artists in America, 1564–1860*. New Haven, Conn., 1957.

Harman, Marion F. *Negro Wit and Humor: Folklore, Folk Songs, Race Peculiarities & Race History*. Louisville, 1914.

Harris, Joel Chandler. *Nights With Uncle Remus. Myths and Legends of the Old Plantation*. Illustrated by W. H. Beard and "Church." New York, 1883.

———. *The Chronicles of Aunt Minervy Ann*. Illustrated by A. B. Frost. New York, 1907.

———. *Daddy Jake the Runaway and Other Stories by Uncle Remus*. New York, 1889.

Harrison, Belle R. *Pomp's People*. New York, 1929.

Harwell, Richard Barksdale. *More Confederate Imprints*. Richmond, Virginia State Library, 1957.

Heite, Edward F. *Painter of The Old Dominion*. Richmond, Va., Valentine Museum, n.d.

Helm, M. *The Upward Path: The Evolution of a Race*. New York, 1909.

Horton, Rushmore G. *A Youth's History of the Great Civil War in the United States from 1861 to 1865*. New York, 1867.

Hudson, Arthur Palmer. *Folksongs of Mississippi and Their Background*. Chapel Hill, 1936.

Hughes, Langston, and Meltzer, Milton. *Pictorial History of the Negro in America*. New York, 1956.

Johnson, Charles S. *Shadow of the Plantation*. Chicago, 1934.

Jones, Charles C. Jr. *Negro Myths from the Georgia Coast*. Boston, 1888.

Jones, Katherine M. *The Plantation South*. Indianapolis, 1957.

Jordan, Robert Paul. *The Civil War*. Washington, D.C., 1969.

Kane, Harnett. *Gone Are the Days: An Illustrated History of the Old South.* New York, 1960.

Kennedy, R. Emmet. *Black Cameos.* New York, 1924.

———. *Mellows, A Chronicle of Unknown Singers.* Illustrated by Simmons Persons. New York, 1925.

———. *More Mellows.* New York, 1931.

———. *Runes and Cadences.* New York, 1926.

King, Edward. *The Great South.* Illustrated by J. Wells Champney. Hartford, Conn., 1875.

King, Ray, and Burke, Davis. *The World of Currier and Ives.* New York, 1968.

Lanier, Sidney. *Florida.* Philadelphia, 1875.

Leap, William Lester. *Red Hill: Neighborhood Life and Race Relations in a Rural Section.* Phelps-Stokes Fellowship Papers, Number 10. Charlottesville, Virginia, 1933.

McCausland, Elizabeth. *The Life and Work of Edward Lamson Henry. National Academy, 1841–1919.* N.Y. State Museum Bulletin Number 339. New York, 1945.

McIntyre, Robert C. *Martin Johnson Heade.* New York, 1948.

Mastai, M. L. O'Trange. "William Aiken Walker, Painter of the Land of Cotton." *Connoisseur Magazine,* Yearbook, 1964.

———. "The World of William Aiken Walker." *Apollo Magazine,* Yearbook, 1964.

Matthews, Eddie Collins. *Aunt Phebe, Uncle Tom, and Others.* Columbus, Ohio, 1915.

Miers, Earl Schenck. *The Story of the American Negro.* New York, n.d.

Miller, Francis Trevelyan, ed. *Photographic History of the Civil War,* 5 Vols. New York.

Moses, Montrose J. *The Literature of the South.* New York, 1910.

Mount, May W. *Some Notables of New Orleans.* New Orleans, 1896.

Nixon, Herman Clarence. *Forty Acres and Steel Mules.* Chapel Hill, 1938.

Nolen, Claude Hunter. *1921 Aftermath of Slavery, Southern Attitudes Toward the Negroes, 1865–1900.* Ann Arbor, University Microfilms, 1964.

Odum, Howard W., and Johnson, Guy B. *Negro Workaday Songs.* Chapel Hill, 1926.

Parrish, Lydia. *Slave Songs of the Georgia Sea Islands.* New York, 1942.

Pennington, Patience P. *Chronicles of Chicora Wood.* New York, 1913.

Percy, William Alexander. *Lanterns on the Levee.* New York, 1941.

Peterkin, Julia. *Roll, Jordan, Roll.* Illustrated by Doris Ulmann. Indianapolis, 1933.

Peters, Harry Twyford. *Currier and Ives, Printers To The American People.* Garden City, New York, 1942.

Pleasants, Mary M. *Which One and Other Ante Bellum Days.* Boston, 1910.

Puckett, Newbell Niles. *Folk Beliefs of the Southern Negro.* Chapel Hill, 1926.

Ralph, Jean. "Our Own Riviera." *Harper's New Monthly Magazine,* March, 1893, pp. 489–510.

Randolph, Buckner Magill. *Ten Years Old and Under, the Recollections on a Childhood Spent on a Farm Which lay in the Battle Ground of the War Between the States and is Covered by the Period 1873–1880.* Boston, n.d.

Robertson, William J. *The Changing South.* New York, 1927.

Roche, Emma Langdon. *Historic Sketches of The South.* New York, 1914.

Rodeheaver, Homer Alvin. *Plantation Melodies.* Winona Lake, Ind., 1918.

Russell, Irwin. *Christmas Night in the Quarters.* New York, 1917.

Rutherford, M. *The South in History and Literature: A Handbook of Southern Authors.* Athens, Georgia, 1906.

Rutledge, Anne Wells. *Artists in the Life of Charleston.* Vol. 39, Part 2, of Transactions of the American Philosophical Society, 1949.

Rutledge, Archibald. *Tom and I on the Old Plantation.* Illustrated by J. Rosenmeyer. New York, 1918.

Sampson, E. *Mammy's White Folks.* New York, 1920.

Savannah Revisited. Athens, Ga., 1969.

Schell, W. G. *Is the Negro a Beast?* Moundville, W. Va., 1901.

Schendler, Sylvan. *Eakins.* New York, 1967.

Simons, Katherine Drayton. *Stories of Charleston Harbor.* Columbia, S.C., 1930.

Smedes, Susan Dabney. *Memorials of A Southern Planter.* Baltimore, 1887.

Smith, Ralph Clifton. *A Biographical Index of American Artists.* Charleston, S.C., Garnier and Co.

Smythe, A. T. *et al. The Carolina Low Country.* New York, 1906.

Speir, Robert F., M.D. *Going South For the Winter.* New York, 1873.

Stanton, Theodore, ed. *Reminiscences of Rosa Bonheur.* New York, 1910.

Stoney, Samuel Gaillard. *Plantations of the Carolina Low Country.* Charleston, 1938.

Stowe, Harriet Beecher. *Uncle Tom's Cabin, or Life Among the Lowly.* Boston, 1895.

Strother, David Hunter [Porte Crayon]. *The Old South.* Illustrated by David Hunter Strother. Edited by Cecil D. Eby, Jr. Chapel Hill, 1959.

Surghnor, Mrs. M. F. *Uncle Tom of the Old South: A Story of the South in Reconstruction Days.* New Orleans, 1897.

Sutro, Ottolie. "The Wednesday Club." *Maryland Historical Society Magazine,* XXXVIII (1943), 60–61.

Talley, Thomas W. *Negro Folk Rhymes.* New York, 1922.

These Are Our Lives, as Told by the Negroes Themselves in North Carolina, Tennessee and Georgia. W.P.A. Study. Chapel Hill, 1939.

Thompson, T. P. *Louisiana Writers Native and Resident, Including Others Whose Books Belong to a Bibliography of that State to Which is Added a List of Artists.* Compiled for State Commission. New Orleans, 1904.

Tindall, George Brown. *South Carolina Negroes, 1877–1908.* Columbia, S.C., 1952.

Trowbridge, John T. *The Desolate South 1865–1866. A Picture of the Battlefields and of the Devastated Confederacy.* Edited by Gordon Carroll. New York, 1956.

Ulmann, Doris. "Among the Southern Mountaineers." *Mentor Magazine,* August, 1926.

Vance, Rupert B. *Human Factors in Cotton Culture: A Study in the Social Geography of the American South.* Chapel Hill.

Van Evrie, John H. *Negroes and Negro Slavery; The First, an Inferior Race—the Latter, its Normal Condition.* New York, 1854.

Weatherford, W. D. *Negro Life in the South.* New York, 1910.

Weeden, Howard. *Bandanna Ballads.* Verses and Pictures by Howard Weeden. Introduction by Joel Chandler Harris. New York, 1903.

Whaley, Marcellus S. *The Old Types Pass, Gullah Sketches of the Carolina Sea Islands.* Illustrated by Edna Reed Whaley. Boston, 1925.

Whitehead, Charles E. *Wild Sports in the South.* Edinburgh, Scotland, 1891.

Winter Cities in a Summer Land, A Tour Through Florida and the Winter Resorts of the South. Cincinnati Southern Railway, 1883.

Woodward, C. Vann: *Origins of the New South, 1877–1913,* 2nd ed. Baton Rouge, 1971. Vol. IX of *A History of the South.* Baton Rouge, 1947–1971.

Woofter, Jr., T. J. *Black Yeomanry; Life on St. Helena Island.* New York, 1930.

Worth, Nicholas. *The Southerner.* New York, 1909.

Young, Thomas Daniel; Watkins, Floyd C.; Beatty, Richmond Croom. *The Literature of the South.* Rev. ed. Glenview, Ill., 1968.

Abercrombie, Lelia. *When the Century Turned.* A pamphlet published by the Pensacola Historical Museum, n.d.

American Paintings of Ports and Harbors, 1774–1968. Cummer Art Gallery. Jacksonville, Florida.

Catalogues, Exhibitions, Pamphlets, and Directories

Art in South Carolina 1670–1970. Compiled and edited by Francis W. Bilodeau and Mrs. Thomas J. Tobias. South Carolina Tri-centennial Commission, 1970.

Baltimore City Directory, 1868–1872.

Bland Gallery Catalogue, New York, February 26, 1940.

The Sixth Annual Art Exhibit, New Orleans Art Association. On file at Tulane University Library.

Catalogue of the Herman Schindler Collection of Paintings by W. A. Walker. Charleston, 1967.

Catalogue of the Life and Work of Alice Ravenel Huger Smith. Manuscript, South Carolina Historical Society, Charleston.

Chapellier Galleries Catalogue. New York, 1964.

Charleston Directory and Stranger's Guide, 1837, 1838, 1840, 1841.

Charter, Constitution and Bylaws of the Art Association of New Orleans, 1893. Tulane University Library, Special Collections Division.

Cumming, Mary G. Smith. *Two Centuries of Augusta.* Augusta, Ga., 1926.

Francisco Vargas' New Orleans Characters. Louisiana Room, Louisiana State University Library, October, 1971.

Frederick Edwin Church. *Catalogue for an Exhibition Organized by the National Collection of Fine Arts.* Smithsonian Institution, Washington, D.C.

Jowett's Illustrated Charleston City Directory, 1869, 1870.

Last Will and Testament, John Falls Walker, Box 9, No. 17, *Will Book I & J, 1839–1845,* State of South Carolina.

Leiding, Harriette Kershaw. "Charleston Pictures and Their Painters." In *Charleston Art and Museum News,* South Carolina Historical Society, 1923.

Louisiana Paintings of the Nineteenth Century. The W. E. Groves Collection, Louisiana State University Library. Baton Rouge, 1959.

M. and M. Karolik Collection of Watercolors and Drawings 1800–1875. Boston.

M. and M. Karolik Collection of American Paintings 1815–1865. Boston.

New Orleans City Directory, 1886–1887.

New Orleans, Its People and Its Environs. Isaac Delgado Museum of Art. New Orleans, 1962.

Norieri Paintings. Catalogue for an Exhibition of the Works of August Norieri. The Friends of the Cabildo. New Orleans, 1970.

Picturesque Vicksburg. Vicksburg, Mississippi, 1895.

Rathbone, Perry T. *Mississippi Panorama,* St. Louis City Art Museum, 1950.

Saidek, Marvin. *The Negro in American Art.* Bowdoin College, Brunswick, Maine.

Southern Scenes, Souvenir Trans Mississippi, International Exposition. Chicago, 1903.

Southern Scenes and Characters (William Aiken Walker). Louisiana Room, Louisiana State Library. Baton Rouge, September, 1971.

The Louisiana Landscape 1800–1969. Anglo-American Art Museum, Louisiana State University. Baton Rouge, September, 1969.

W.P.A. Notebook on Artists of New Orleans. Unpublished manuscript, Isaac Delgado Museum of Art.

Journals and Magazines

Atlantic Monthly, LXXIX, 1892.

American Heritage, Autumn, 1950; June, 1967, pp. 28, 29.

Antiques, "St. Augustine, City of the Artist, 1883–1895. August, 1966. August, 1969, p. 148; April, 1950.

Apollo Magazine. June, 1961, p. 214.

Arts and Letters. August, 1887; February, 1887.

Art News, October, 1949.

Cosmopolitan, 1886–1896.

De Bows Review, III (1869).

Harper's Weekly, 1860–1870; August 20, 1887.

Harper's New Monthly Magazine, "The Oklawaha," January, 1876; "Along the Gulf, Biloxi," LXXV, p. 595; I–XL; XLVIII–LXXXV.

Kennedy Galleries Quarterly, IV, No. 2; VII, No. 1; March, 1967; April, 1964.

Leslie's Weekly, 1900.
Lippincott's Magazine, 1868; December, 1891.
McClure's, 1893.
Munsey's, 1891–1900.
Portfolio Magazine, October, 1958.
Russell's Magazine, Charleston, S.C., 1857–1860.
Southern Quarterly Review, February, 1857, "The Fraser Gallery."

Augusta *Chronicle,* 100th Anniversary Edition on Religion and Culture.
Charleston *Courier,* February 20, 1840; October 21, 1845; November 27, 1850.
Charleston *Mercury,* June 12, 1858; February 16, 1859.
Charleston *News and Courier,* January 3, 1921; July 16, 1961; May 1, 1964; Section 4C, November 15, 1962.
Daytona *News Journal,* March 10, 1953.
New Orleans *Daily Picayune,* November 6, 1884, p. 2; November 30, 1884, p. 5; October 25, 1885; November 6, 1886; January 27, 1893, p. 3.
New York *Sun,* March 2, 1940.
New York *Times,* Travel and Resorts, May 18, 1969.
St. Augustine *Tattler,* March 5, 1892.
Times Picayune, Section 2, p. 9, October 18, 1970.
The Mountaineer (Waynesville, N.C.), Centennial Edition, July, 1971.

Newspapers

Index